HIROSHI FUJIWARA

fragment

New York · Paris · London · Milan

This volume is the first comprehensive monograph on the complete work of Hiroshi Fujiwara as designer and curator. A crucial figure in the development of streetwear and attendant trends, the overwhelming majority of product designs and graphics featured in this book were authored by Fujiwara himself, or were conceived as part of a collaborative effort. The book also includes items that Fujiwara adapted on commission from existing designs for brands that have proprietary trademark over the original designs. Products and artwork that Fujiwara cites as generative influences to his work and worldview are also featured in the book.

Hiroshi Fujiwara: Fragment
Copyright © 2014 Hiroshi Fujiwara, with contributions by Sarah Lerfel Andelman, Eric Clapton, Issey Enomoto, Hidefumi Ino, James Jebbia, Takashi Murakami, Mark Parker and Jun Takahashi.

First published in the United States of America
by Rizzoli International Publications, Inc.
300 Park Avenue South, New York, NY 10010
www.rizzoliusa.com

Editor: Ian Luna
Editorial Coordination: Marie Iida, Monica Adame Davis, Tomomori Yabe and Kumiko Inaba
Production: Kaija Markoe
Production Coordination: Kayleigh Jankowski
Editorial Management: Lynn Scrabis
Editorial Consultants: Atsuo Watanabe and Jennifer Renée Bangs
Translation Services: Marie Iida
Principal Photography: Osamu Matsuo, Toru Kogure, Shoichi Kajino, Outstanding Magazine and Shoes Master Magazine

Publisher: Charles Miers

Book Design & Art Direction: Motoki Mizoguchi

The Editor would like to extend his gratitude to the following individuals: John C. Jay, Stan Wooh, Jacob Lehman, Kumiko Inaba, Toby Feltwell, Lauren A. Gould, Chieri Hazu, Brad Plumb, Masako Iida, Loïc Villepontoux, Cecil Offley, Sabina Lucas, Reina Nakagawa and the invaluable editorial support of Jennifer Renée Bangs.

Printed in China
2014 2015 2016 2017 2018/ 10 9 8 7 6 5 4 3 2 1

Library of Congress Control Number: 2013956664
ISBN: 978-0-8478-4239-1

HIROSHI FUJIWARA
fragment

The Future Hiroshi Fujiwara

Introduction by John C. Jay

Hiroshi Fujiwara action figure, a collaboration between Adfunture & Fragment Design (2009).
Personal Collection of John C. Jay.

I.

The relevant parts of his biography are known well enough. In 1982, a young man traveled from the sacred city of Ise to the big city. Shy, soft-spoken, and all of eighteen, Hiroshi Fujiwara seemed as unlikely a candidate as any to help bring about a cultural phenomenon—one that in two decades would reverberate from the streets of Harajuku to the boardrooms and runways of Paris, London, and New York. From Tokyo, wanderlust would soon see him journey to the West. He would forever be changed by living in London. He would then take in the art and music of New York like a man possessed.

On his return to Japan, Fujiwara recast himself as a "cultural" DJ. By the 1990s, he was known to the great and the good simply as HF. As a sign of his growing influence, his name would be shortened still, reduced to the first initial of his given name. Like the way of all flesh, it would be branded. Collaborating on product designs with some of the most influential creators in the world, he would in time be the 'H' in HTM, the über-exclusive line of shoes he'd created with Tinker Hatfield, the legendary sneaker designer and creator of the original Air Jordans; and Mark Parker, the multitalented CEO of Nike Inc. Embodying the many contradictions of his homeland, Fujiwara is an enigma in practice; he is at once, more than a designer and less than a designer. Agile on the snowboard, he moves effortlessly between the street to elite circles, as he does between East and West.

But Tokyo remains home, and H is indisputedly the Godfather of Harajuku. His fief, a "village" within Shibuya ward, was long the Holy Land for a subculture of self-expression, where acolytes worshipped in the latest streetwear. It was here that the legendary Nigo® first assisted Hiroshi, and went on to create *A Bathing Ape and his first store, Nowhere. Harajuku too spawned Jun Takahashi's Undercover. Hiroshi helped Takahashi's apparel line, and directed Good Enough, bringing high fashion and avant-garde sensibilities into streetwear, and transformed common goods like a T-shirt or a pair of sneakers into objects of modern luxury.

Hiroshi left Harajuku transformed. Now shorthand for a uniquely Japanese worldview, it can be argued that Nigo® and Jun Takahashi emerged and occupied the front rank of a global phenomenon that was built on the very foundation Fujiwara laid down. But as a mentor to many, Hiroshi never felt competitive with those that would become his peers. In a 2010 feature in Interview magazine, Hiroshi commented on the success of an entire generation of designers: "I think it's amazing. I don't think that kind of thing would ever happen to me, as I'm not like those kinds of designers—I don't want to express myself in such a categorized way. I kind of want to be in the middle of the majority and the minority. I really don't want people to know what I am."

II.

Post 3/11—the twin tragedies of the great Tohoku earthquake and tsunami, and the subsequent reactor failure at the Fukushima-daichi nuclear station—and Japan is finally seeing some financial momentum as it embraces the difficult changes brought on by Prime Minister Shinzo Abe's policies. A battered economy (at least in First-World terms) that was further set back by natural disaster is now experiencing a period of incremental growth, with globalization and a renewed commitment to technological innovation as the catalysts. Since change is happening day-by-day, most people do not perceive just how dramatic it really is. To Fujiwara, this "technological tsunami" is not making the same front-page headlines in Japan. "I think the economy has changed, but mentally we didn't really change much. With the nuclear thing, people are talking louder now, that's changed...I don't think I've changed that much, maybe I don't enjoy going to other cities like I did before. It's kind of the same thing everywhere today."

"The culture I am in, Harajuku, is finished. It's not dead—it's just more international now. For example, Undercover, I don't think people think of it as a brand from Japan. It's just known as Undercover. In 1992, Harajuku was a happening place, especially within sneaker culture. Then I started working with international companies such as Nike. Later, I couldn't see sneaker culture really moving on...it all became kind of the same. The culture really went down a bit, but now it seems to be moving back up again. Maybe it's the same with music?"

I asked him if there could ever be a new Hiroshi Fujiwara in today's tech-driven, social-media age: "No, I don't think so. I was getting information before anyone else and now everything is flattened, everyone is getting their information at the same time. You can't sell information anymore. When I was young, I was traveling the world and getting new information. I was finding new things, shooting and putting new stuff together for magazines. Before the internet, in the 1970s and 80s, everyone seemed so far away...to travel to the States, Rome, Paris, everything seemed far away."

Clearly, the cultural landscape has shifted, and technology has altered the subculture of collecting limited-edition products, and what used to be a predictable design lifecycle. Hiroshi observes, "Everything has a cycle, but I think the concept of cycles is changing too. Today, nothing is ever gone in the digital world. People might not see anything Punk for three years because they are hoping to see something new. But meanwhile, Punk culture never went away...it's still on YouTube." When asked about how technology has affected the cycle of buying, Fujiwara laments, "In the past, when you saw sneakers that you liked, you thought,

'I have to buy it because if I don't buy it now, I will have no chance to own it.' But now, if I see some sneakers in NYC, 'Oh, I should check on eBay. So if I see it on eBay, I think I can buy it anytime—eBay has become my closet... if I want to wear it, I can just buy it from eBay tomorrow. There is no treasure hunt anymore." So what happens to our world when nothing ever disappears, when nothing goes away forever? This is the age where all ideas, memories and expressions can survive forever. "That's why new things often are a result of nostalgia. In the last twenty years, pop culture kind of stayed the same too, it didn't grow."

"Clearly, Japan has suffered through decades of economic malaise. Are we in danger of a cultural downturn as well?" Hiroshi points out, "Younger people are making groups of friends in the same age as themselves. They really don't talk to older or younger people. If you are 25 years old, people in your group are mostly 23- to 25-year-olds with the same taste and interests in the same categories. When I was young, I enjoyed talking to people in other demographic categories, other ages and cultures."

There is a talent in being curious, and having the ability to maintain that curiosity and keeping an open mind, which gives you a certain creative edge. That edge starts with an acute sense of adventure, which fuels a constant desire to immerse oneself in a hitherto unknown culture. One has to wonder if Hiroshi's diminished desire to travel will affect the very curiosity that has fueled his ability to stay on top for so long. Being connected is just one answer, and learning online is a great way to discover information, but that is not quite the same as having knowledge or insight.

III.

Hiroshi's reputation as a person who exerts immense creative influence has led him to some unlikely places, but none as surprising or personally rewarding to him as being named Guest Professor of Pop Culture at Kyoto Seika University. His students will benefit from a wealth of experiences that overlap the most conflicting aspects of art and commerce, and will no doubt impart the kind of wisdom that can help them find their own way onto the world stage. His greatest gift to youth will be how they can remain fearlessly original. In return, he clearly derives a certain benefit: "I enjoy speaking at universities, talking to young people. I still want to see what's happening in their world of sneakers and fashion...what they are interested in."

Today, his observations on his beloved Tokyo continue to reflect his ability to see the unseen, to "feel" design and not just find it. He remains a master of "sense," the Japanese intangible that you cannot teach the West. Hiroshi's world is very immediate and tactile, a humanity that cannot depend on technology to deliver. His source of inspiration is now well beyond the global street. He is instead looking for creative expressions that are unique only to their place of origin. "Food is interesting, it's very international. Food might be the only thing you cannot truly import or export. You have to go there to taste and experience it. You can't taste the food and feel the atmosphere online. Atmosphere is everywhere if you come to Japan. But, you cannot import atmosphere. When you go to a club in London or New York, you feel so good with great music. But if you bring the same music to play in Japanese clubs, it would create a completely different atmosphere. So conversely, you cannot bring the atmosphere overseas to Japan. Maybe it's the people, the audience and the culture."

Hiroshi has mastered the art of being undefined. His accomplishments go below the radar of business school case studies and mainstream journalists. Now, there are younger students and tribes who don't recognize the extraordinary influence his strokes of inspiration still carry today. Limited-edition products are commonplace today, but it was his ability to create collaborations between his friends, often actually competitors, that inspired a generation in Harajuku and beyond. He has often single-handedly advanced the concept of product and lifestyle curation as well, most recently with the retail experience at "Tabletop" at Comme des Garçons' Dover Street Market. Here, an eclectic mix of designers and creators made exclusive products in collaboration with Hiroshi. It was the art of the mix...all on a single table.

I believe that Fujiwara's greatest accomplishments are yet to come. But we can already credit him as a guiding hand in melding high and low into a global theory for practice. Today, when we purchase exclusive limited-edition designs, or watch the glamorization of streetwear on the runway, where expensive luxury items are paired with the mundane, or when we see collaboration among the world's great talents as a way of life, we acknowledge Fujiwara's prodigious gifts. Although his work is clearly not finished, he can confidently call on a legacy.

When I brought up the power and influence of the High/Low concept with him, he naturally rebounds the credit to others: "It's the same thing you do. You introduced me to Nike, you picked me up...you found me." While there is certainly an element of truth in his comments, no one can ever wrest the title of Godfather of Harajuku from Hiroshi, and the unparalleled achievement that honorific recalls. It has been a remarkable three decades of curiosity and intrigue, and all this from a kid from the little town of Ise whose only true aspiration was to become a global citizen.

Don't be fooled by this book, he is far from being finished. By the time you read this book, it will have achieved its aims if it prompts even more inquiry. That is the power of an enigma.

So where does Hiroshi Fujiwara go from here? His role in Japanese youth culture has matured as the digital revolution is fast severing the bureaucratic habits of mind that still tether Japan to its history of isolation. The dynamic Harajuku culture has been altered by globalization, fast fashion and what Hiroshi describes as the "illusion of taste. I am looking into some other spaces, some other world... creating with a friend. Even if it's something people don't think is cool. I am trying to find something new, to make something new and bring it back to Japan... Something that will help people."

Change is coming, and Hiroshi is already looking well beyond the visible horizon: "I wonder what will be new in the 25th century?"

John C. Jay is the President / Executive Creative Director of GX and the Global Executive Director of the advertising agency Wieden+Kennedy.

section.01
Artwork / Graphics

Artwork / Graphics

**A Conversation with
Takashi Murakami and Hiroshi Fujiwara**

Takashi Murakami's friendship with Hiroshi Fujiwara dates back to when he invited Fujiwara to serve as a guest judge for the tenth edition of GEISAI (2006), the bi-annual art event that Murakami inaugurated in 2002. Fujiwara subsequently served as the curator for the exhibition Hi&Lo, which was presented by Murakami and was held at Kaikai Kiki's Roppongi gallery in October 2008. As conceived, Hi&Lo saw a presentation of art, design and fashion objects selected by Fujiwara and Murakami. Drawing from their own work as well that of their contemporaries, Hi&Lo described the arc of Japanese visual and plastic arts in the first decade of the 21st century.

TAKASHI MURAKAMI: Hiroshi and I have been close ever since he appeared as a juror at my art fair, GEISAI. By pure coincidence, I also happen to have purchased a draft of the same pattern that appears in the painting Texas Chainsaw (2006) by the artist Takeshi Masada, one of the artists in Fujiwara's collection, so I feel a special connection to him that way. Fujiwara seems to attend overseas auctions and art fairs quite frequently. As a cultural leader of Japan, he has spent the last twenty years creating opportunities to present art in a cool, sophisticated manner. This is something that nobody else has been able to do and I've learned a great deal from him. I believe that we'll soon see the day when the rising artists discovered by Fujiwara will spread throughout the world.

 Fujiwara's art collection is very impressive and I was surprised by the way he chooses his pieces according to his own unique logic. I immediately thought that I'd like to get to know him better and that's how we decided to work together on Hi&Lo.

HIROSHI FUJIWARA: My first encounter with art was in middle school when I was into music and other cultures. If it weren't for those other mediums, I think I would have bought the stereotype that art is something rigidly academic, with a very high threshold. I'd followed the work of Warhol, Basquiat, Clemente—artists who were active in New York during the 1980s. I began by buying posters and silk-screen editions of their work, and after I turned thirty, I purchased my first painting by Basquiat.

Artwork / Graphics

TM: In terms of fashion trends, Japan has taken its own initiative recently and I for one think we owe that progress to Fujiwara and the others like him who have helped steer the course over the last twenty years. It is a testament to what a great connoisseur he is. To me, Fujiwara seems to be in the same vein as Honami Koetsu of the Rimpa School, who is seeing a return to relevance these days. He is an artist whose way of life and sense of style become part of history.

HF: Instead of focusing on "the scene," I'm intrigued by how Murakami works. Beginning with the art event, GEISAI, that he directs, I feel a strong connection to his merchandizing and marketing strategies. Moreover, the challenge he posed to the Japanese art establishment was unprecedented and it's amazing how he's succeeded internationally as a result. He's taken so many risks to get to where he is today.

TM: With Hi&Lo, we hoped to present an artistic movement that began in Japan. I also wondered how I could contribute and respond to the pieces that Fujiwara submitted. Both Fujiwara and I hope that after we die, this exhibition will survive as an episode in history: "Once, a Japanese fashion leader and art collector named Hiroshi Fujiwara worked in collaboration with Takashi Murakami to organize an event." Perhaps future collectors will look at this and think: "So this is what fashion was back then. This is exactly the sort of thing that is going through a revival now." In that sense, the pieces in this show are definitely ones that those collectors will want to buy. In the art world, there's a tendency to value history itself and the pairs of jeans and sneakers I've asked Fujiwara to produce are truly collectible. When I explain this exhibit to people working in the arts overseas, they all become very interested and curious as to what it is we're trying to do. My aim is to introduce the kind of work Fujiwara has been involved in and the reasons why he is interested in art. From there, I wanted to give a presentation of the overall cultural scene in Tokyo.

HF: When I went to Art Basel with Murakami, a magazine editor who traveled with us said something interesting to me. He said, "Although I would be too embarrassed to decorate my room with the work that Murakami purchases, I have no such qualms about what you pick out." [laughs]

TM: How rude! [laughs]. The pieces that the editor pointed out as too embarrassing are among my favorites and they decorate my room to this day. [laughs]

HF: Oh, the one where Jimmy Hendrix is masturbating, right? [laughs] Those are pieces that otaku love and I like them too.

TM: I think our respective antennae respond to completely divergent things. I look for works that express the artist's shame—their most private, innermost parts—and for me, the deeper the shame the better. This is because that's the only field in which I can compete. On the other hand, I think Fujiwara is more fashion-oriented…

HF: I think I can't help but gravitate towards the more iconic.

TM: I think you have the ability to rapidly identify what fits your sensibility while keeping a finger on the current generation's context.

HF: I think I have two extreme tendencies within me. One preference is for unknown artists whose work I find interesting. The other is "uncharacteristic" work by famous artists. My intent is to discover new things and give birth to new value by mixing things that "seem unlike them." I've always had this sensibility. I think it's a sensibility that everyone should have. Just because something is famous or valued does not mean it's necessarily good; on the other hand, there can be something great in a completely unknown or disregarded work. What matters is whether you can arrange them on a single table within the context of your own sense of value. Whether it is in fashion or music, I've continued to do just that. It is the same way with Hi&Lo.

Pages 16-59: Identity graphics for Hiroshi Fujiwara's Fragment Design, Electric Cottage and GOODENOUGH, a collaborative apparel line conceived in 1993 by Fujiwara and Jun Takahashi of Undercover.

Pages 60-61: Identity graphics for Sacai Pop-Up Store

Pages 64-67: Identity graphics for Burton x Fragment collaboration.

Pages 68-71: Art and liner notes for "Nothing Much Better To Do," an album Hiroshi Fujiwara released in 1994.

Pages 72-73: Identity graphics for GOODENOUGH and Supreme collaboration.

Pages 74: Identity graphics for Head Porter, another company of the cult bag maker Yoshida Kaban.

Pages 75: Identity graphics for the store Every Little Thing.

Pages 76-77: Identity graphics for GOODENOUGH, Electric Cottage, Finesse, and More About Less among others.

INTENSE
VOLUME

DANGER
INTENSE
VOLUME

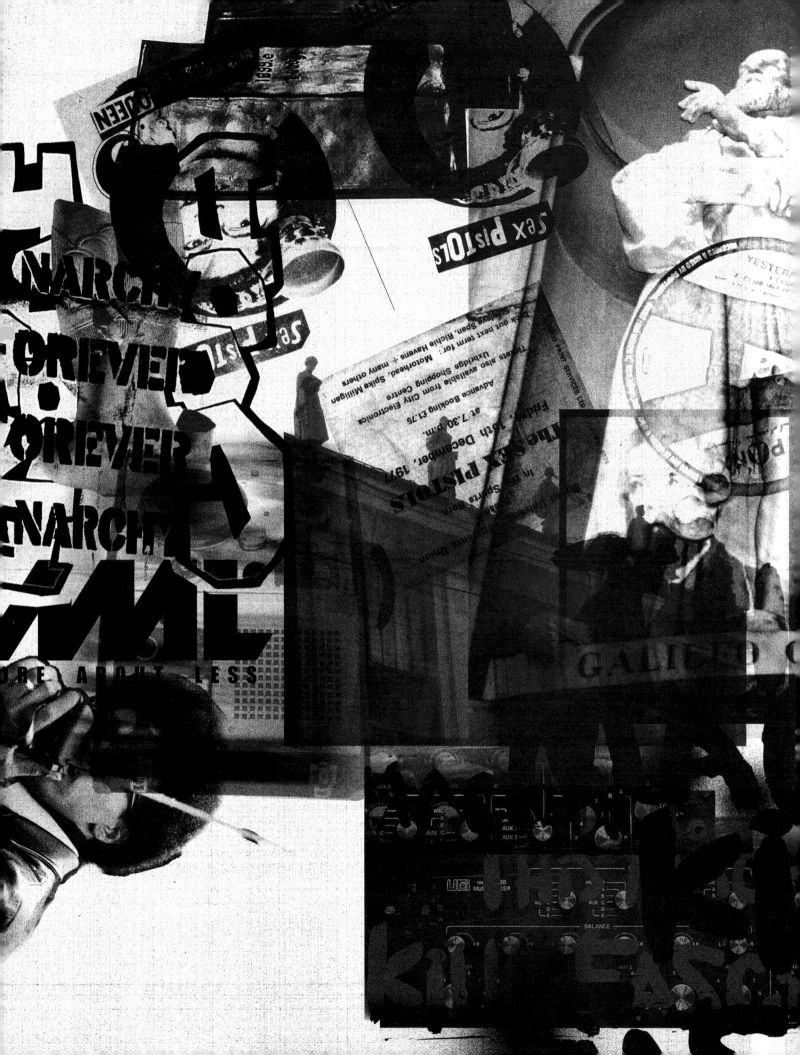

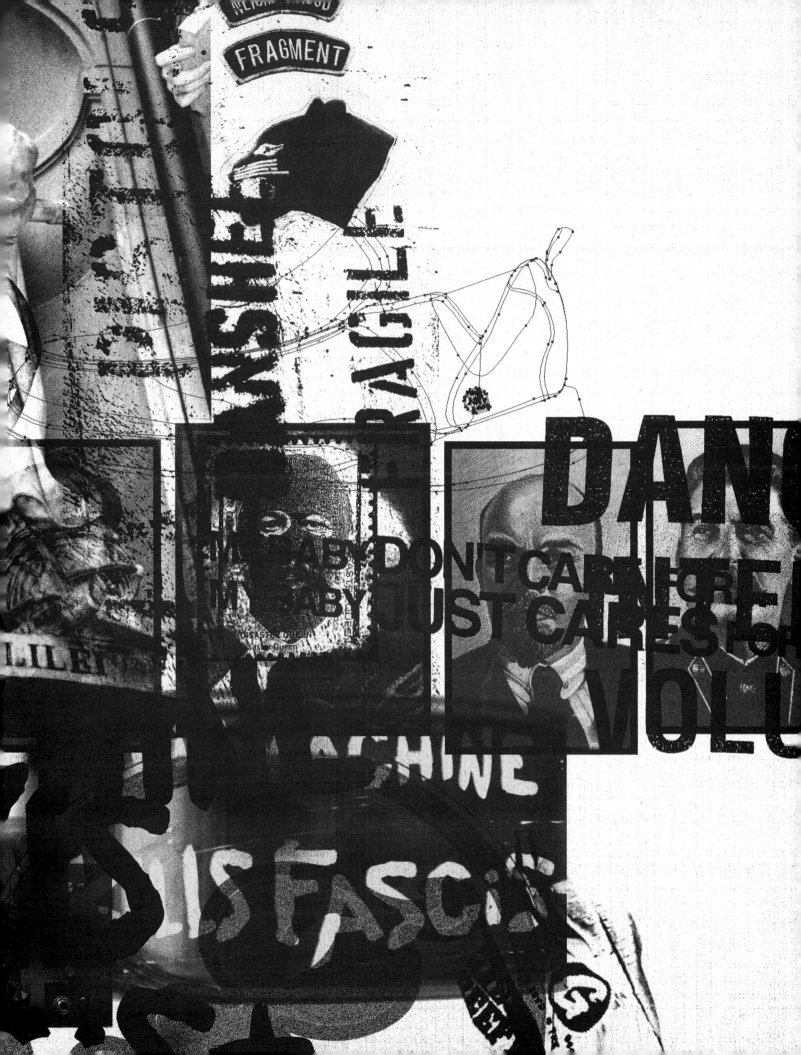

GOODENOUGH *goodenough* GE Ⓖ ⓖ

GOODENOUGH *goodenough* G̶E *G̶* *S̶*

SPECIAL EDITION SPECIAL

END RACISM

ANARCHY

1991

LOVE ENOUGH
E ENOUGH
GOOD ENOUGH

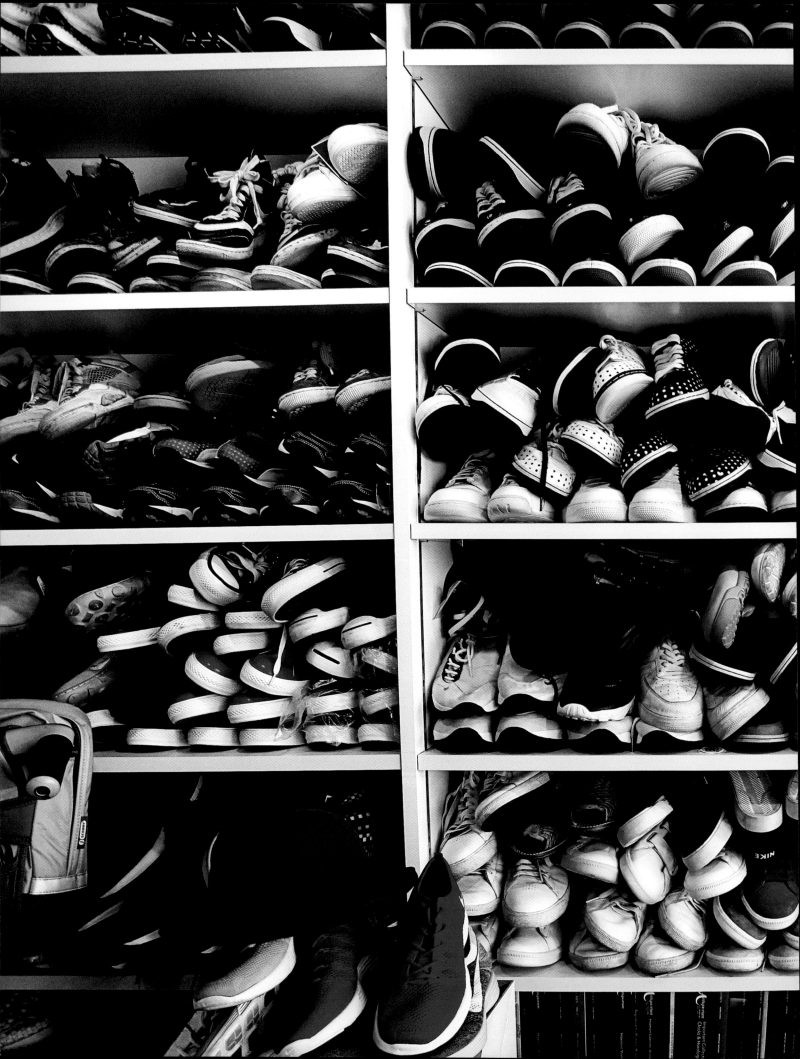

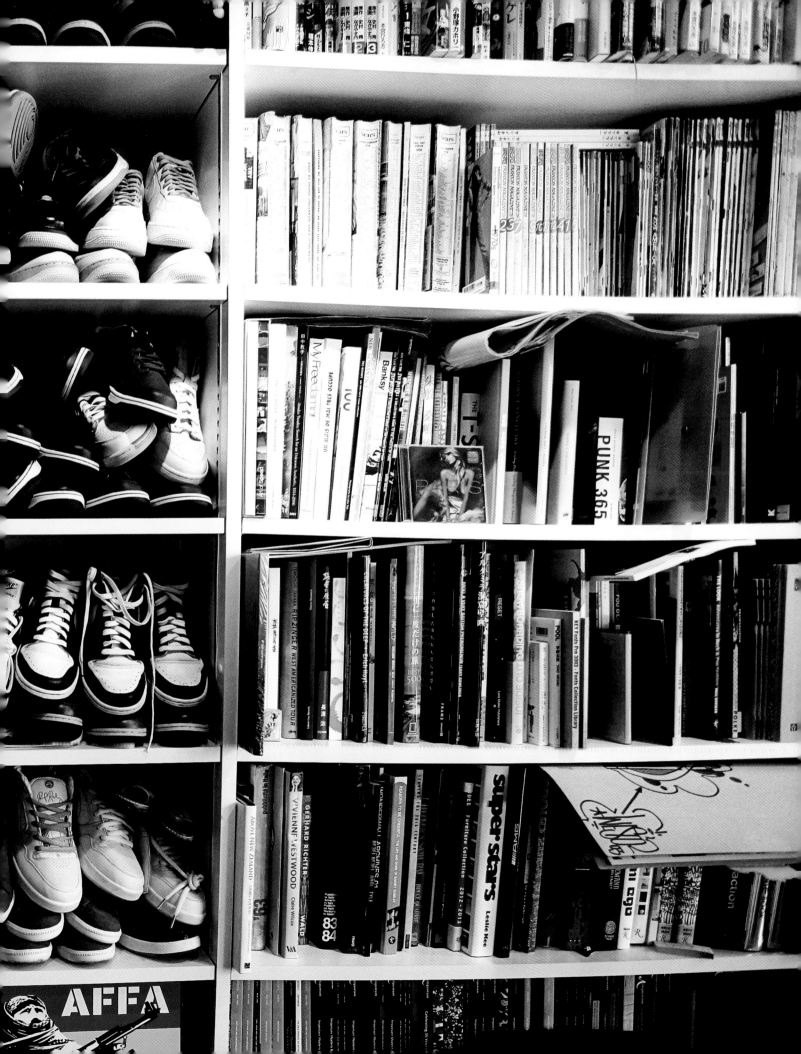

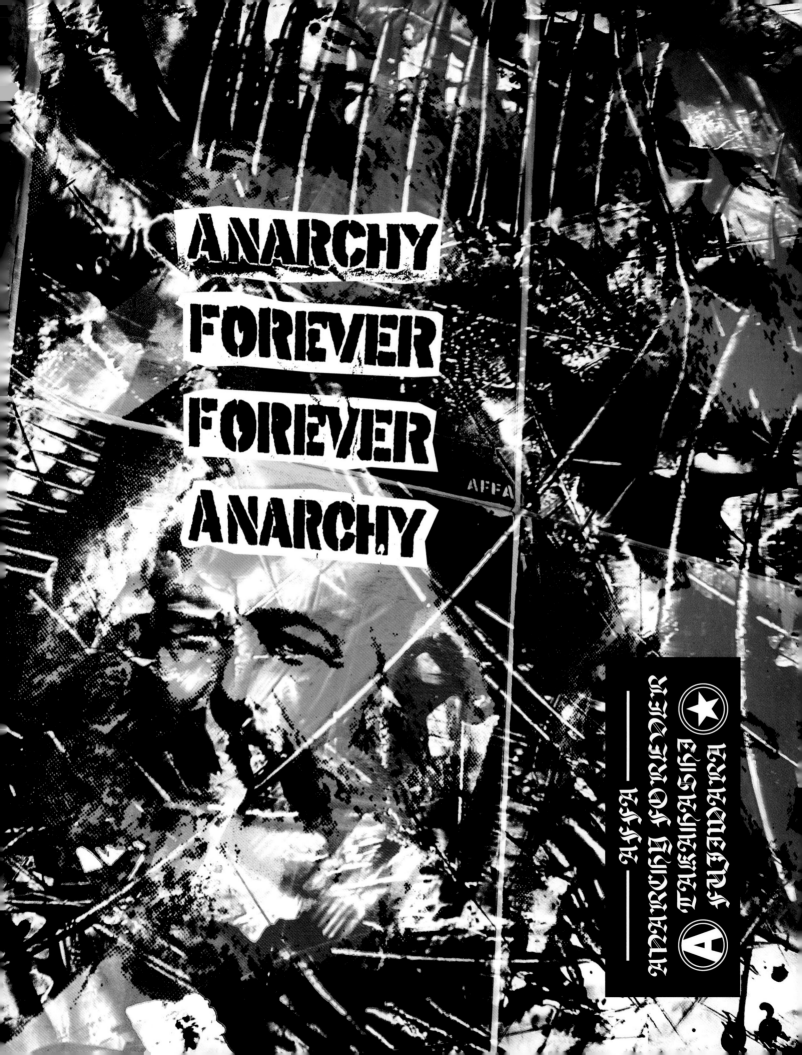

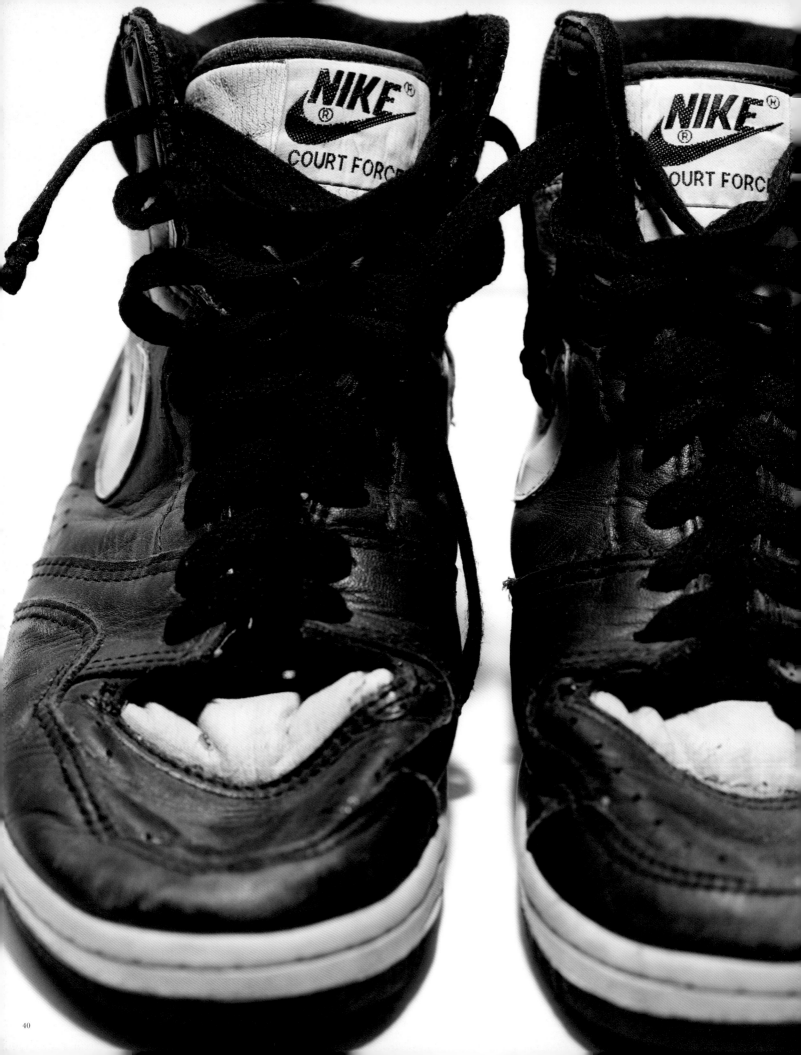

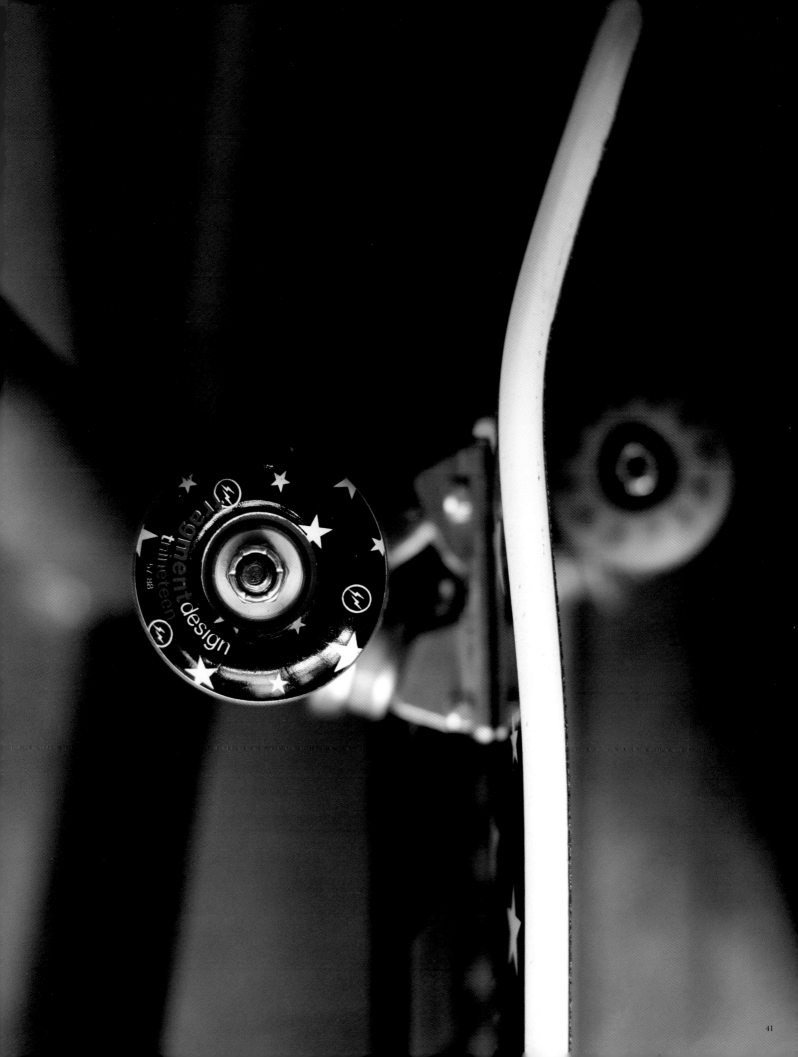

GOODENOUGH

ALL WORKS & NO PLAY MAKES YOU A DULL BOY
ALL WORKS & NO PLAY MAKES YOU A DULL BOY
ALL WORKS & NO PLAY MAKES YOU A DULL BOY
ALL WORKS & NO PLAY MAKES YOU A DULL BOY
ALL WORKS & NO PLAY MAKES YOU A DULL BOY

A NEW HIGH IN THE MUSIC SKY.
BEST SOUND AND CALM

ELECTRIC COTTAGE

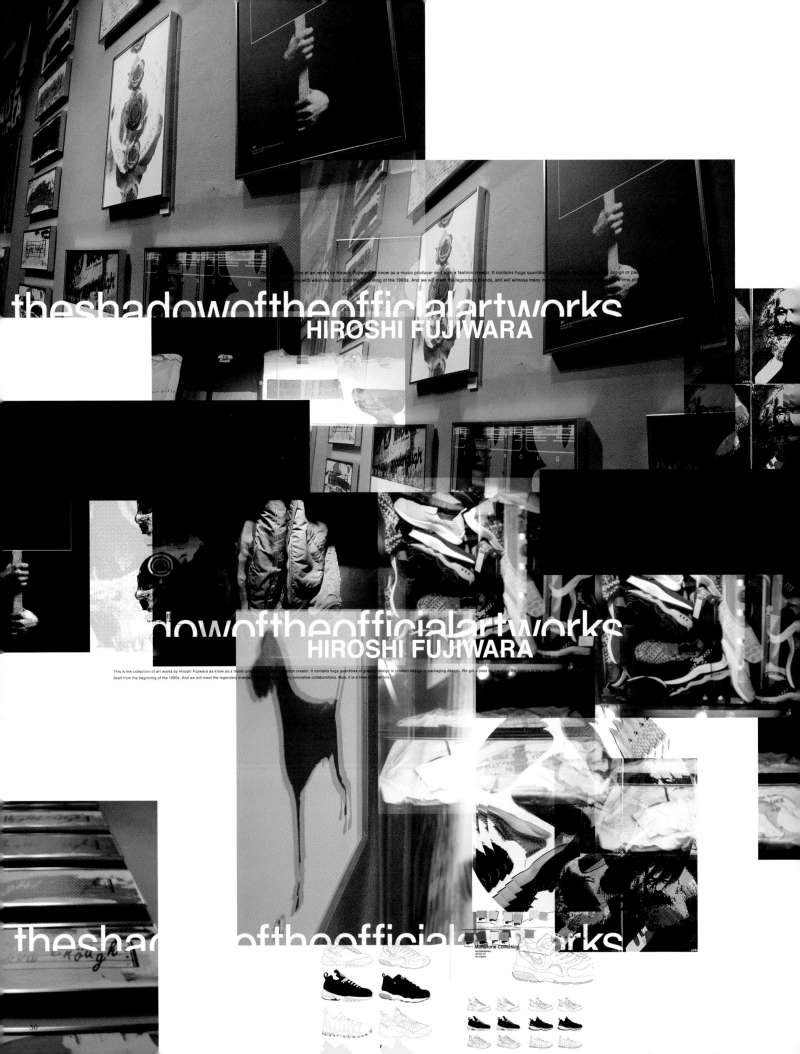

theshadowoftheofficialartworks
HIROSHI FUJIWARA

This is the collection of art works by Hiroshi Fujiwara as know as a music producer and also a fashion creator. It contains huge quantities of graphic design or product design or packaging design. We got a pass for traveling the history of the works with which he dealt from the beginning of the 1990s. And we will meet the legendary brands, and will witness many innovative collaborations. Now, it is a time of departure.

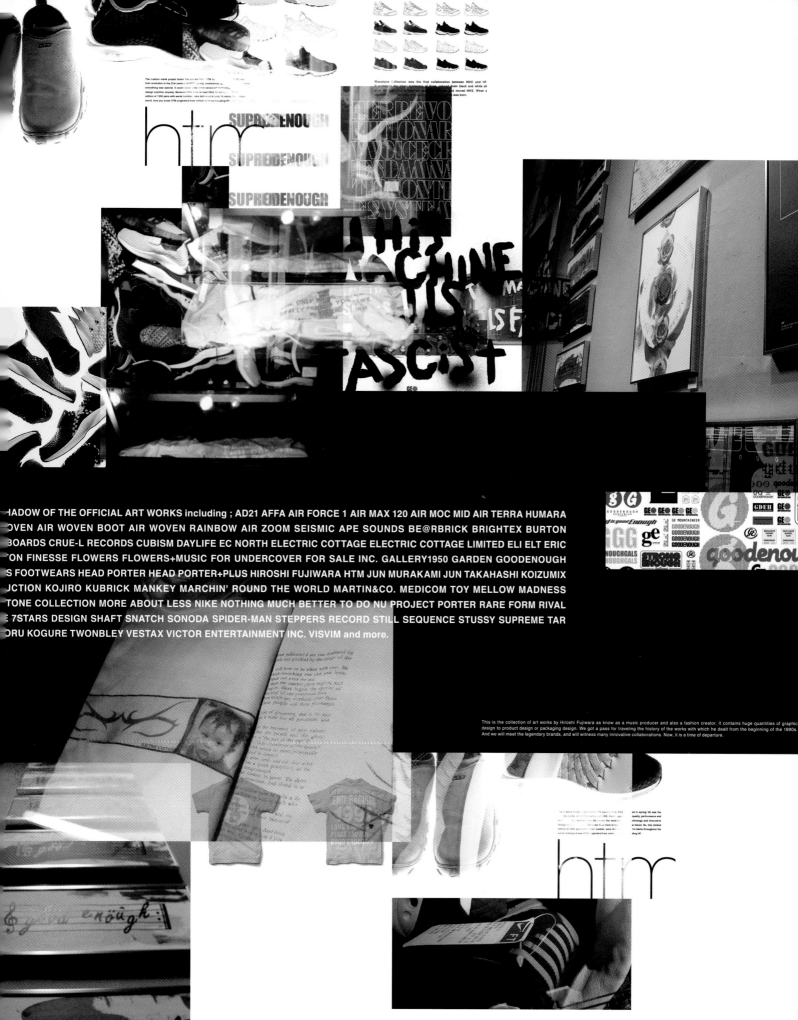

SHADOW OF THE OFFICIAL ART WORKS including ; AD21 AFFA AIR FORCE 1 AIR MAX 120 AIR MOC MID AIR TERRA HUMARA
OVEN AIR WOVEN BOOT AIR WOVEN RAINBOW AIR ZOOM SEISMIC APE SOUNDS BE@RBRICK BRIGHTEX BURTON
BOARDS CRUE-L RECORDS CUBISM DAYLIFE EC NORTH ELECTRIC COTTAGE ELECTRIC COTTAGE LIMITED ELI ELT ERIC
ON FINESSE FLOWERS FLOWERS+MUSIC FOR UNDERCOVER FOR SALE INC. GALLERY1950 GARDEN GOODENOUGH
S FOOTWEARS HEAD PORTER HEAD PORTER+PLUS HIROSHI FUJIWARA HTM JUN MURAKAMI JUN TAKAHASHI KOIZUMIX
JCTION KOJIRO KUBRICK MANKEY MARCHIN' ROUND THE WORLD MARTIN&CO. MEDICOM TOY MELLOW MADNESS
TONE COLLECTION MORE ABOUT LESS NIKE NOTHING MUCH BETTER TO DO NU PROJECT PORTER RARE FORM RIVAL
E 7STARS DESIGN SHAFT SNATCH SONODA SPIDER-MAN STEPPERS RECORD STILL SEQUENCE STUSSY SUPREME TAR
ORU KOGURE TWONBLEY VESTAX VICTOR ENTERTAINMENT INC. VISVIM and more.

This is the collection of art works by Hiroshi Fujiwara as know as a music producer and also a fashion creator. It contains huge quantities of graphic design to product design or packaging design. We got a pass for traveling the history of the works with which he dealt from the beginning of the 1990s. And we will meet the legendary brands, and will witness many innovative collaborations. Now, it is a time of departure.

ANARCHY FOREVER FOREVER ANARCHY
2000-2001 JT / HF

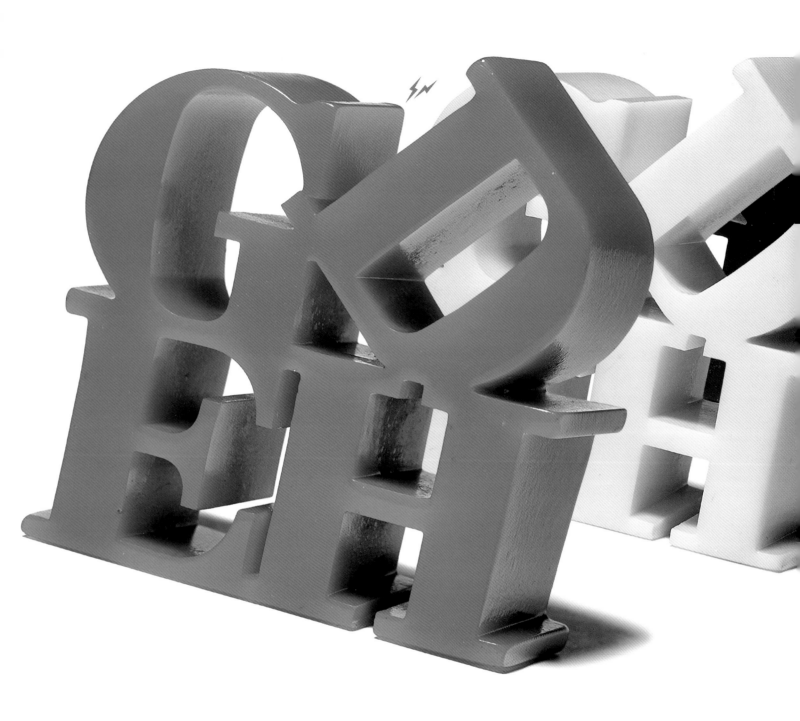

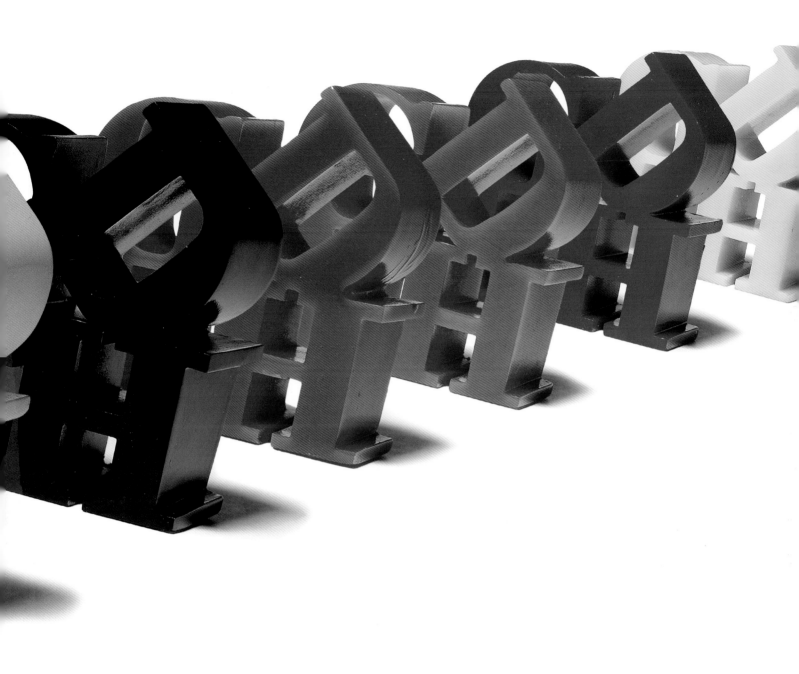

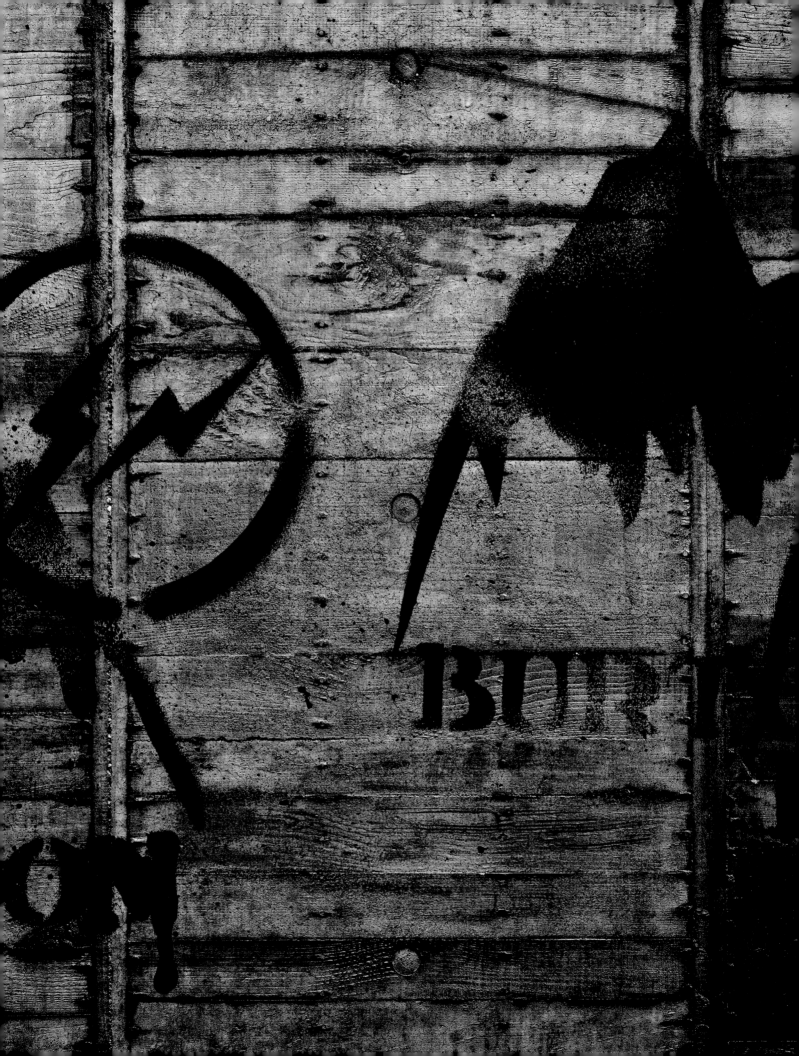

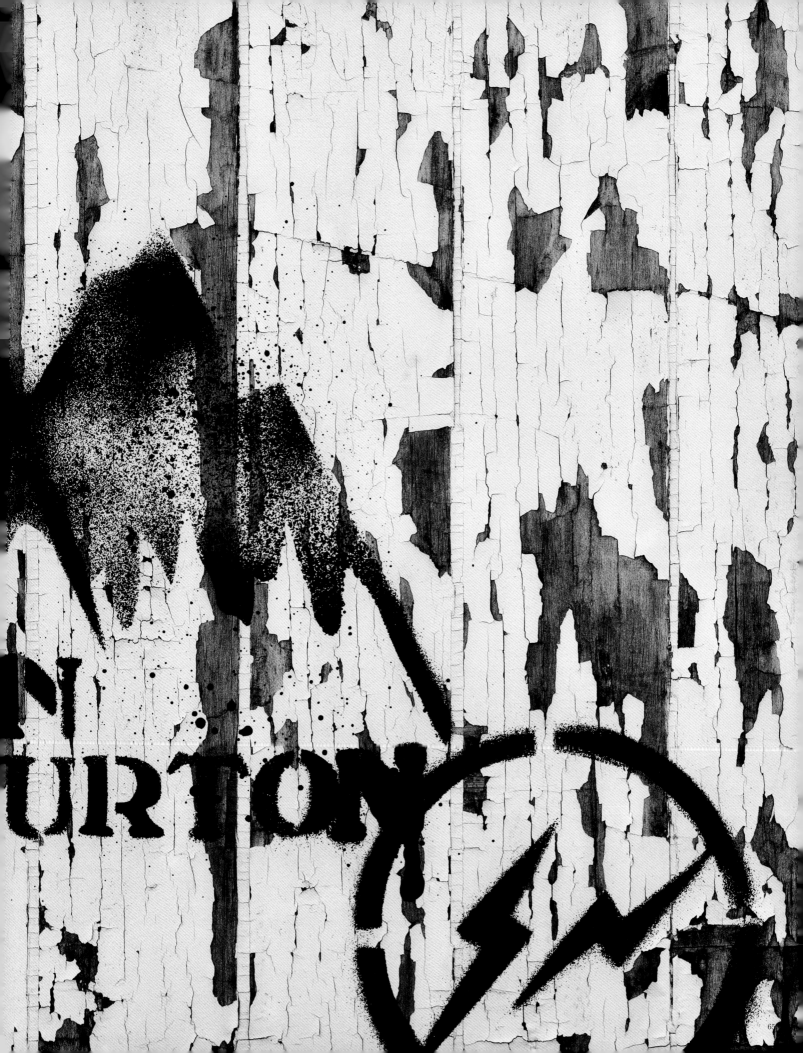

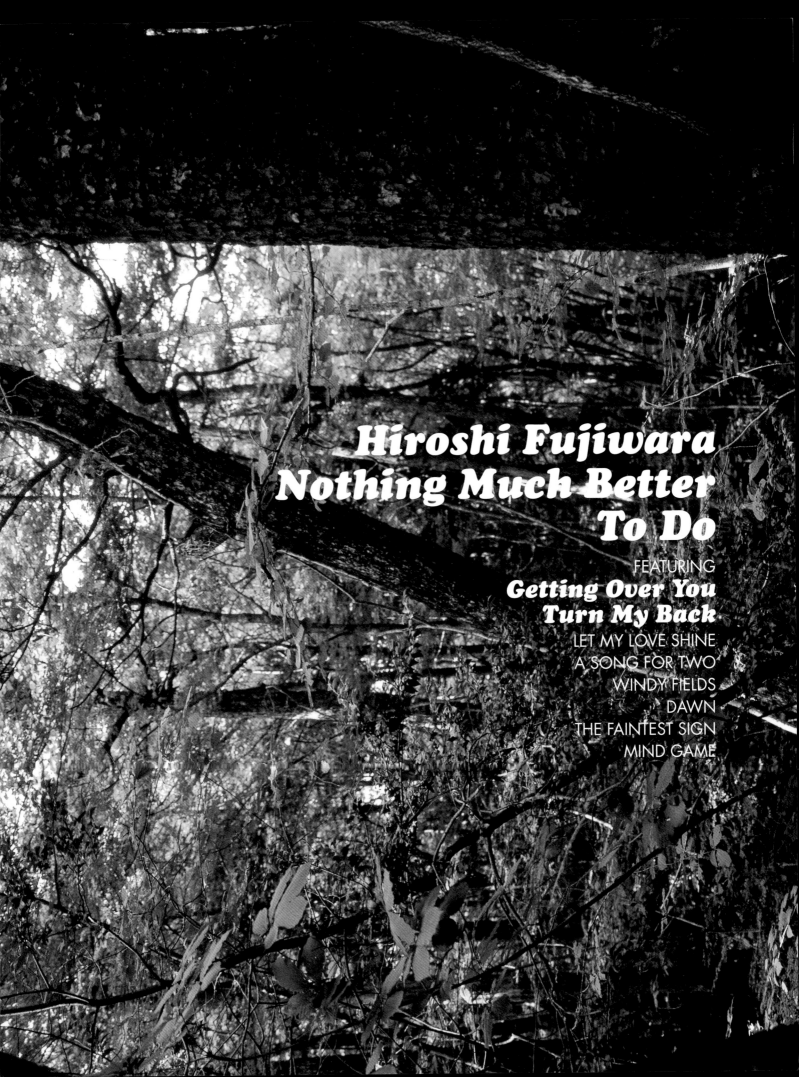

GSOOUDPRENMOEUGH

T O K Y O - N Y

GSOOUDPRENMOEUGH

T O K Y O - N Y

SUPREDENOUGH

SUPREDENOUGH

SUPREDENOUGH

SUPREDENOUGH

SUPREDENOUGH

SUPREDENOUGH

MAX.CW 67.
TARE
MAX.CW 58.
26

HEAD PORTER

goodenough

cotton base
GOODENOUGH-T-SHIRT-SIZE-XL

cotton base
GOODENOUGH-T-SHIRT-SIZE-S

cotton base
GOODENOUGH-T-SHIRT-SIZE-M

cotton base
GOODENOUGH-T-SHIRT-SIZE-L

GOODENOUGH
UNDERWEAR
100% COMBED COTTON

cotton base
GOODENOUGH-T-SHIRT-SIZE-XL

ELECTRIC COTTAGE LIMITED

MORE
about
LESS

finesse

GOODENOUGH

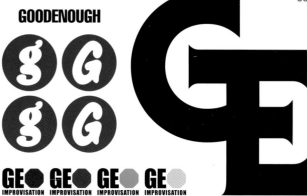

ELECTRIC COTTAGE

GOODENOUGHGALS

GOODENOUGHGALS

GOODENOUGHGALS

GE● GE● GE● GE●
IMPROVISATION IMPROVISATION IMPROVISATION IMPROVISATION

FINESSE

FINESSE

MML
more about less

brightex

more about less

World is good Enough

MML

more about less

more about less

allery
GoodDesign
1950

GOODLIVING
ENOUGH

GOODLIVING
ENOUGH

GOODENOUGH

S 1/2
Stussy ½

section.02
Sneakers

Sneakers

Mark Parker

I first learned about Hiroshi around 1998. I love to travel and Japan has always been one of my favorite countries to visit. I've been going there since 1979. I believe the best way to gain a deep understanding of a particular country's culture is to make a friend in that country. We had more than a few mutual friends, and I discovered that Hiroshi was also collaborating with Eric Clapton, Shawn Stussy, and JONIO (Jun Takahashi of UNDERCOVER), among others. I was also aware of the context of Hiroshi's music, fashion, style, his career as a designer, as well as his own personal interest in Nike. Of course, I also knew that he had a formidable influence on Harajuku and its surrounding culture. I had also been interested in Harajuku for a long time and was eager to learn about the influence Hiroshi had on Japan and the rest of the world.

John C. Jay of Wieden+Kennedy was the one who introduced me to Hiroshi. Given our respective backgrounds, we got along immediately from the beginning. I also consider myself a student of different cultures rather than a typical businessman. I always make it a point to meet people that a person in my position normally cannot. That was my first encounter with Hiroshi, so the specific business conversations came much later.

Hiroshi is someone who stands at the forefront of Japanese culture. His presence is like a door that introduces Japanese culture to the rest of the world. I think the Tokyo consumer is very sophisticated, very discerning, very critical, and pays very high attention to detail. I think it's important that we recognize that obsession with quality and detail, and we bring that to the design of the products that we create. It sets a very high standard. The word in Japanese, otaku, is something I personally relate to.

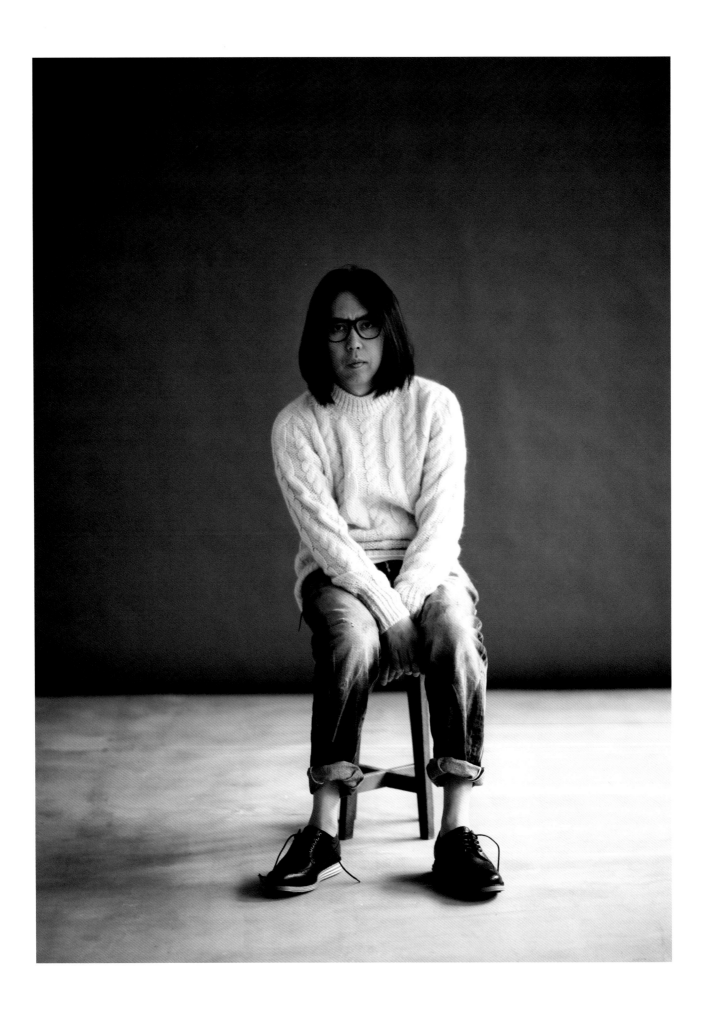

Sneakers

I'm an otaku of sneakers, toys, technology, art, and design, so I can completely relate. I also like anime, and some of the early animation coming out of Japan, which later turned into a big focus on design. I think the sneaker culture first lit up and exploded in Japan and went on to other major cities like London, Los Angeles, New York and Philadelphia. I've always found Japan to be incredibly inspiring from a design standpoint as well as a cultural standpoint, and when I can connect with talented people, creative people like Hiroshi, it makes it even more exciting and interesting.

HTM is Nike's experimental design project, launched in 2002 by Hiroshi, Tinker Hatfield, and myself. We all love design and HTM is a way for us to experiment and test new ideas, and have a good time while we are at it. Our project takes on a rather informal and casual progression. When one of the three poses an idea, he will share that with the other two and if we all like it we will launch it as a project. All three of us have similar interests, so even if one person initiates the idea we always manage to organize and steer it in a common direction.

HTM has taken on many projects over the years. We discovered that when you look at a classic sneaker in a different way and reconstruct it with a new twist, you gain a whole new user base. A good example of this is how we took the basketball shoe, Air Force 1, as a foundation, and by utilizing new materials and changing its logo, we were able to reinvent it as an HTM limited-edition shoe.

All of HTM's work is special and limited-edition. We always strive to challenge ourselves with new experiences. In order to do so, it's crucial to expedite and simplify the process of HTM as much as possible. Nike is a huge corporation so their internal system is complex, so our way is more suited for experimentation and new ideas. Moreover, HTM aims for the highest quality so naturally we obsess over the finished product and it makes sense for them to be limited edition. In this way, I think HTM manages to stimulate Nike as a whole.

Hiroshi is someone with a keen understanding of what he likes and does not like. Also, he has a remarkable editorial sense. He demonstrates an extremely sharp talent during the editorial process that encompasses selection, reinterpretation, and reconstruction. I think his approach to HTM is similar to how he creates music. Perhaps creators who make quality products all work like that.

My expectation of Hiroshi is that he continues to do what he does very well. He has very deep insights into design and technology, style, youth culture, popular culture. Not just in Tokyo, but from a global perspective. And we share that passion, so it makes our interaction very easy.

Mark Parker is the President and CEO of Nike, Inc.

HTM is the name of Nike's experimental design project launched in 2002. HTM takes its initials from the first names of its three collaborators: Hiroshi Fujiwara; legendary Nike designer Tinker Hatfield; and Nike Inc. CEO and designer Mark Parker. While HTM began as a code name for the trio among Nike insiders, the name stuck through the merchandizing process. From the reinterpretation of existing designs to the development of new products, the design collective helms a wide range of initiatives. Produced as special products in extremely small quantities of 1,500 to 3,000 units, the HTM models are available only at a few select retailers. The accelerated production process, impossible to realize with Nike's standard (in-line) editions, is another characteristic of HTM. The quick pace from development to release is otherwise unthinkable for an enterprise of Nike's scale. Today, HTM continues to release its products on an irregular schedule.

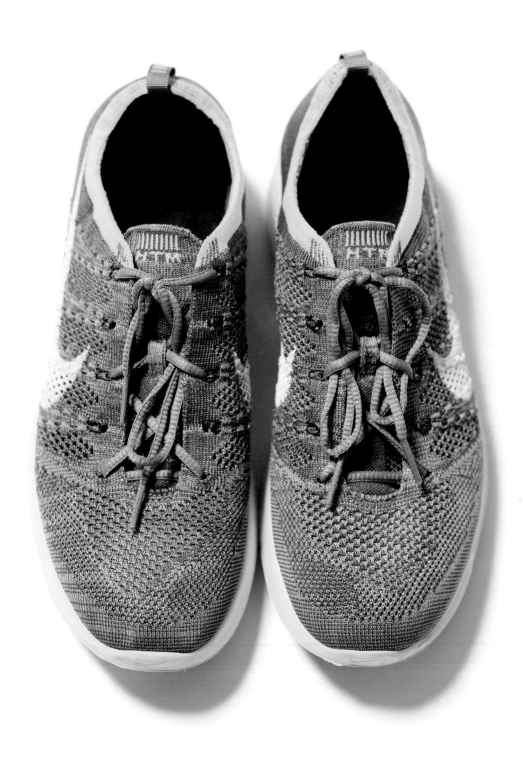

HTM
NIKE FLYKNIT

The revolutionary Nike Flyknit technology made its debut in New York in February 2012. Developed over a span of four years, the agile shoes fit like a second skin and feel as light as a feather. As the name suggests, Flyknit features an upper framework and supporting areas woven entirely of special thread. At the time of its launch, HTM released two models of its own (Nike Lunar Flyknit, Nike Flyknit Racer) in conjunction with the standard (in-line) editions. The recent launch of HTM's Lunar Flynit Chukka garnered further attention. The unique colorways and the original logo design on the insole and tongue distinguish the HTM models.

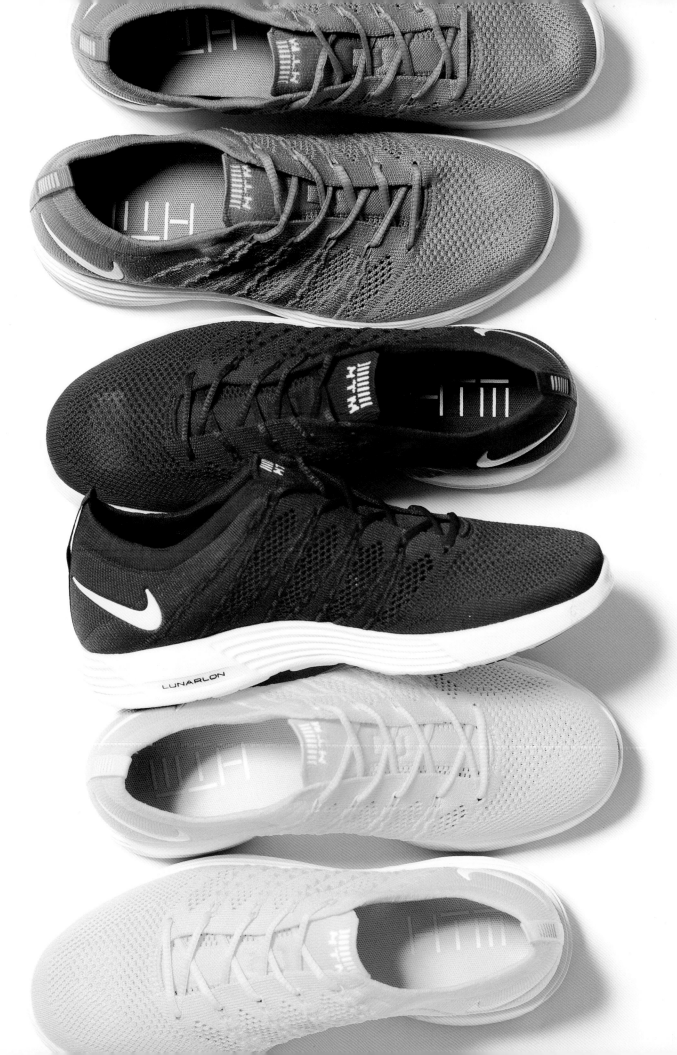

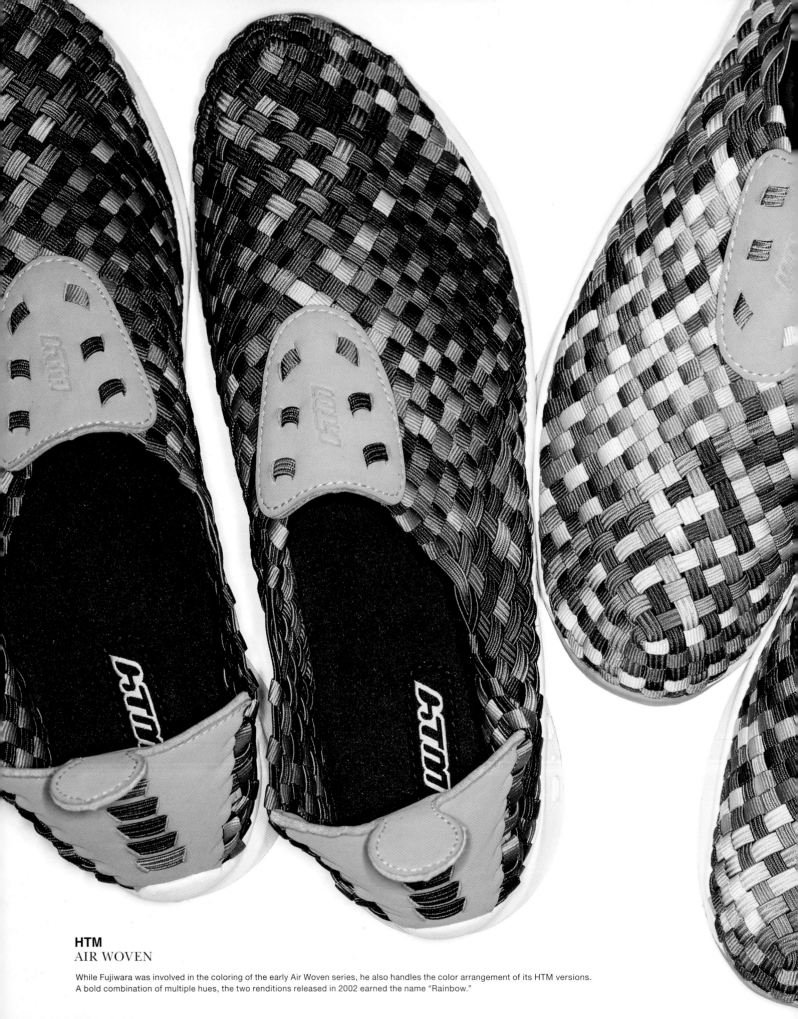

HTM
AIR WOVEN

While Fujiwara was involved in the coloring of the early Air Woven series, he also handles the color arrangement of its HTM versions.
A bold combination of multiple hues, the two renditions released in 2002 earned the name "Rainbow."

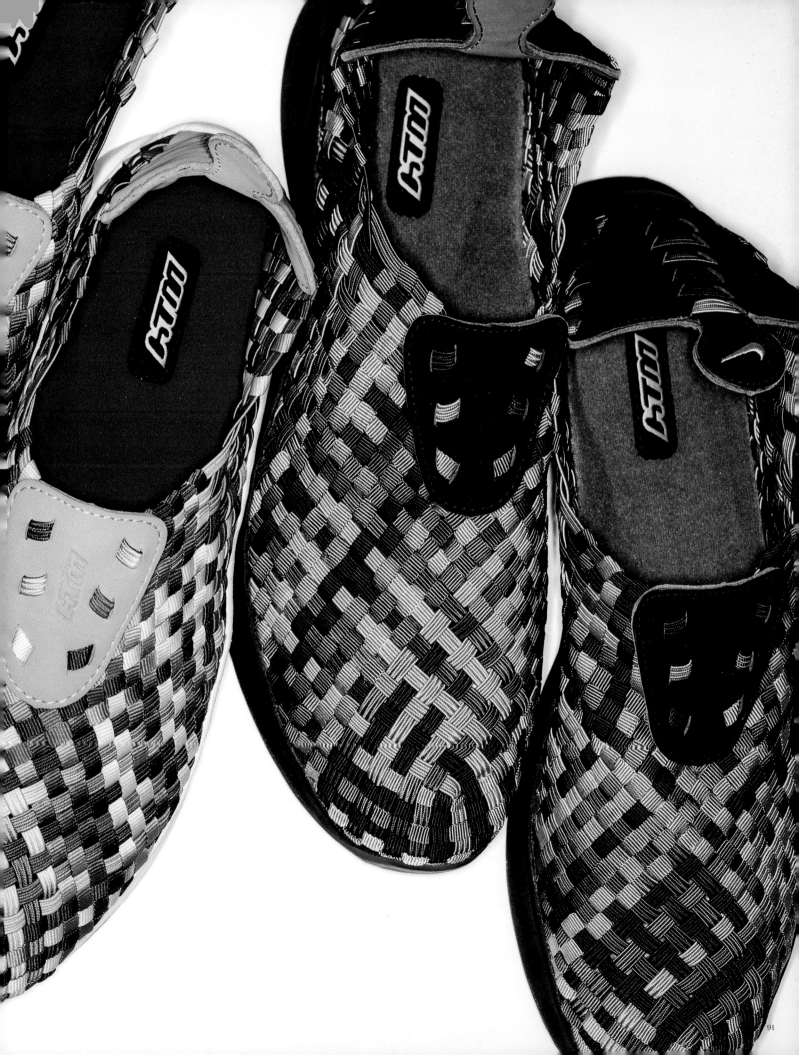

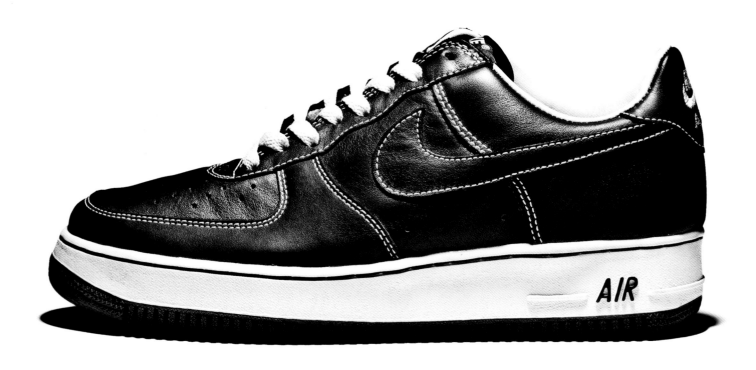

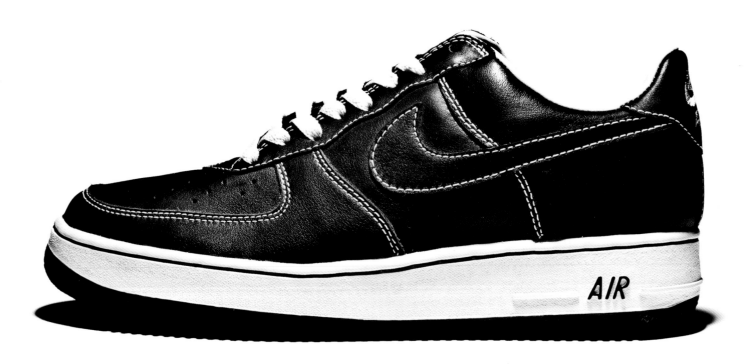

HTM
AIR FORCE I

The reissue of the Air Force I by HTM marked the official start of the design collaborative in 2002. The shoe, which transformed the street essential Air Force I in luxurious materials, caused a stir at the time of its release. The upper features lustrous, high-quality leather accented with white stitches.

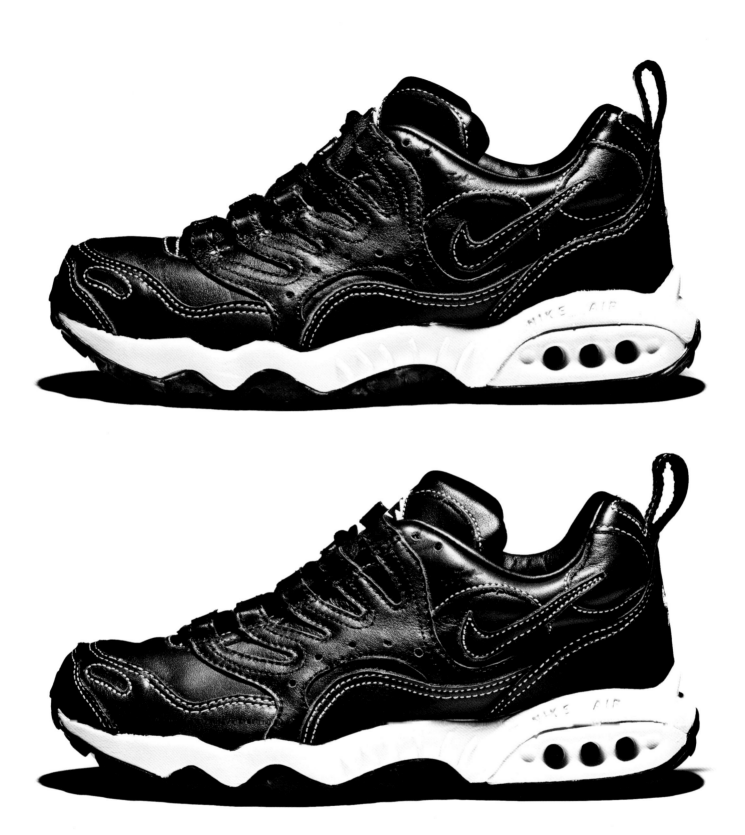

HTM
AIR TERRA HUMARA

During the 1990s, the Air Terra Humara was known as the masterpiece of the trailrunning shoe released by Nike's outdoor category ACG. HTM released its own rendition in 2002. The beautiful monochrome makes it a rarity among ACG releases, which tended toward eye-catching colors. A more fashionable pair has never been seen in the history of outdoor shoes.

HTM
AIR FORCE I

The glossy croc-embossed leather underscores the premium status of Air Force I. The Nike Swoosh embellishes the tongue and the heel, while the HTM logo adorns the toe and the insole, and the Fragment logo appears on the side of the heel. Introduced in 2004.

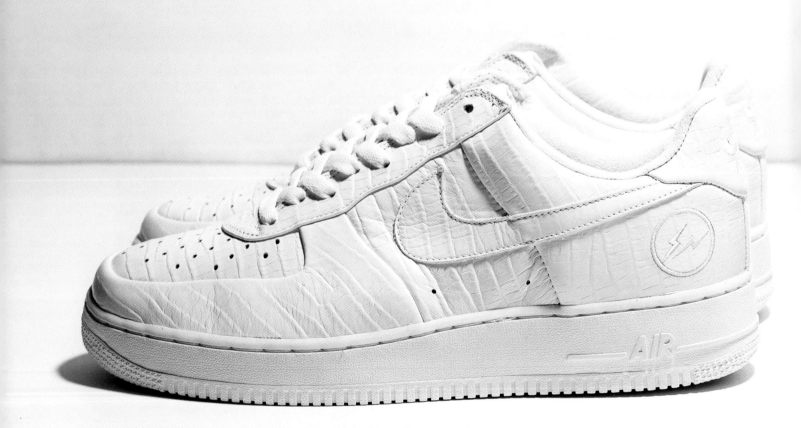

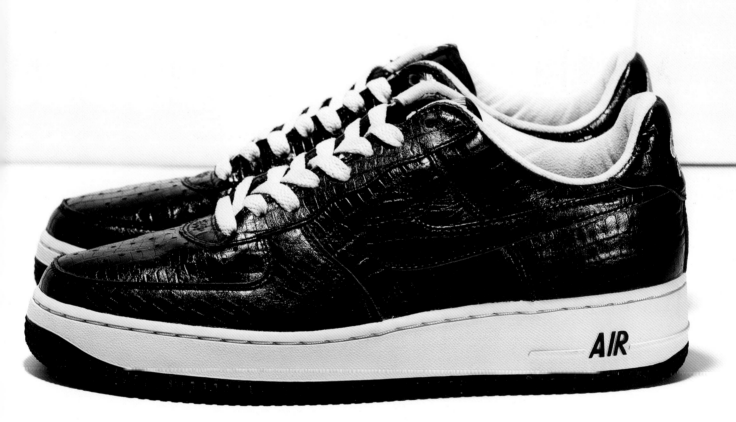

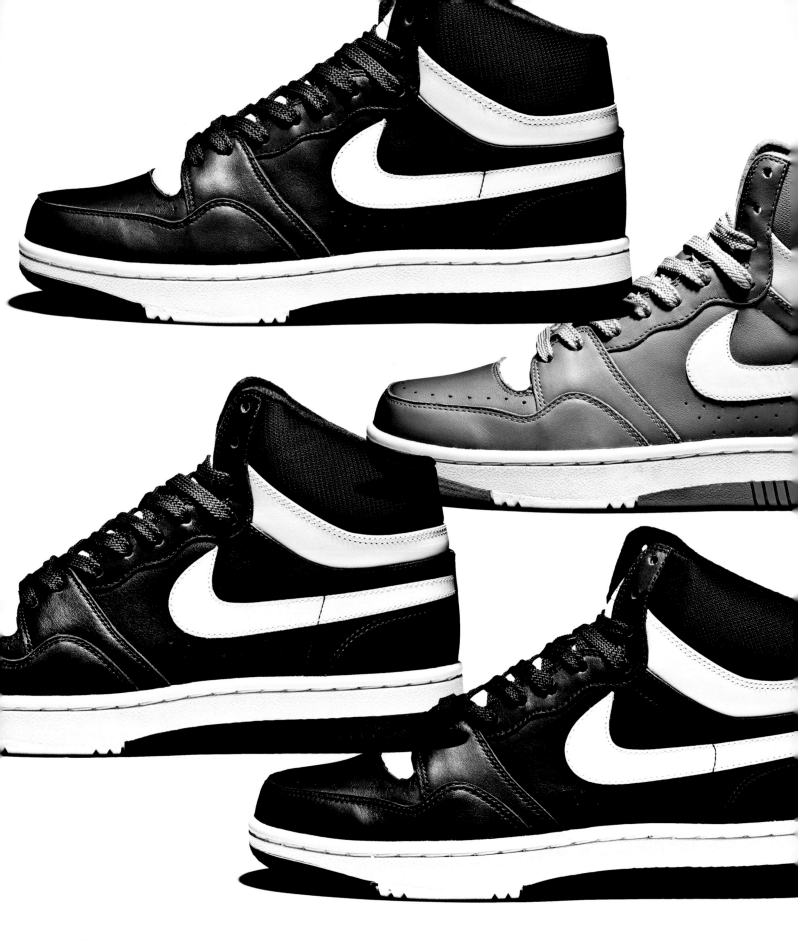

HTM
COURT FORCE

During the 1980s, Fujiwara liked to wear the basketball shoe Court Force while skateboarding. HTM revamped his beloved model for the first time in 2005. Free of unnecessary flairs, it is an impressive reproduction of the original.

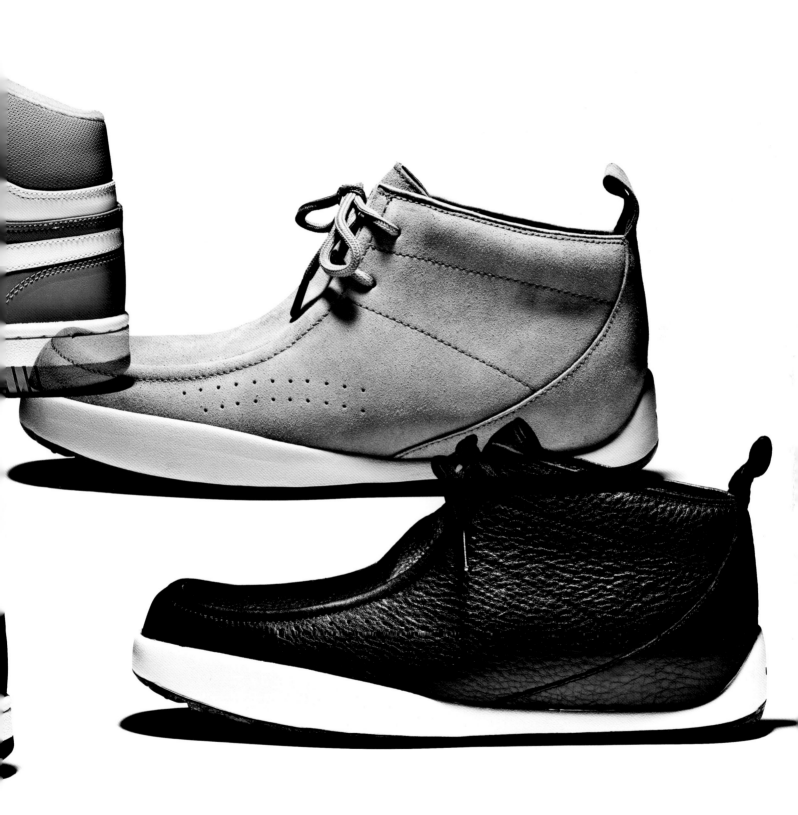

HTM
ZOOM MACROPUS

The appearance of Zoom Macropus suggests low, comfortable boots rather than sneakers. Outfitted with a Zoom Air sole, the shoe provides superior comfort. Following its initial release by HTM, the design was also adopted into standard (in-line) editions.

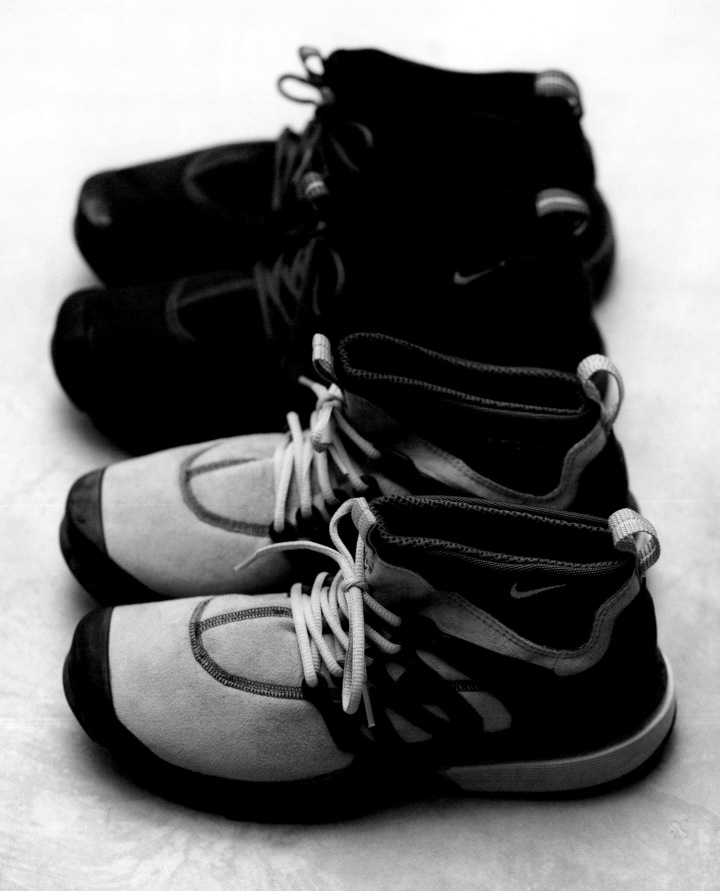

HTM
AIR PRESTO ROAM

The high-cut version of Nike's Air Presto, which had become a synonym for casual, relaxed shoe with its lightweight, flexible upper. The redesign replaces the original fabric with suede and gives it a grown-up sophistication with its subdued brown palette. The Air Presto Roam was released in 2002.

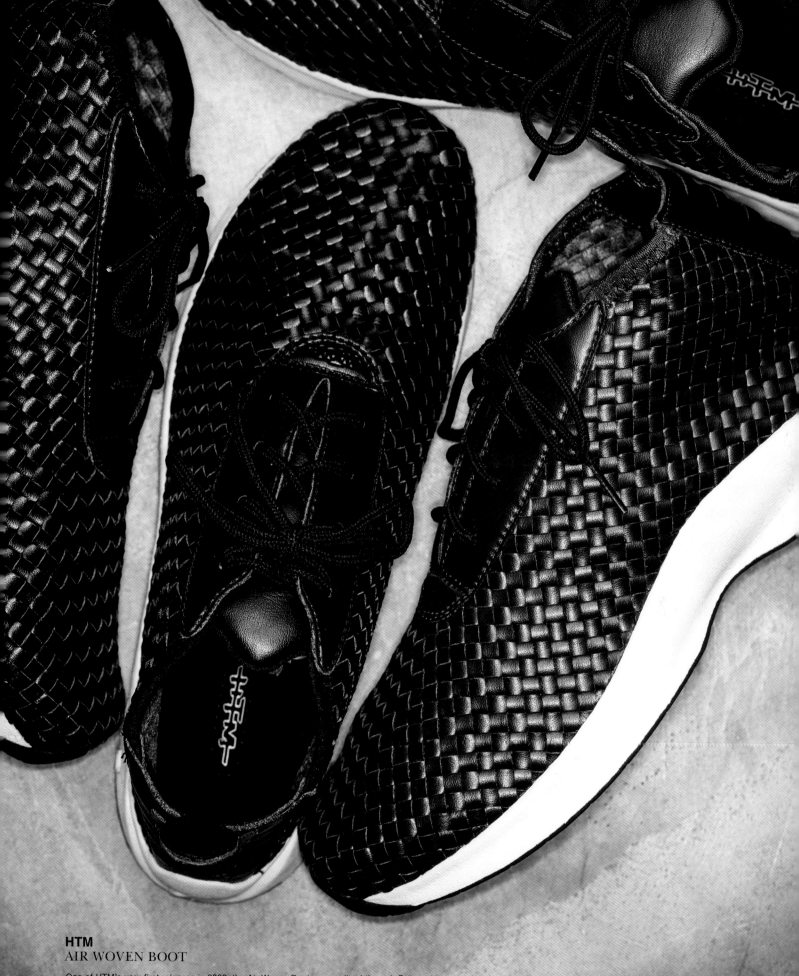

HTM
AIR WOVEN BOOT

One of HTM's very first releases in 2002, the Air Woven Boot was realized through Fujiwara's suggestion that the mid-cut silhouette works better for fashion than the original low-cut Air Woven. The shoe features the original HTM logo on the insole and a lustrous leather upper.

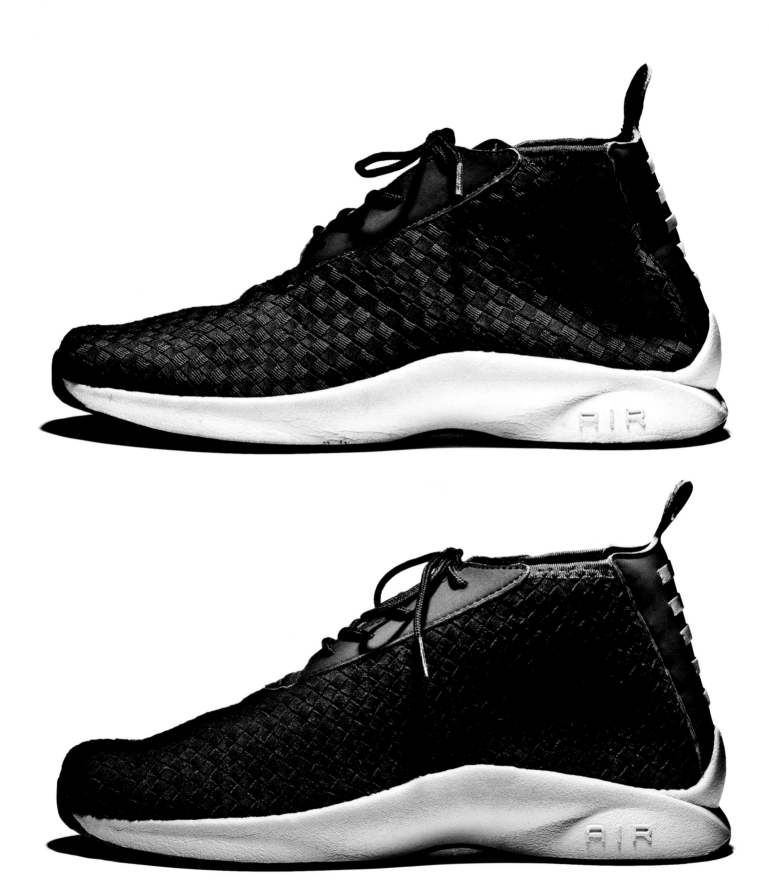

HTM
AIR WOVEN BOOT

Released in 2002, the Air Woven Boot features a suede construction and HTM logo on the insole and around the upper lace.
The design is also distinguished by earthy tones such as brown and olive.

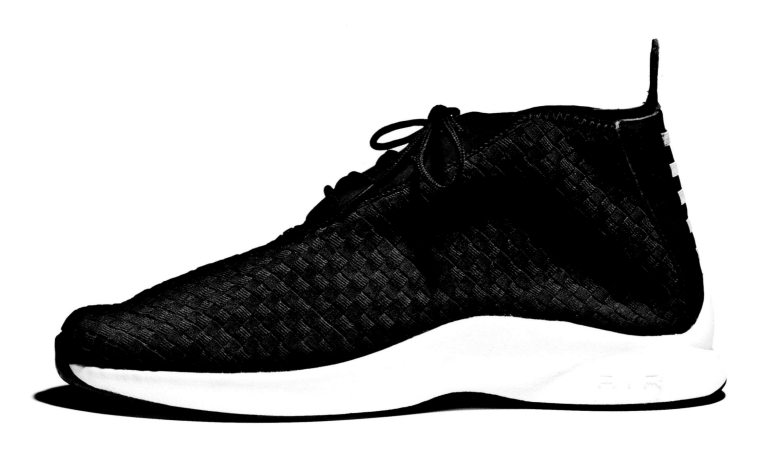

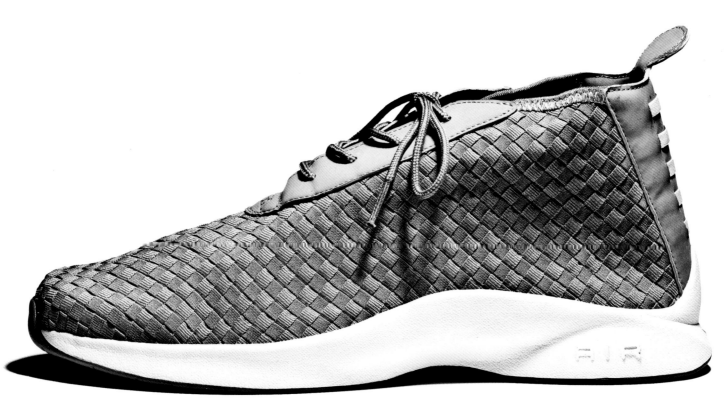

NIKE
TERMINATOR

The Terminator was born in 1985, the same year as Dunk and Air Jordan. The high-top sneaker is known for the large Nike lettering on the heel. At Fujiwara's suggestion, the letters were changed to NOISE for the 2009 reissue after the commonly called "NOISE Tee" was released to wide acclaim during the same year. Constructed of the premium leather Himalaya WP, the new model also advances the functionality of the original with its newly installed Zoom Air insole.

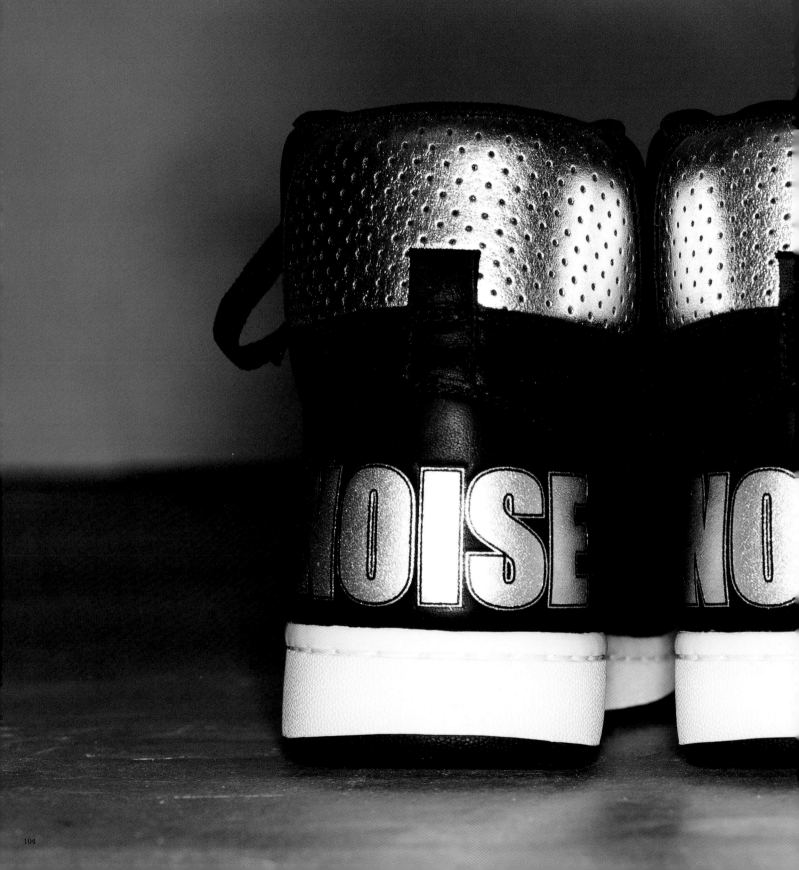

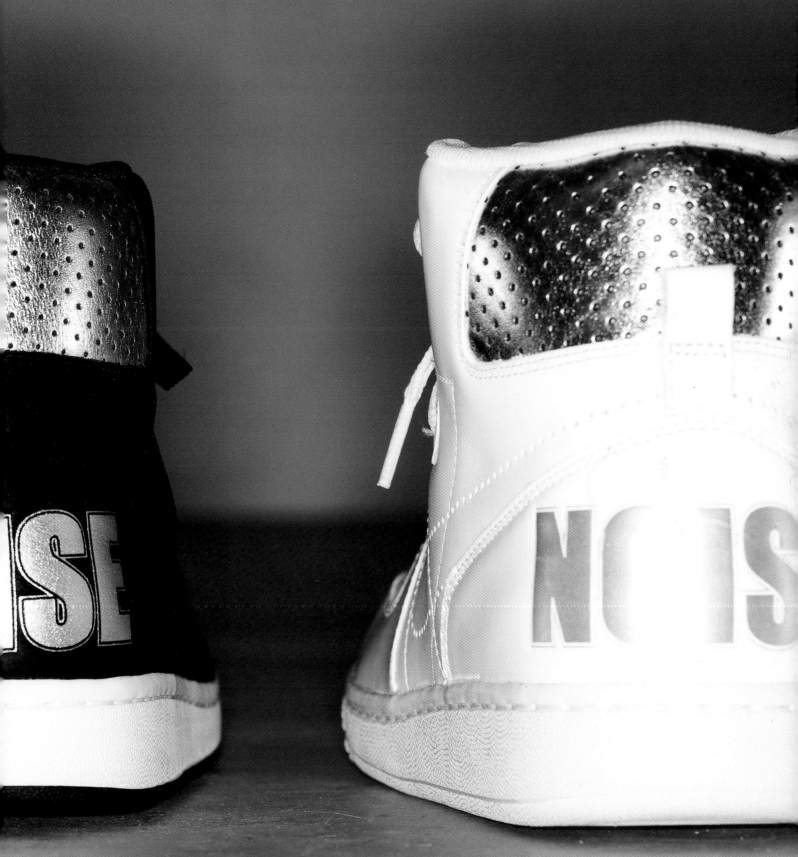

NIKE
AIR FORCE I

In 2002, Fujiwara produced the exclusive, not-for-sale Air Force I for the advertising company Wieden+Kennedy Tokyo. A hairy slunk leather comprises the upper and embroidered "Tokyo" letters adorn the left and right sides of the heel. The tongue is specially designed with the words "W+K Tokyo 2002."

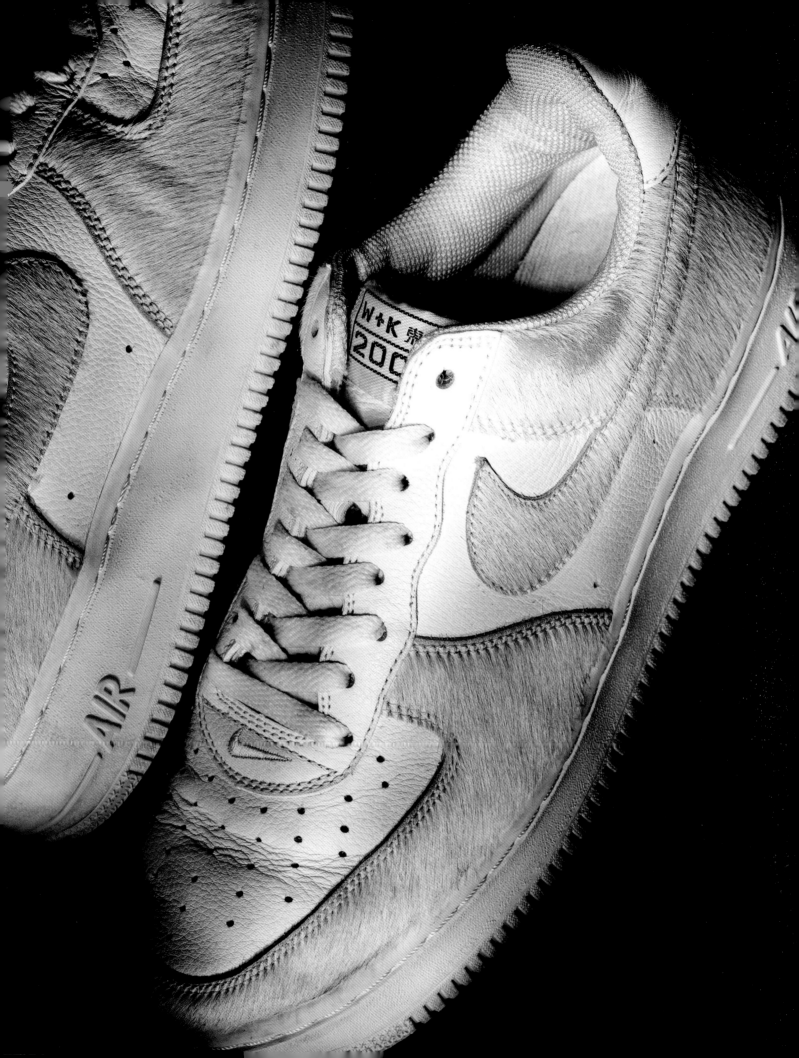

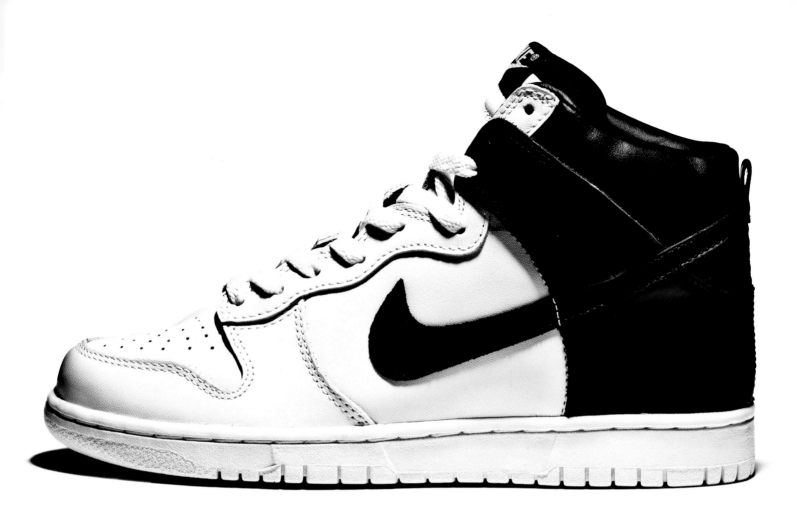

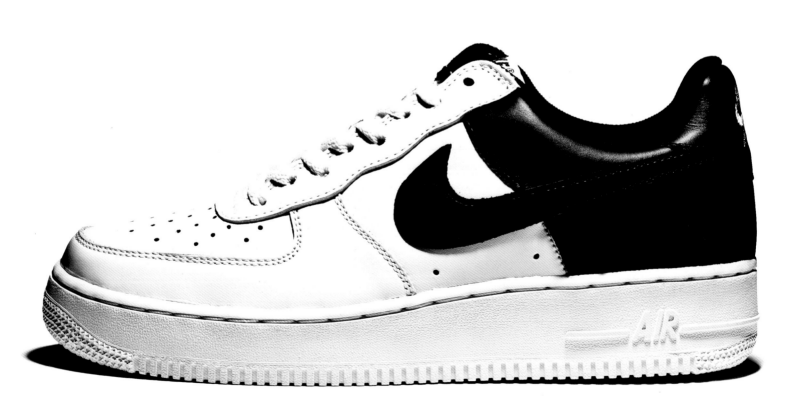

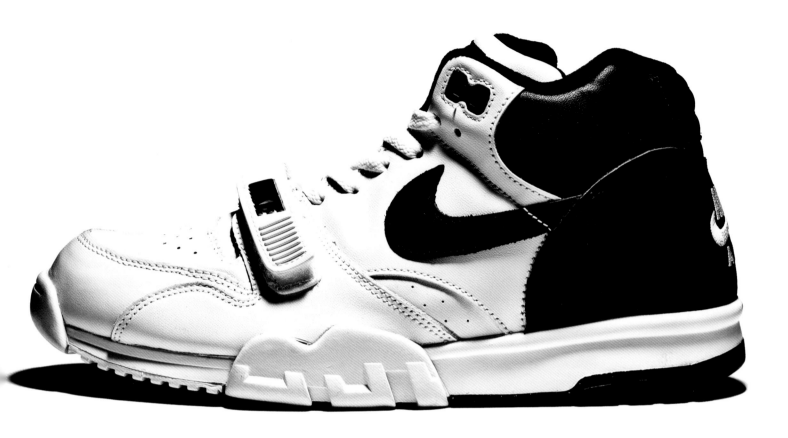

NIKE
ORCA

Released in 2004, the ORCA series takes its cues from the killer whale and features a simple coloring restricted to black and white.
The lineup includes four models: Dunk Hi, Dunk Lo, Air Force I, and Air Trainer Hi. In Japan, the series was sold in only two stores.

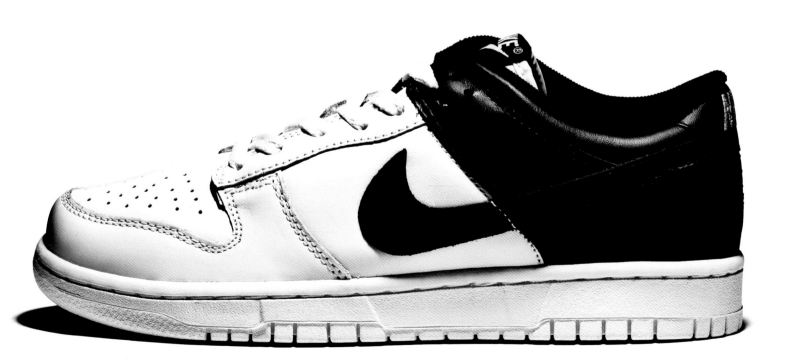

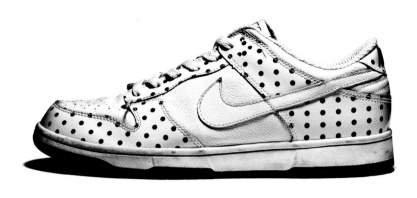

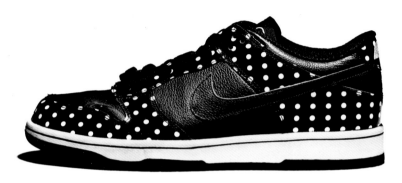

NIKE
POLKA DOT

Helmed by Fujiwara in 2006, the Polka Dot was released in a handful of select stores in major cities around the world. Part of the upper is outfitted with patent leather embellished with polka dots. Each model comes in two colorways using only black and white. Models include Dunk Lo, Air Force I, and Air Footscape Woven.

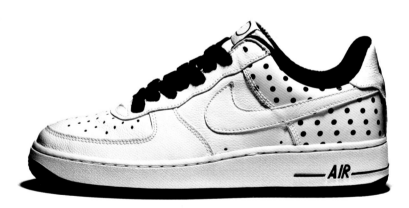

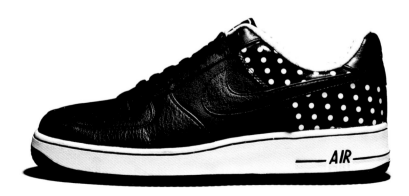

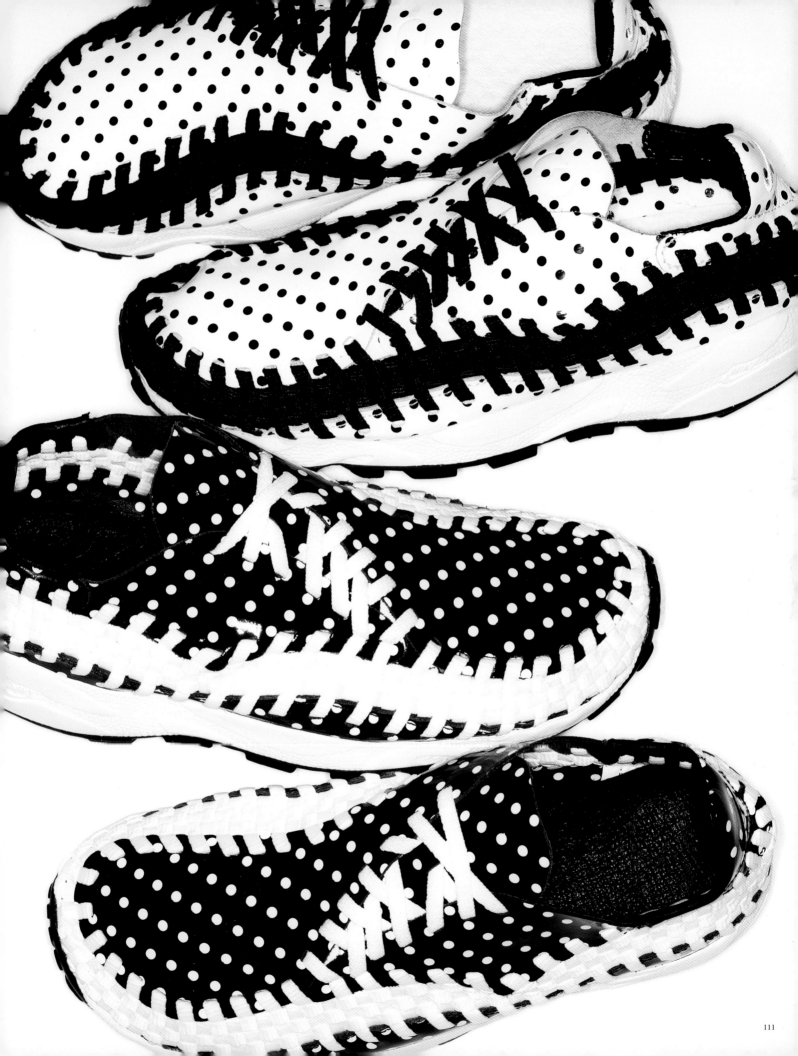

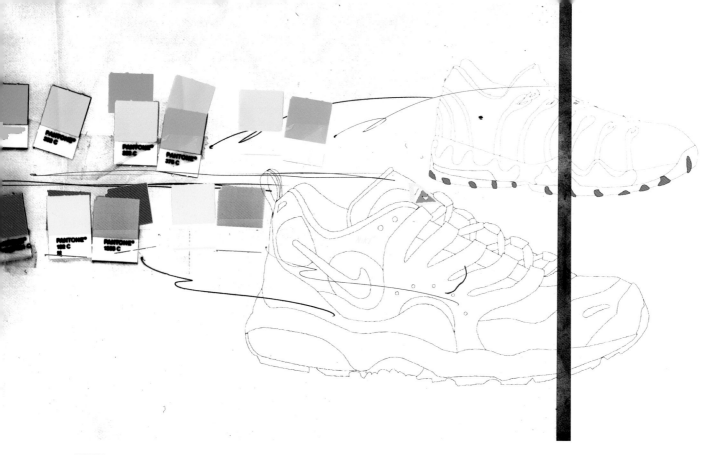

NIKE
MONOTONE COLLECTION

The Monotone Collection, released in 2001, marks the first collaboration between Nike Japan and Fujiwara. As the name suggests, their initiative was to reinterpret existing models such as Air Terra Humara, Air Zoom Seismic, and Air Max 120 in a monotone scheme. While the concept itself was unique, the fact that it was executed on a personal level at a time when the idea of "made to order" was still new in Japan made the collection truly revolutionary.

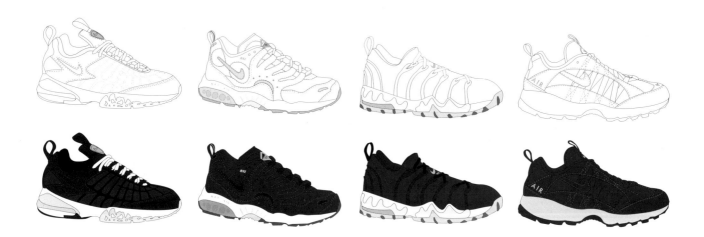

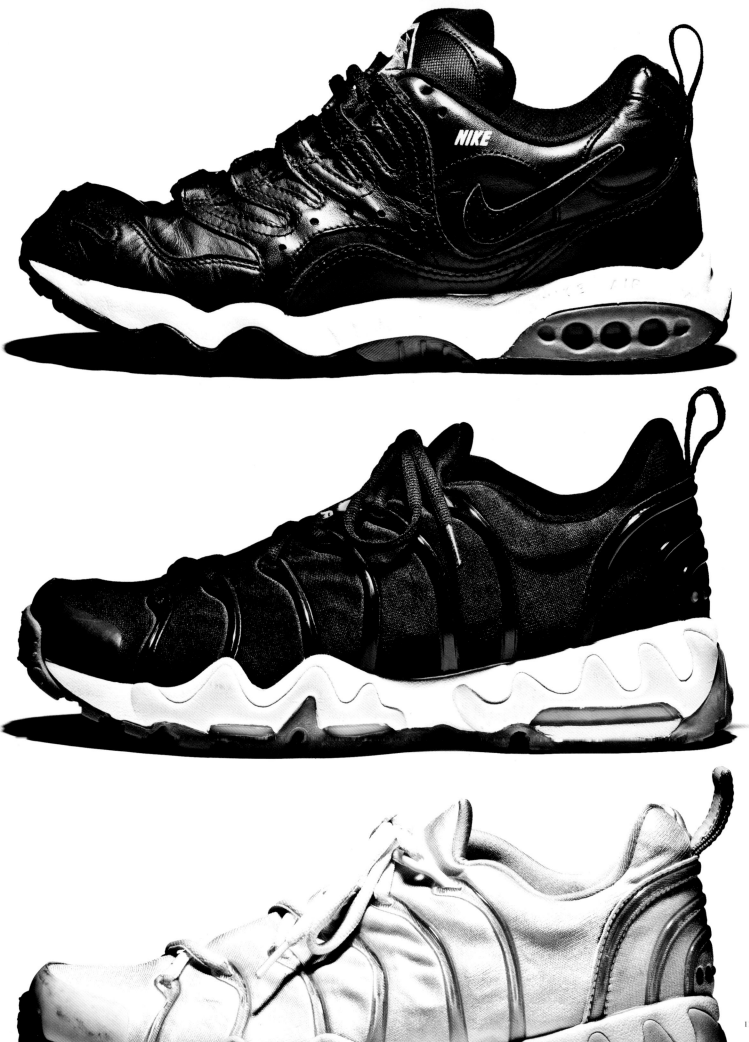

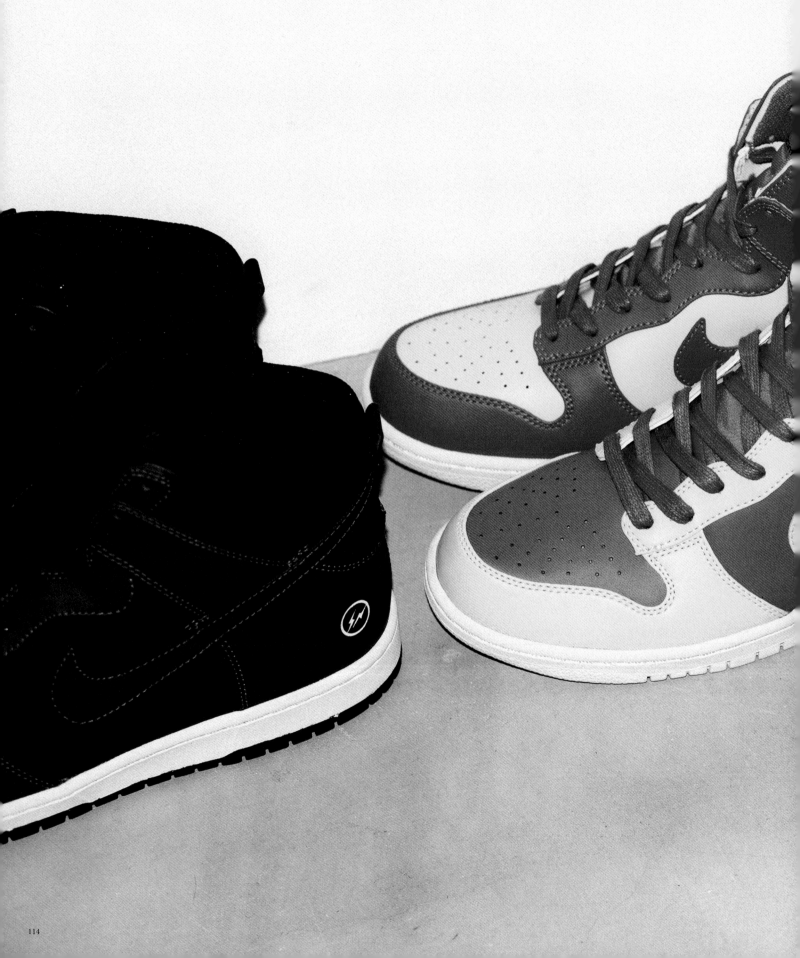

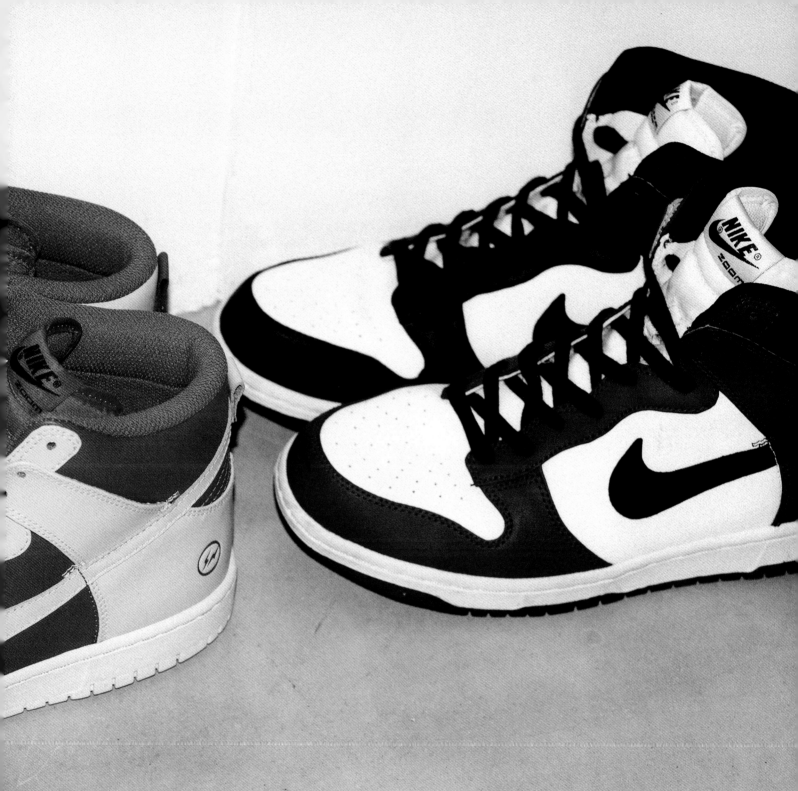

NIKE
DUNK

The special model of DUNK resulted from Nike's collaboration with Fujiwara's Fragment Design. The innovative and playful shoe features mismatched left and right coloring and the brand's trademark circle thunder on the side of the heel. Released in 2010.

NIKE
AIR PRESTO × HELLO KITTY

Fujiwara produced the special Air Presto model to commemorate the 30th anniversary of Hello Kitty.
Made for promotional purposes in 2004 and not available for retail, the model comes in two designs.

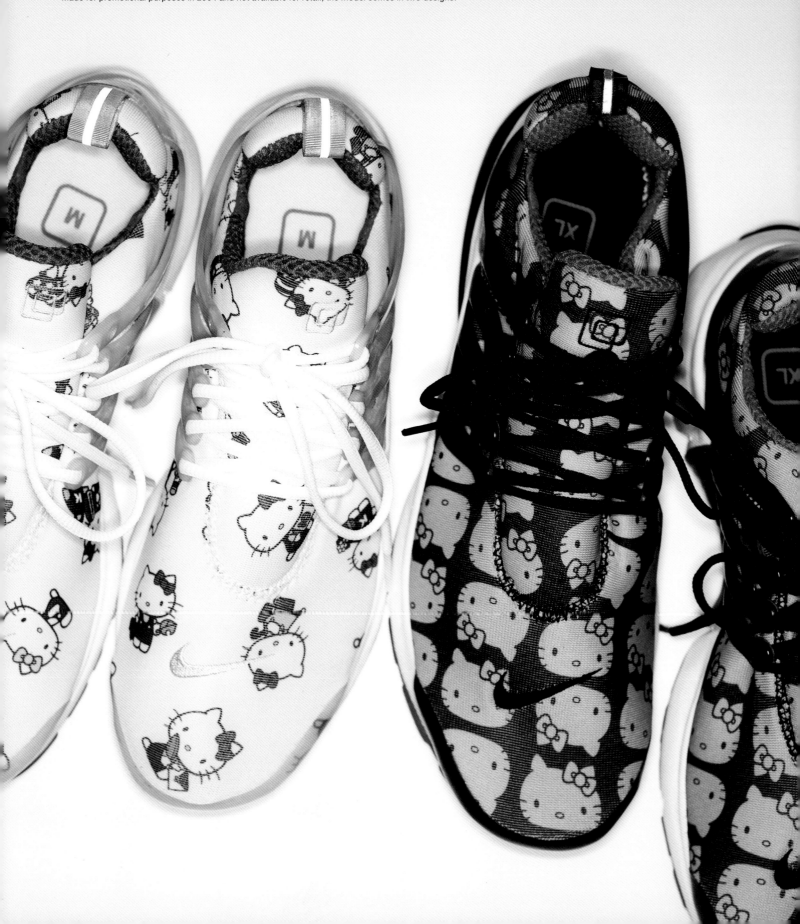

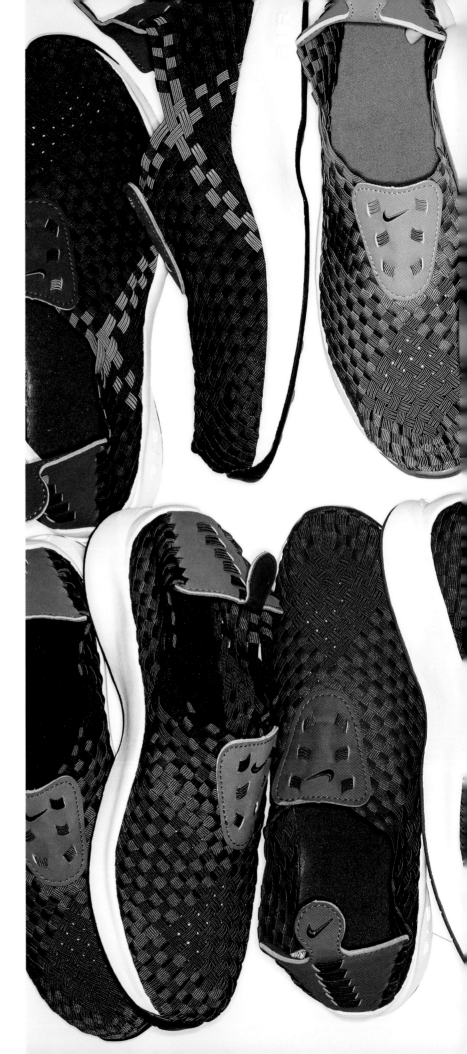

NIKE
AIR WOVEN

The discovery of a 10,000-year-old cloth during an archaeological dig in Fort Rock Cave, Oregon, is said to be the inspiration behind the Air Woven, launched in 2000. As the name suggests, the shoe features a woven upper, giving it lightness, breathability, and flexibility. While the production of regular sneakers results in material ends and scraps, the woven construction of the shoe reduces waste since it does not require cutting or sewing. The spread shows the monumental first collection of Air Woven with Fujiwara-designed colorways.

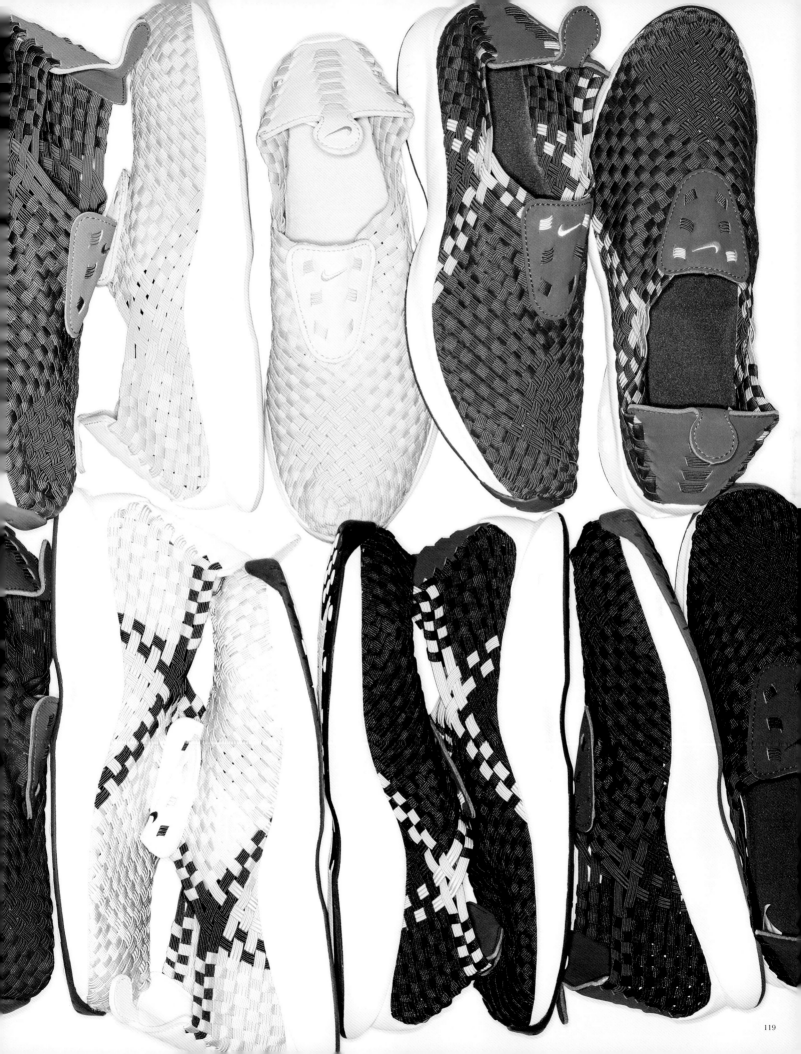

NIKE
ZOOM MERIWEATHER

Introduced in 2011, the Zoom Meriweather retains the aesthetics of the authentic mountain boot while combining state-of-the-art functionality and superior lightness to create the ultimate high-tech outdoor shoe. In November of the same year, a collaboration model with Fragment Design also appeared on the scene. The model features waterproof hairy suede upper, an interior zipper for ease of wear, and a lining specially designed with a Fragment Design tab.

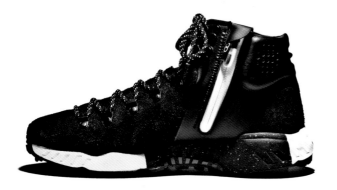
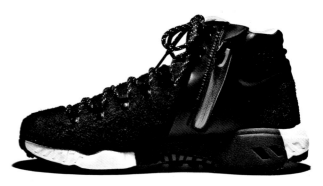

NIKE
AIR MAGMA

The Fragment Design model of Air Magma, the classic hiking shoes originally released in 1988. The shoe is offered in waterproof hairy suede upper with an interior water-stop zipper detail in bright neon colors—a signature move for the design label. Fragment Design's original pull-tab can also be found on the lining. A 2011 release.

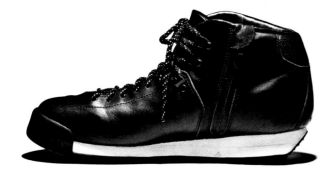
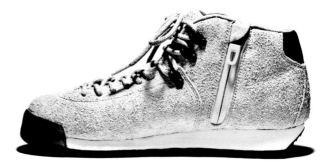

NIKE
AIR FORCE I PREMIUM

The Air Force I Premium was released in 2007 to commemorate the 25th anniversary of the Air Force I. The model shown on the right features luxurious premium leather upper and color design by Fujiwara. The shoe is finished off with a distinctive perforated heel.

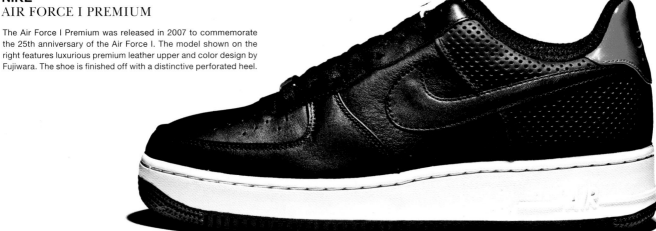

NIKE
AIR FOOTSCAPE

For Fujiwara, the Air Footscape, released in 1995, was one of the most shocking sneakers he had ever encountered. The limited-edition model with Fragment Design's original colorways dropped in 2009. Constructed with a mesh upper, the shoe completes its look with a gray suede toe—Fujiwara's personal homage to the shoe's forbear.

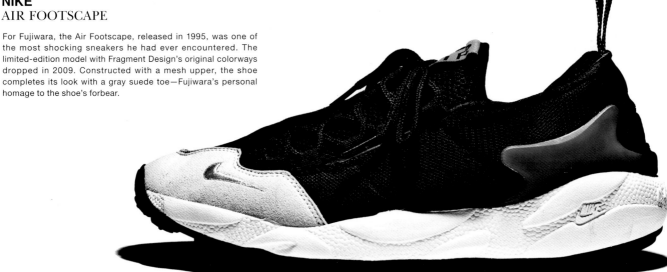

NIKE
AIR FOOTSCAPE

This high-cut version of the Air Footscape was released in 2006. While the boot-style shoe with the woven outsole had been developed in the past, this model uses the Footscape outsole. The Fragment Design model was released only in low quantities at select stores. The lineup was later expanded to standard (in-line) editions.

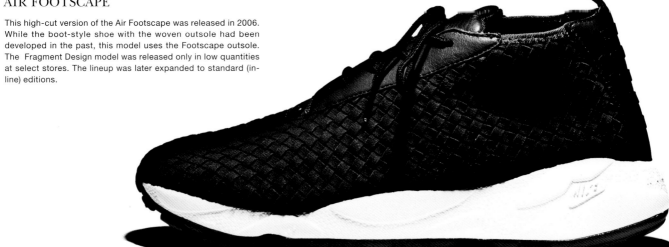

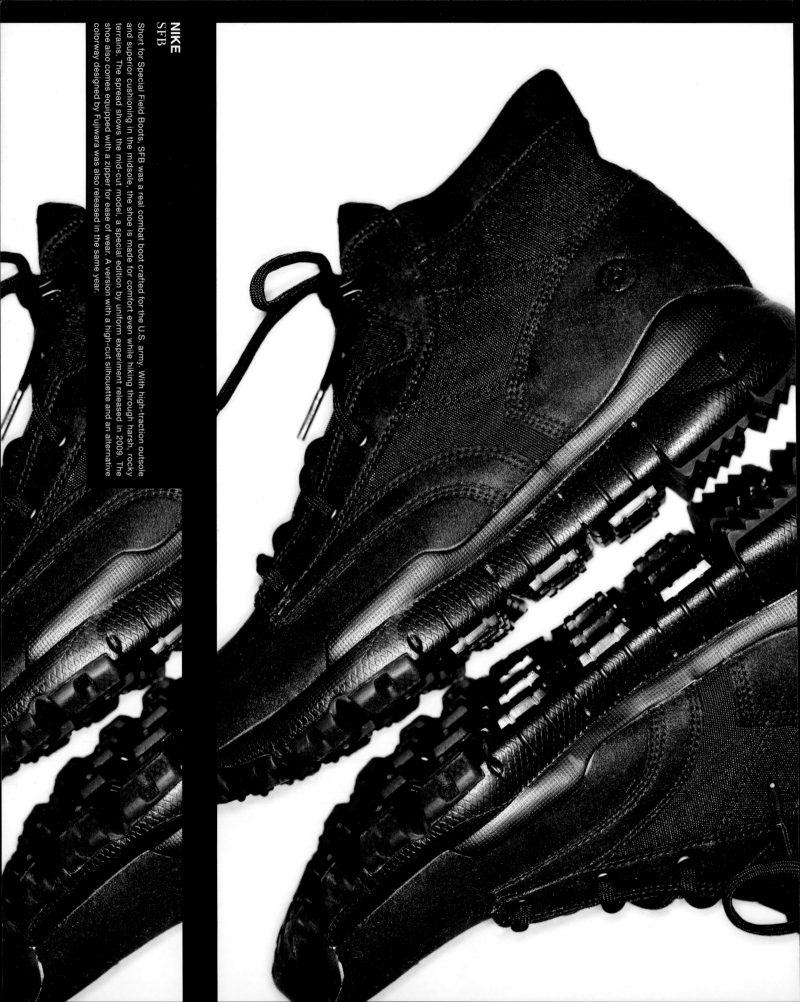

NIKE
SFB

Short for Special Field Boots, SFB was a real combat boot crafted for the U.S. army. With high-traction outsole and superior cushioning in the midsole, the shoe is made for comfort even while hiking through harsh, rocky terrains. The spread shows the mid-cut model, a special edition by uniform experiment released in 2009. The shoe also comes equipped with a zipper for ease of wear. A version with a high-cut silhouette and an alternative colorway designed by Fujiwara was also released in the same year.

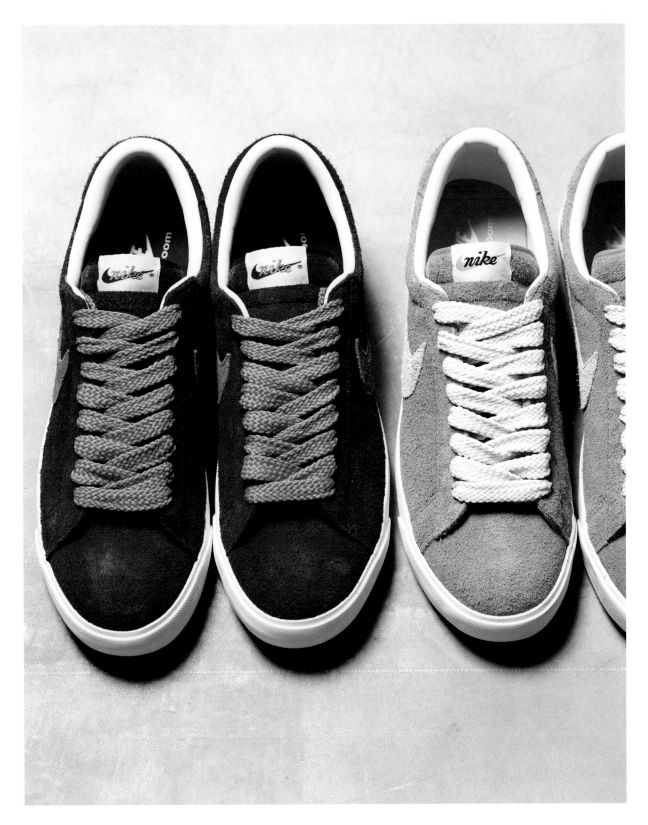

NIKE
AIR ZOOM TENNIS CLASSIC × uniform experiment

The Tennis Classic's collaboration model by Nike and uniform experiment, a label helmed by Fujiwara and SOPH.'s Hirofumi Kiyonaga, appeared in the latter's collection for Fall/Winter 2011. The longhaired suede leather upper gives the shoe a vintage flair, and the uniform experiment logo and Fragment's circle thunder logo adorn the side and the heel counter, respectively. The shoelaces come in either normal or fat.

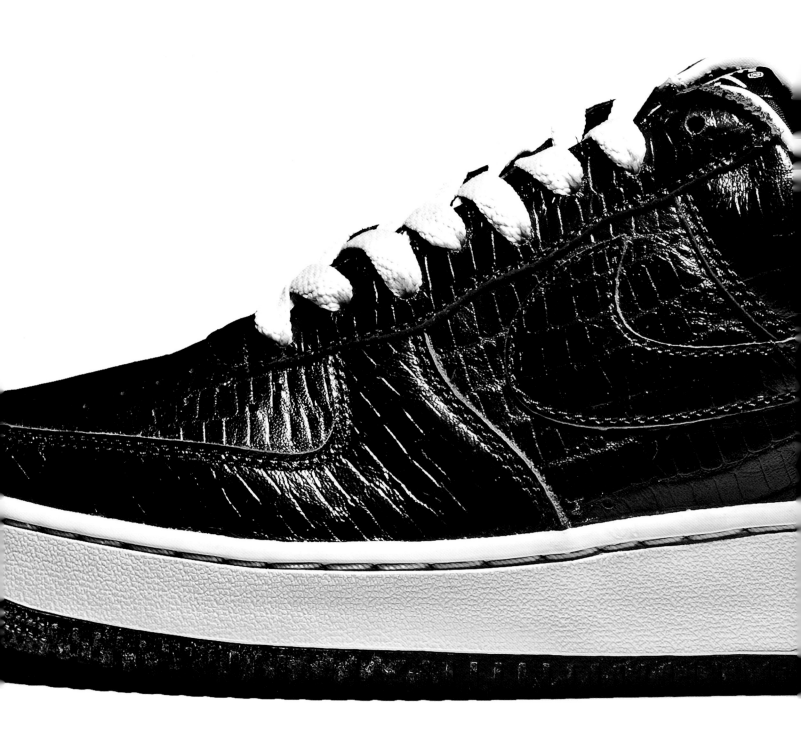

NIKE
AIR FORCE I

Constructed of a high-quality embossed leather upper, Fragment Design's special edition of the Air Force I is given its unique identity by the thunder mark on the side of the heel.

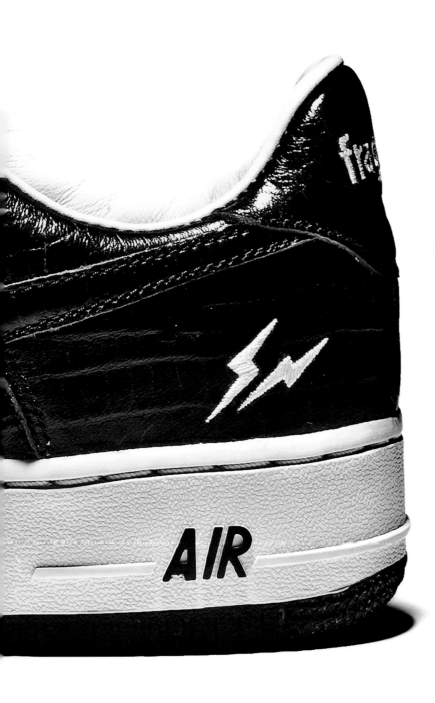

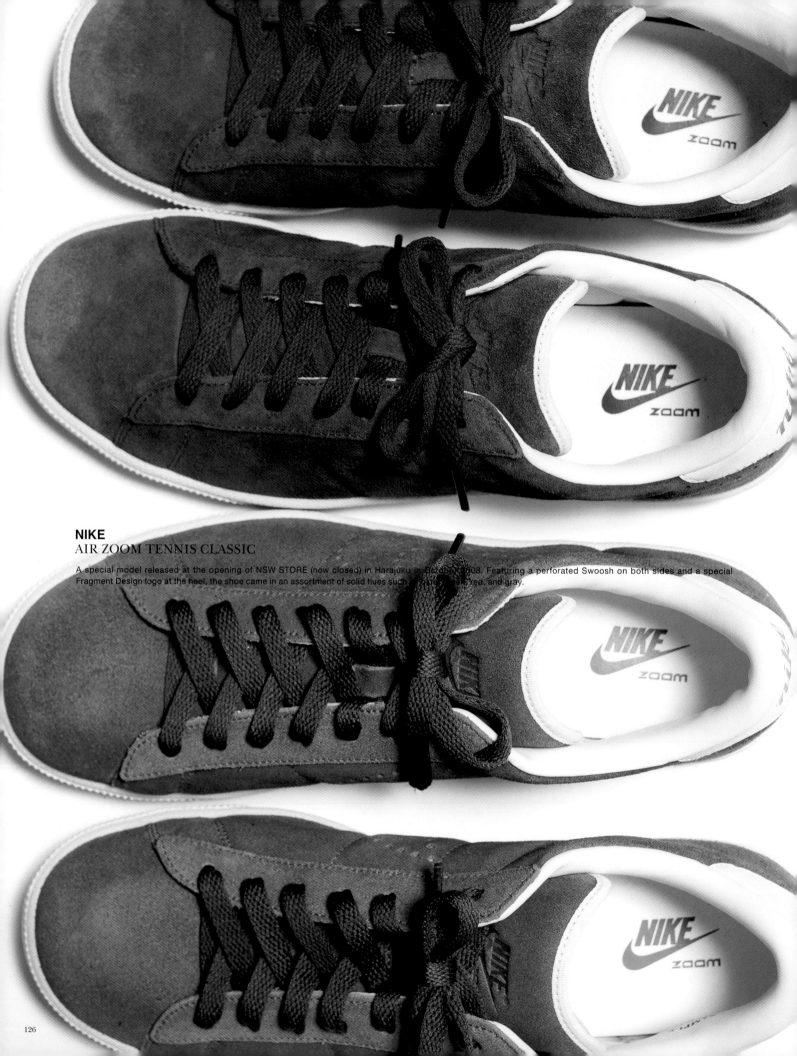

NIKE
AIR ZOOM TENNIS CLASSIC

A special model released at the opening of NSW STORE (now closed) in Harajuku in October 2008. Featuring a perforated Swoosh on both sides and a special Fragment Design logo at the heel, the shoe came in an assortment of solid hues such as blue, red, and gray.

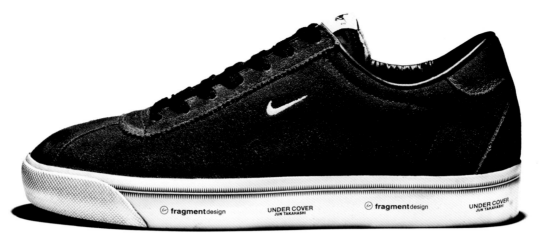

NIKE
MATCH CLASSIC UNDERCOVER × fragment design

Nike's Match was born in 1973 as tennis shoes. The model was given new life for the first time in 2008 by UNDERCOVER and Fragment Design. According to Fujiwara, the shoes "work well for a bike ride." The mini Swoosh on the side reflects the strict dress code in tennis during the 70s that frowned upon the display of the large Swoosh. The midsole of the collaboration model features the iconic logos of both brands and UNDERCOVER's signature jiggered stripes.

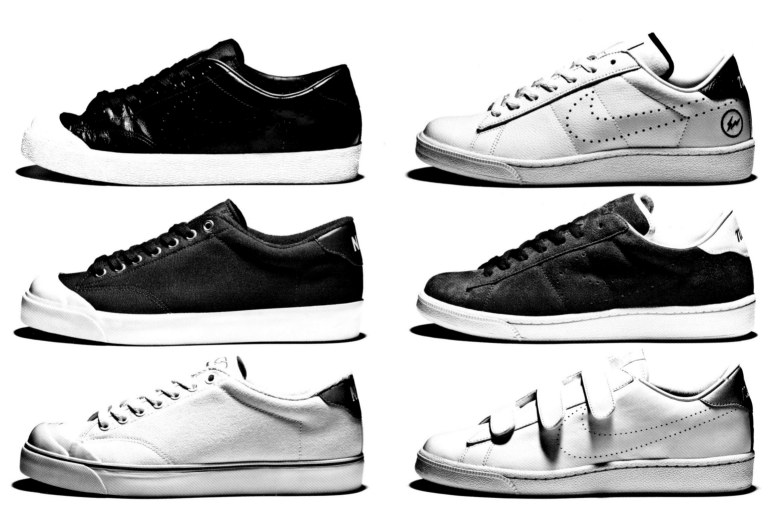

NIKE
ALL COURT

As its name suggests, the All Court, released back in 1975, was an all-purpose shoe that set a precedent for the cross trainers that would come later. Fragment Design's premium version, featuring lustrous glass leather upper, was introduced in 2009. 2010 saw the release of the canvas Air Zoom All Court with its decidedly simple aesthetic devoid of the Swoosh on either side.

NIKE
TENNIS CLASSIC

Fujiwara began wearing Tennis Classic in 2007 after ordering a pair through Nike iD. Later on, he played a role in the release of its several different adaptations through his collaboration with Nike. Fujiwara imagined the simple shoes to be Nike's answer to Adidas' Stan Smith. The perforated Swoosh is inspired by the Wimbledon, a legendary tennis shoe released in 1973.

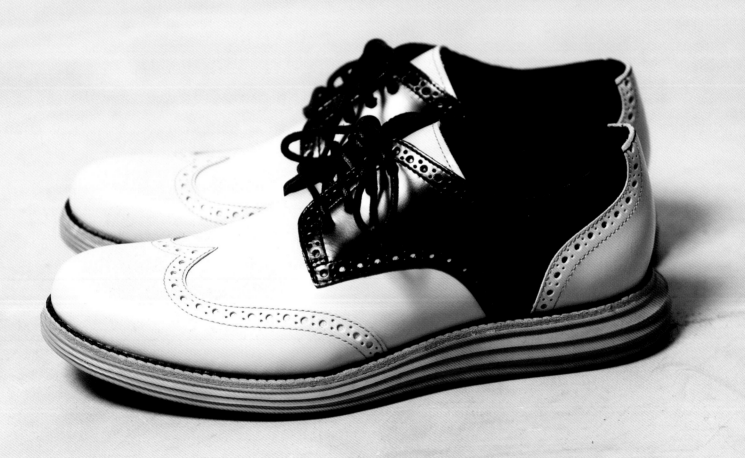

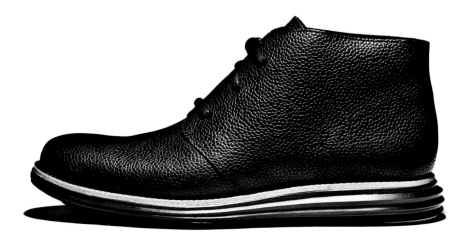

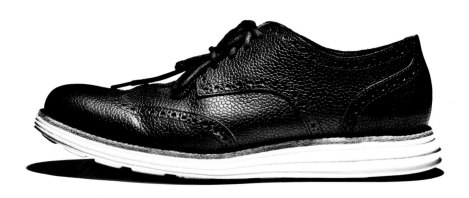

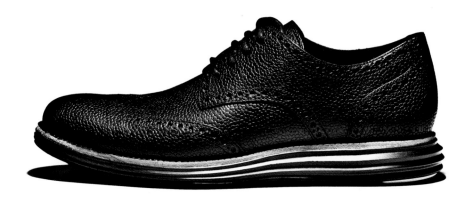

COLE HAAN
LUNARGRAND

Cole Haan's Lunargrand was introduced in 2011. The wingtip design on the upper is a Cole Haan heritage; the sole, on the other hand, boasts Nike's Lunarlon, which gives the wearer an experience akin to "walking on the surface of the moon." A special model of this revolutionary shoe arranged by Fragment Design was released in 2012. In addition to the wingtip, the new model comes in chukka boots and saddle shoes, as well as slip-ons with bit detail. While simple, the model showcases the distinctive character of Fragment Design in its unique coloring and use of material.

VISVIM
FBT

Developed under the concept of Native American moccasins that are equally at home on city sidewalks, the FBT, arguably the most iconic shoes by the fashion brand visvim, combines the moccasin upper with the soles of sneakers. After the release of its first model in 2001, FBT has spawned numerous iterations as it underwent continuous upgrades in functionality. The concept of the shoe took shape from Fujiwara's idea and the name FBT has its roots in the music group FUN BOY THREE. Fujiwara customizes his own pair with medallions from the legendary Japanese jeweler Goro's.

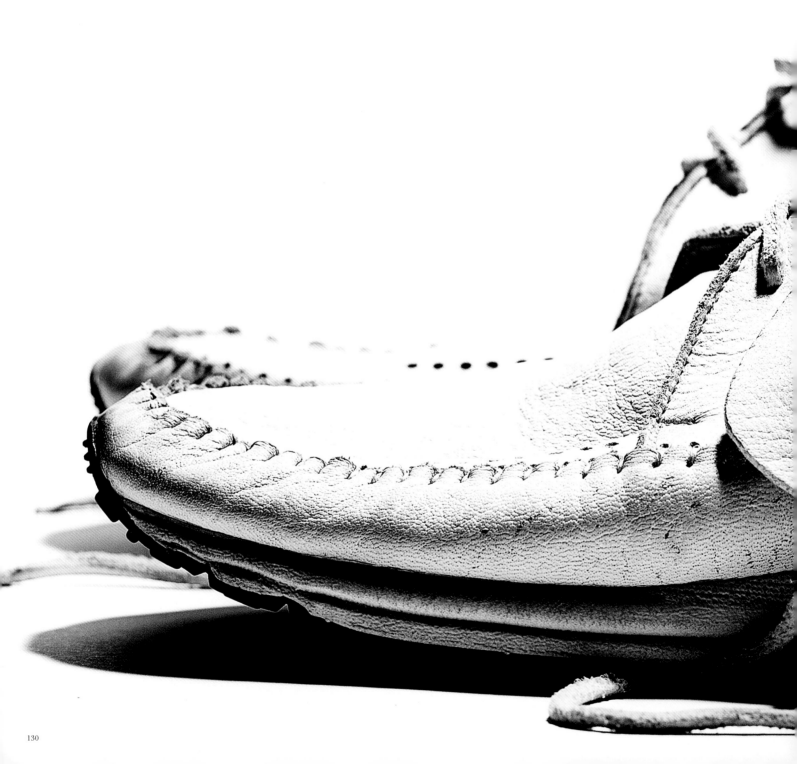

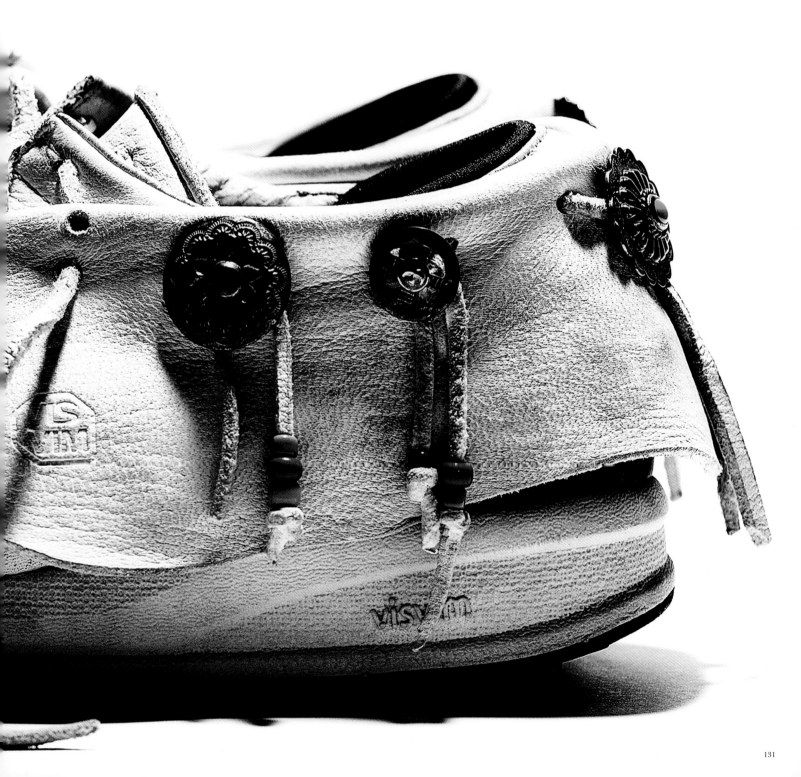

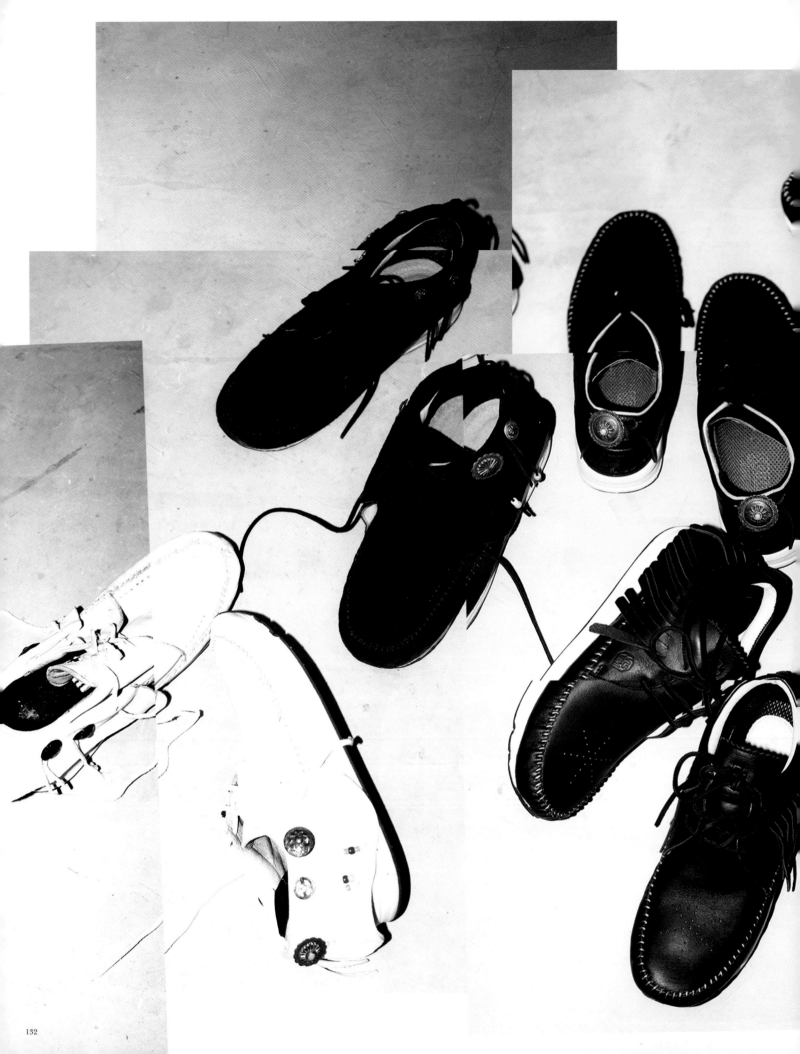

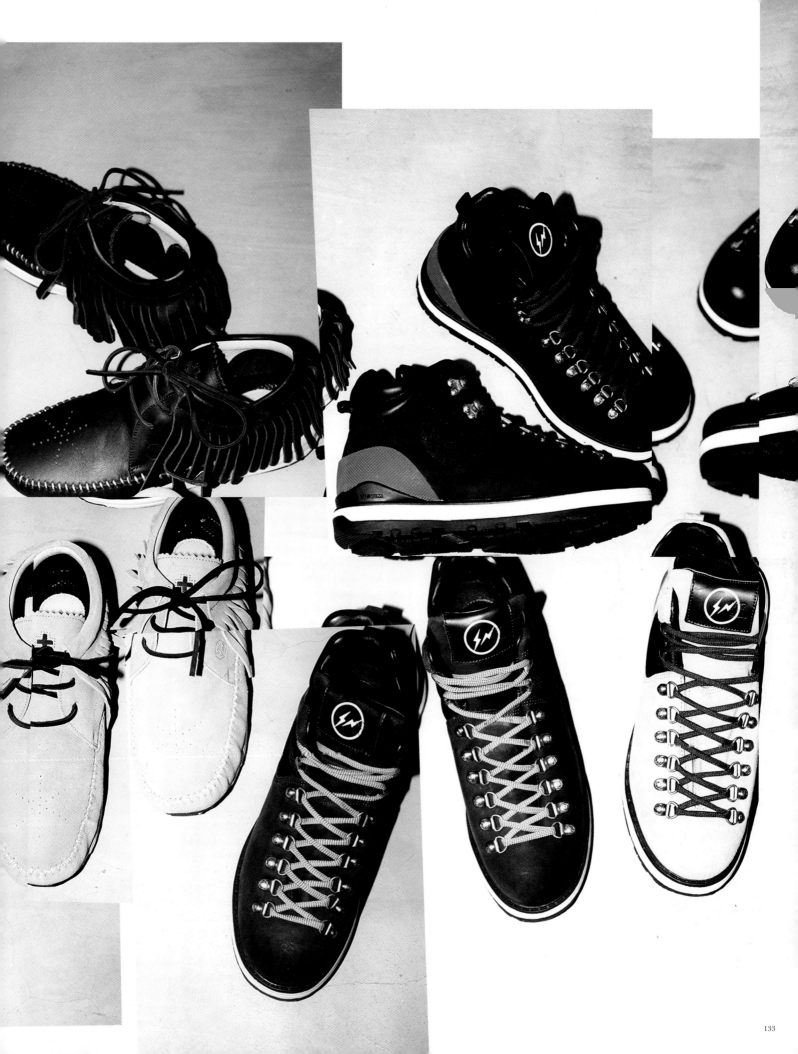

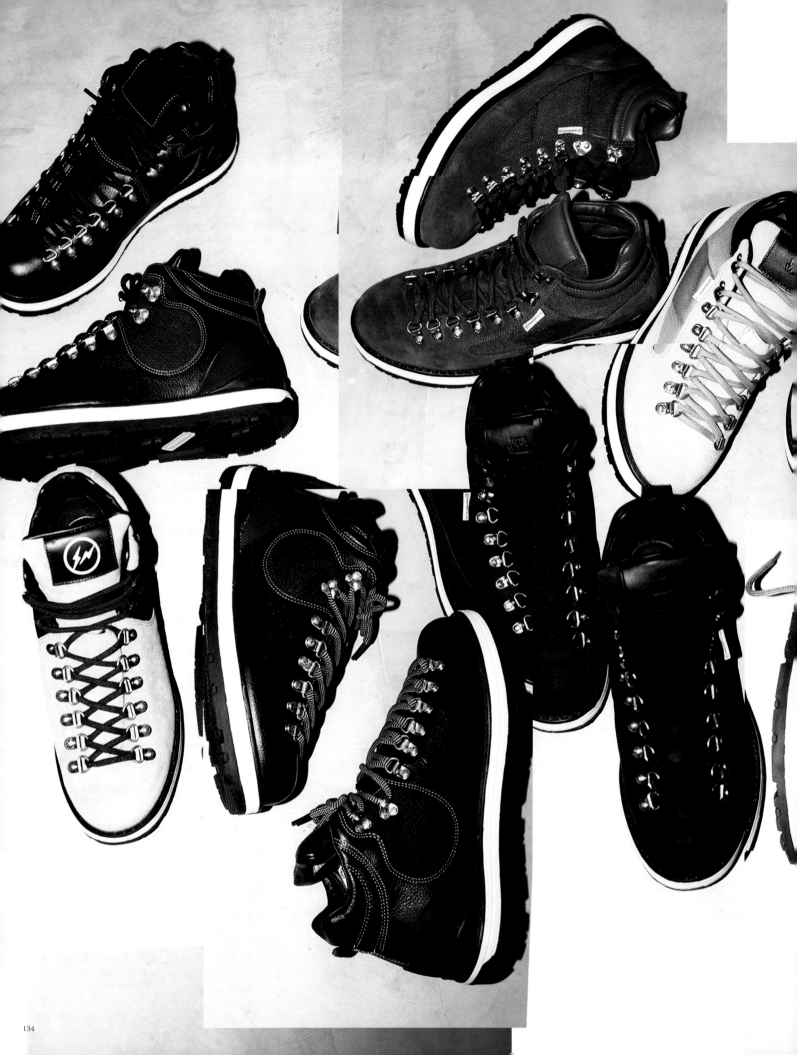

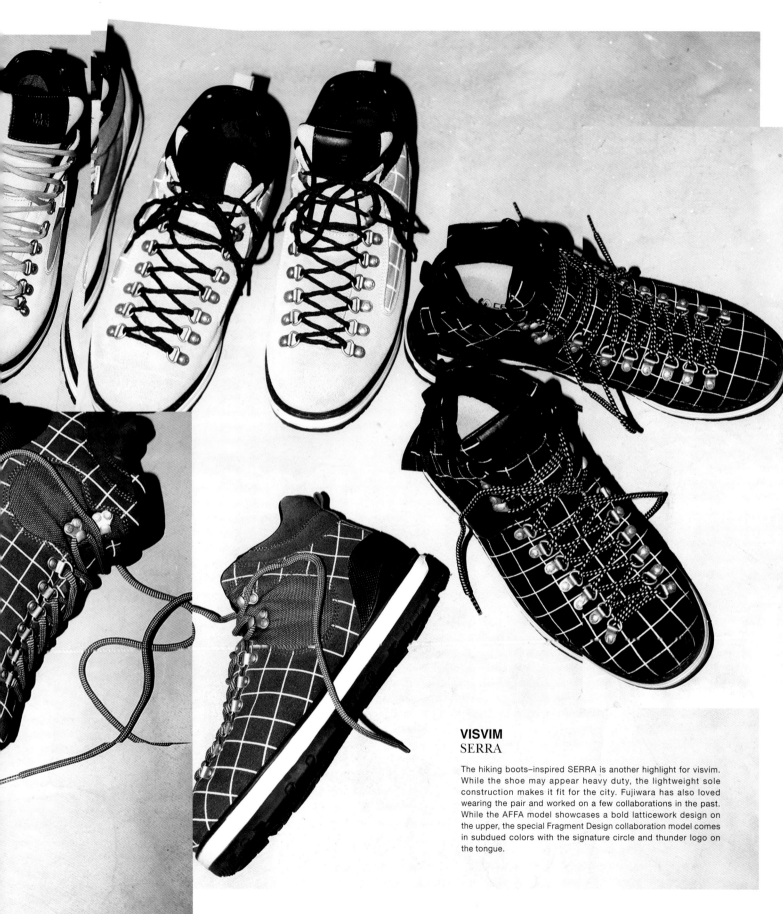

VISVIM
SERRA

The hiking boots–inspired SERRA is another highlight for visvim. While the shoe may appear heavy duty, the lightweight sole construction makes it fit for the city. Fujiwara has also loved wearing the pair and worked on a few collaborations in the past. While the AFFA model showcases a bold latticework design on the upper, the special Fragment Design collaboration model comes in subdued colors with the signature circle and thunder logo on the tongue.

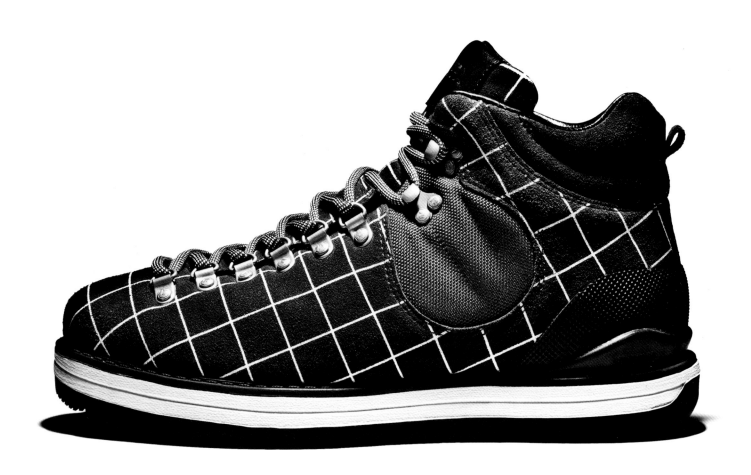

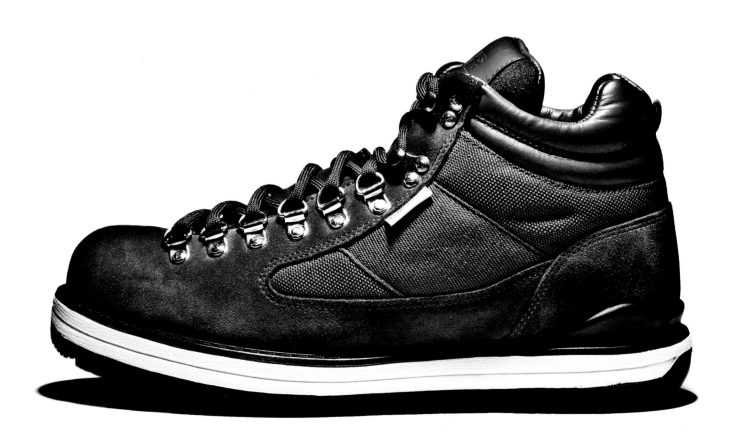

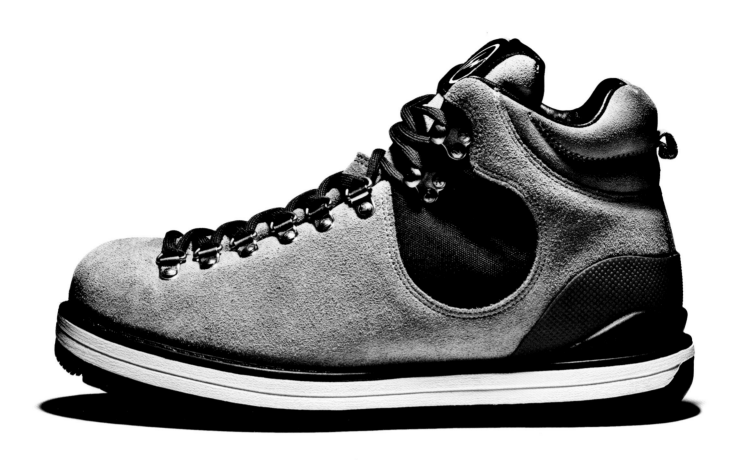

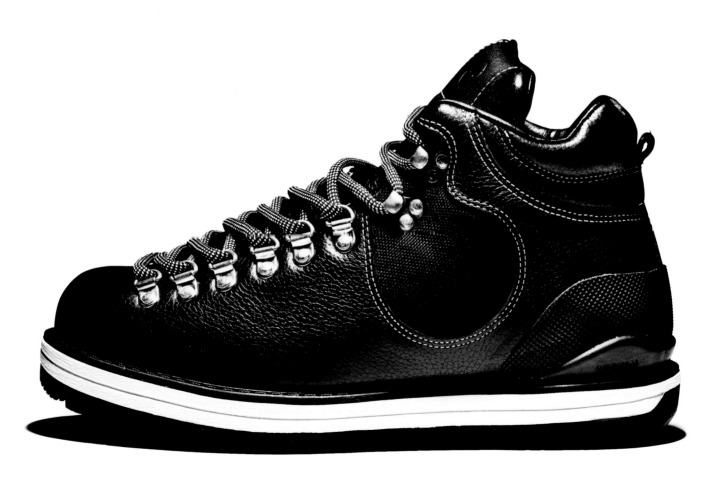

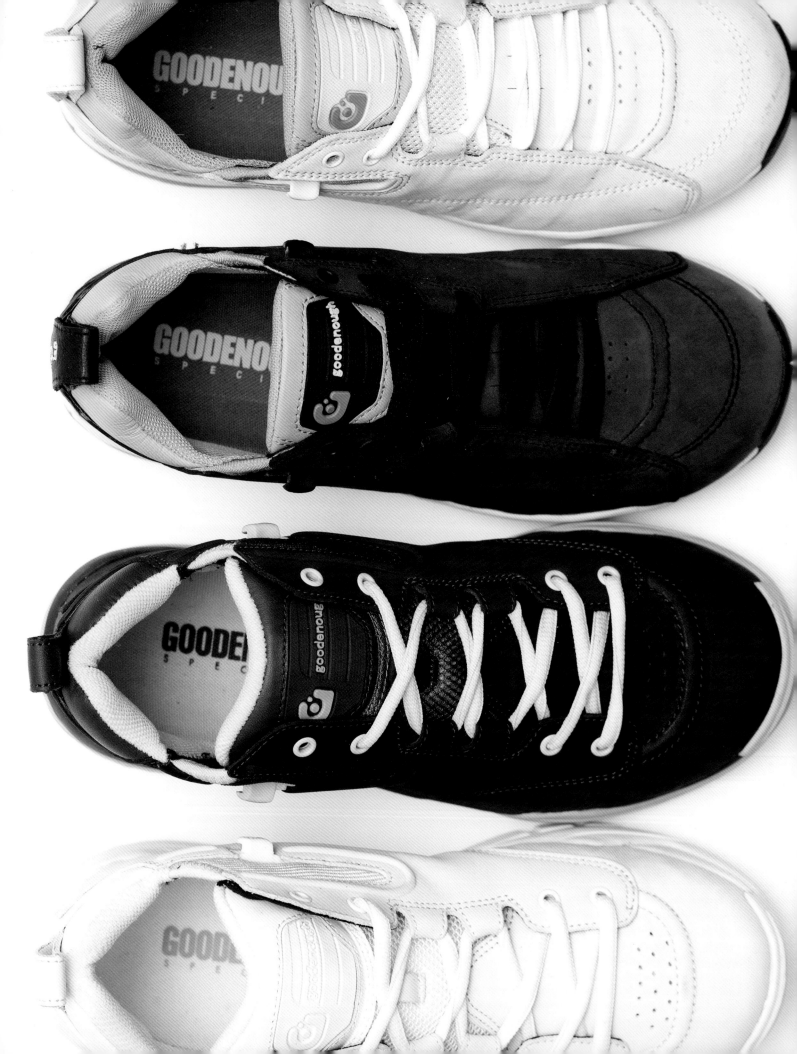

GRAVIS
RIVAL

GRAVIS was launched in 1999 as the footwear division of Burton Snowboards. Under the groundbreaking initiative to produce comfortable shoes to wear post-snowboarding, the brand has introduced many innovative sneakers to the world. Fujiwara contributed many ideas during the brand's onset. Rival, its most representative model, became a huge hit thanks in part to Fujiwara introducing it in magazine articles and other media. Fujiwara has also admitted that Rival is his favorite Gravis model. The left spread shows the collaboration model with GOODENOUGH.

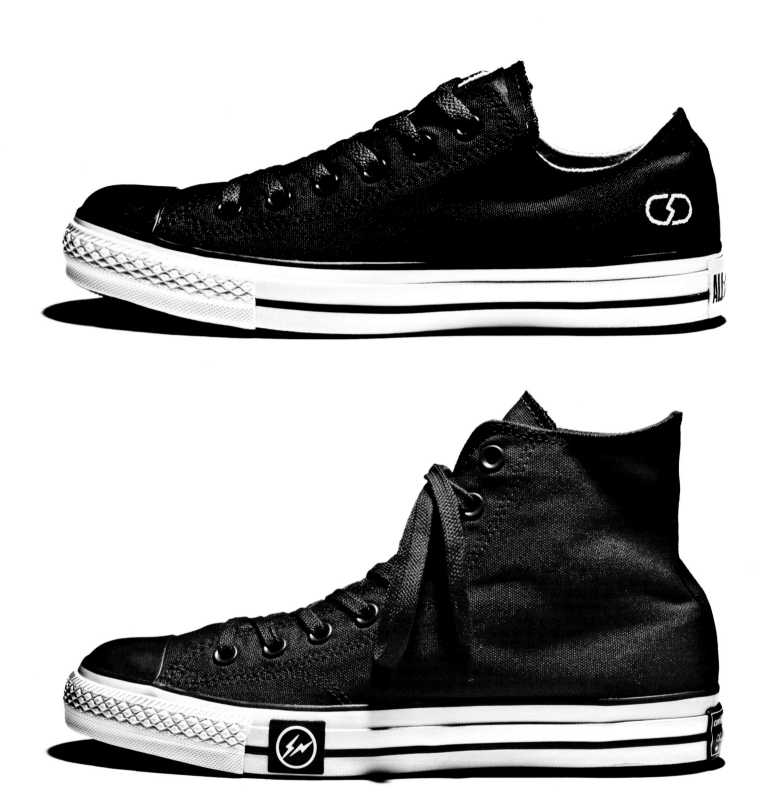

CONVERSE
ALL STAR

Ever since its birth in 1917, Converse All Star has been an enduring favorite among fans irrespective of gender or age. Fujiwara has also been wearing the universal favorite since he was young, and in 2007 he produced a special model through Fragment Design. The model coordinates every part of the shoe including the upper, the toe cap, the shoelace, and the heel patch in a single color. While the low-cut version was produced in 2007, it was never made available in Japan for various reasons. The hi-cut model released in 2012 resulted from the collaboration between the sneaker shop Undefeated and Fragment Design and features both brands' logos on the heel.

section.03
Products

Products

Jun Takahashi/UNDERCOVER

When NIGO® and I opened the select shop NOWHERE in Harajuku back in April 1993, Hiroshi [Fujiwara] brought in all sorts of people. NOWHERE had a tiny storefront—in a back alley behind a Wendy's—and it was the first store to sell NIGO®'s A Bathing Ape and Jun Takahashi/UNDERCOVER.

Hiroshi has an unbelievable network of people. The day before the store opened, he helped stack clothes with us. When we do something together, he'll do the grunt work together as well. He printed T-shirts for us, too. Of course, he'd also slack off from time to time [laughs]. In that regard, I think he is someone who has a strong DIY spirit at his core. But on the other hand, he's also interested in the forefront of technology so he's really uncanny. He's so versatile—an almighty force. It was a special treat for me whenever I had the chance to visit him at his house.

My first exposure to Hiroshi was through a magazine. I read the issue of Popeye featuring Hiroshi when I was in high school. I was really into punk ever since I was in middle school, and right when I became interested in Vivienne Westwood, I read the issue where Hiroshi introduced the Seditionaries. That's how I began to notice Hiroshi. During my last year of high school, I read Hiroshi's column "Last Orgy" in the magazine Takarajima and watched FM-TV (featuring the seminal Japanese hip hop band TINNIE PUNX) every week.

Jun Takahashi is the founder and design director of UNDERCOVER

Products

A.F.F.A—Jun Takahashi's collaboration with Hiroshi Fujiwara

In 1993, Hiroshi Fujiwara and Jun Takahashi of UNDERCOVER, working under the brand name A.F.F.A (ANARCHY FOREVER FOREVER ANARCHY), introduced their collaborative products at NOWHERE Harajuku: AFFA Type MA-1 Custom and AFFA Portrait Marx Silkscreen. Fujiwara customized an MA-1, a nylon flight jacket issued to all branches of the US military.

The two designers' collaborative effort was acknowledged as a rare move at the time, but A.F.F.A was not the first brand to incorporate military gear into high-street fashion. For instance, the bestselling Tanker series of bags launched by Yoshida Kaban in 1983 featured a fabric like the one used in MA-1. Hiroshi had publicly stated that he was a fan of the Tanker series since their debut. Vivienne Westwood's "Clint Eastwood" collection (A/W 1984-85) also used a fabric similar to that of MA-1. A.F.F.A was revolutionary because it customized an MA-1—manufactured by the American company Alpha—in its entirety. The designers made one of the sleeves in a different material, and they emblazoned the words "Anarchy Forever Forever Anarchy," "Anarchy Comes Naturally," and "Chaos" on the original black or olive drab jacket.

In 1995, Yoshida Kaban's chief director Katsuyuki Yoshida, who also tapped Hiroshi for their first ever collaboration—for their Head Porter line—commented on how a younger generation reinterpreted militaria: "I did not know Hiroshi personally then, but I had read about him a little in magazines. The image of him wearing the customized MA-1 remains with me to this day. I thought, wow, there are young people who are interested in what we wore back in the Sixties and Seventies. When we were young we incorporated military clothing as a sign of protest against the war."

JUN TAKAHASHI: Hiroshi came up with the idea of customizing the MA-1. He said, 'Why don't we re-create the Seditionaries' Anarchy shirt while retaining the details of the MA-1?' We began making t-shirts together after that. We also made the official t-shirt for Kyoko Koizumi's tour.
HIROSHI FUJIWARA: We made about thirty A.F.F.A MA-1's. They were all handmade, one-of-a-kind pieces. When we sold them in NOWHERE back in 1993, customers formed a long line in front of the store. For Jonio [Jun Takahashi] and myself, this was an effort to shape our understanding of punk into our own clothes. But we hated New Punk, so just when the brand started to take off, we stopped.
JUN TAKAHASHI: Around this time we also started writing a column together in the magazine ASAYAN [in December 1993] called BACK TO CHAOS. I would never even consider writing a column now [laughs]. I got tired of writing for a magazine after a while so I focused on making clothes. But Hiroshi was always great at maintaining a balance in his life—he influenced me that way. Whenever I see how Hiroshi leads his life, I think: "I should always be true to myself." My roots are in punk so I feel a great affinity to Hiroshi's style.

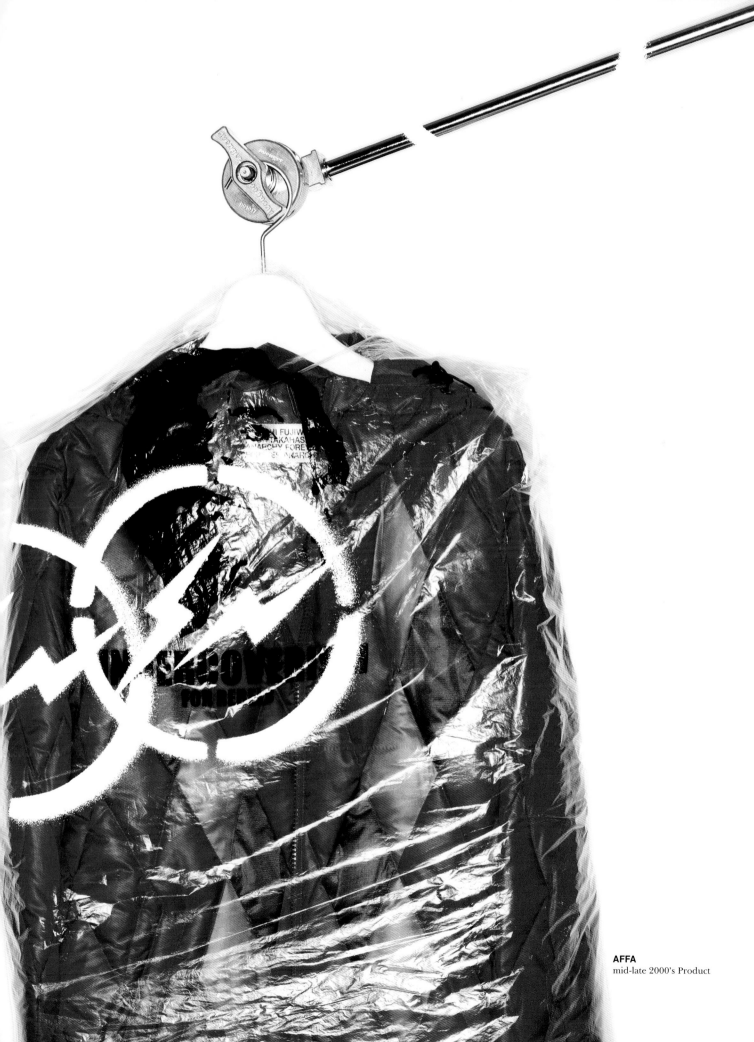

AFFA
mid-late 2000's Product

Products

Sarah Andelman

I can't remember the first time I met Hiroshi [Fujiwara] much less when I first heard about him. I feel as if I've known him forever, as if he was always there, never aging but forever evolving. Hiroshi must have an innate understanding of the art of keeping things—like his person and his activities—shrouded in mystery. I believe that is one of his strengths.

Another is his ability to create remarkable products through his collaboration with a variety of brands: Nike, Levi's, Medicom, Converse… On top of all that, he is involved in music and passionate about bicycles. I truly tip my hat off to him for his expansive range and curiosity. I think his greatest talent is never losing sight of his discretion and integrity no matter what project he is involved in.

For me, he is the godfather of all the young, promising designers today. Moreover, and from an international standpoint, he is the godfather of street culture. He noticed and understood everything before anyone else did.
Hiroshi forever!

Sarah Andelman (née Lerfel) is the Director of Colette Paris

Hidefumi Ino

Nearly a decade ago, Hiroshi came over to Café Tenement, my store in Ebisu, with SOPH.'s Hirofumi Kiyonaga. Another time, when I was eating out with A.P.C.'s Jean Touitou, we happened to bump into Hiroshi. That's how we gradually came to know each other. In December of 2006, I held my solo show, which was sponsored by the hotel With the Style and A.P.C. Hiroshi and Jean have been good friends for a long time, so Hiroshi made a guest appearance and that was our first time performing together.

I lived in Fukuoka from the time I was 20 to when I was about 30 years old. I knew of Hiroshi's work from Last Orgy, but back then I was also mad about bands like Happy End and 60s music in general. I was 25 when I first listened to Hiroshi's I Dance Alone and My Emotion, and that's how I began listening to a lot of his music. What I find most interesting about Hiroshi's sensibility is how he experiments by playing Bob Marley's reggae or Lauryn Hill's hip hop with an acoustic guitar and Fender Rhodes. Also, as a vocalist, I like that he does not necessarily belt out his songs, like Tracey Thorn, for instance.

His live shows are structured on a case-by-case basis: he may develop the show as we run through rehearsals or he may come in knowing exactly what he wants from the beginning. Rehearsing with him is a lot of fun—especially when we deviate and improvise. It's a rare chance to see Hiroshi sing Kenji Sawada, for example [laughs].

A Conversation with James Jebbia and Hiroshi Fujiwara

Coordinated by Kunichi Nomura

JAMES JEBBIA: I think we first met through Shawn [Stussy]. Even before we met Shawn was always going on and on about Hiroshi this, Hiroshi that. He said the person who introduced Stussy to Japan is Hiroshi.

HIROSHI FUJIWARA: Yes, we've known each other for a long time now. Back then, you were working at the select shop Union and I remember being amazed when I saw the store. At the time when everyone else was focused on high fashion you were selling London's streetwear. I thought, "this is the right place to sell Stussy" [laughs].

JJ: Well, I'm originally from Britain after all.

HF: After that you launched Supreme in 1994. At that time there was no such thing as a crossover between fashion and skateboarding, right? In New York I mean.

JJ: Technically there was, but it was still on a level that you could describe as non-existent. Around that time I happened to rent out a place for cheap on Lafayette Street and since I had a lot of skater friends and knew that something was happening in that scene, I decided to start a cool skateboard shop.

HF: I think what makes Supreme different from any other skateboard brands is how you brought contemporary art over to skate culture—this is also among your greatest accomplishments. You are communicating culture to kids through the brand. You and I both grew up in the early 1980s when those kinds of art were born.

JJ: There were definitely art stars back then. It was as if there was no distinction between an artist and a musician; even if you didn't know much about art you came to know them naturally—it was that kind of era.

HF: So I think what you're doing now is great. I don't think kids these days will know what we're talking about when we say Barbara Kruger. But they can be introduced to it by learning it here [at Supreme].

JJ: Of course. But it's not as if I'm deliberately trying to teach kids about art [laughs].

HF: Right. Your stance is that kids will seek it out if it interests them.

James Jebbia is the founder of Supreme

GOODENOUGH

When GOODENOUGH started in 1990, both Hiroshi Fujiwara and Skatething worked as staff. The brand released many items with unrivalled aesthetics, which can be seen in everything, from the precise detailing, unique graphics and in simple designs—with a twist. At the time of its inception the brand adhered to a strict code of anonymity that made it hard to decipher the designer behind the item, and the added mystery appealed all the more strongly to fans. GOODENOUGH, whose name was coined by Fujiwara, did not officially announce his involvement until much later. The brand continues to evolve today and the new lineup GOODENOUGH Ivy launched in Spring/Summer 2013.

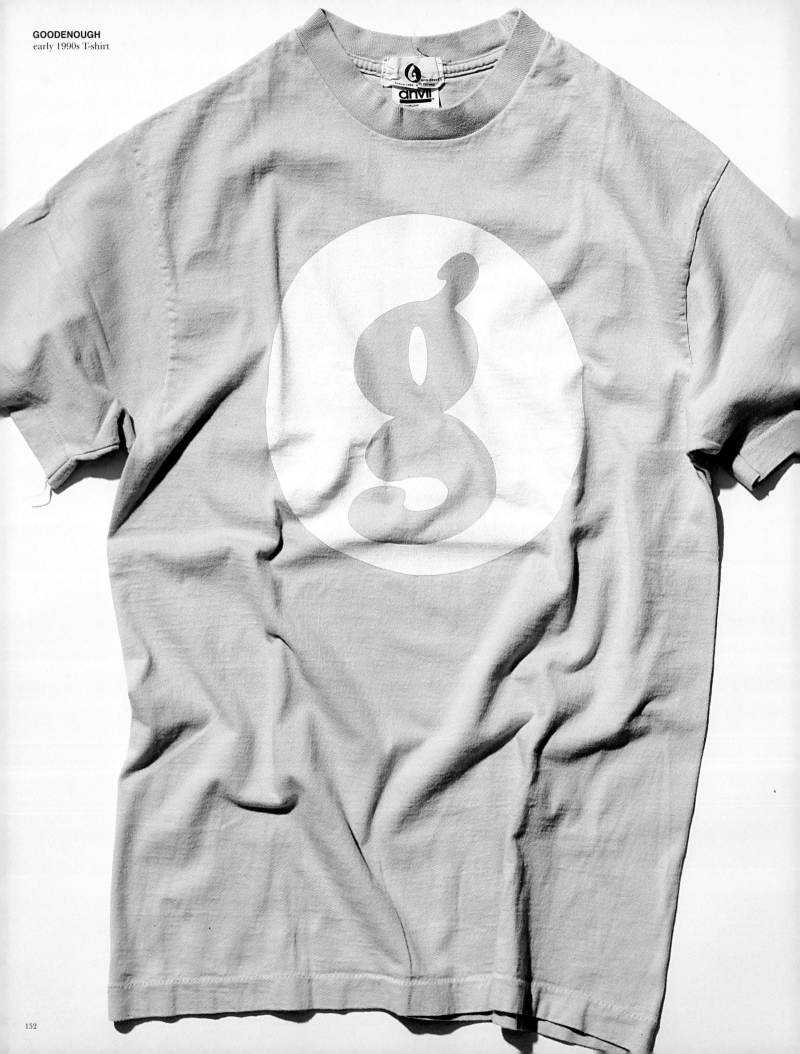

GOODENOUGH
early 1990s T-shirt

152

ELECTRIC COTTAGE

During the 1990s, Fujiwara established the label Electric Cottage, whose name was given by Shawn Stussy. Because the label started out with clothes Fujiwara designed for his close circle of friends, the products were released only sporadically in extremely limited quantities. The label also collaborated with Goodenough and Stussy during the same decade. Its apparel line ended when the name of Fujiwara's office changed from Electric Cottage to Fragment Design.

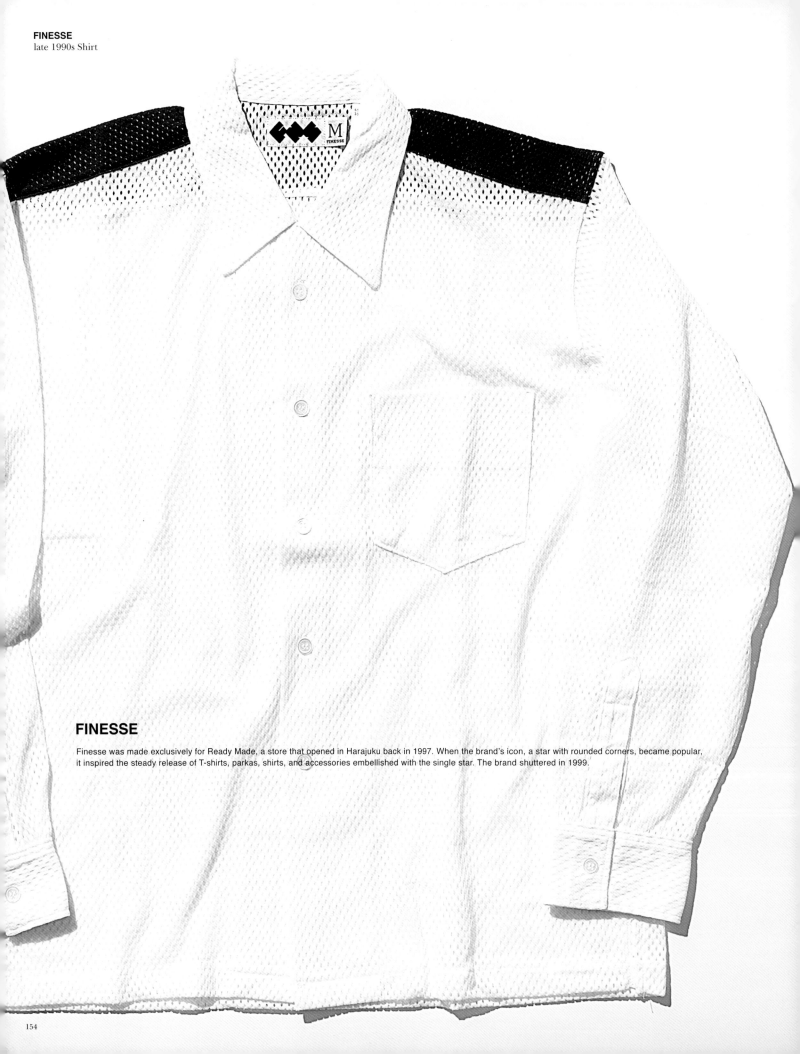

FINESSE

Finesse was made exclusively for Ready Made, a store that opened in Harajuku back in 1997. When the brand's icon, a star with rounded corners, became popular, it inspired the steady release of T-shirts, parkas, shirts, and accessories embellished with the single star. The brand shuttered in 1999.

DANGER INTENSE VOLUME

MORE ABOUT LESS

More About Less was born when Finesse underwent a name change in 1999. The brand's structure did not differ greatly from Finesse, and it was also available exclusively at Ready Made. More About Less ended when the shop closed its doors in December of 2000.

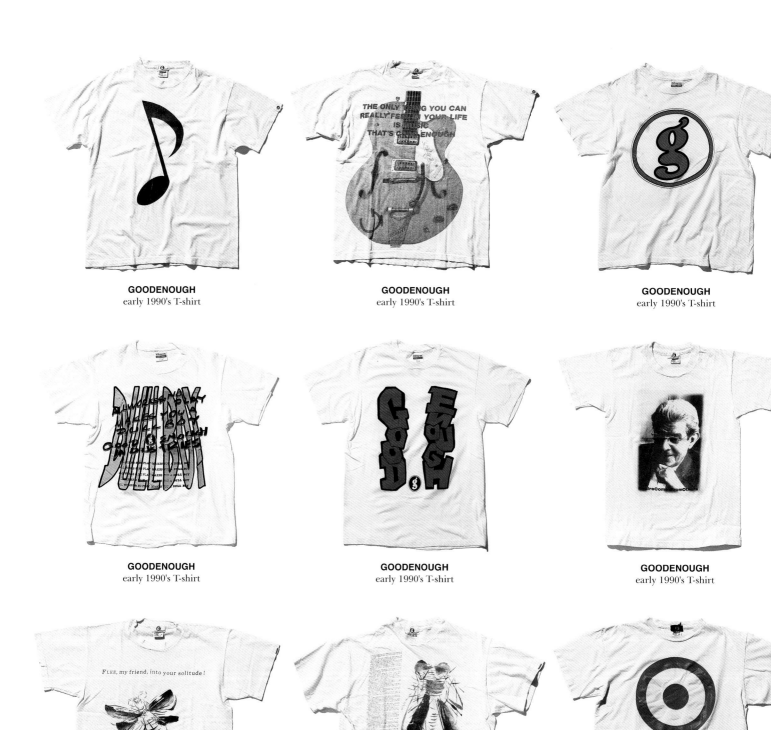

GOODENOUGH
early 1990's T-shirt

GOODENOUGH
early 1990's T-shirt

GOODENOUGH
early 1990's T-shirt

GOODENOUGH
early 1990's T-shirt

GOODENOUGH
early 1990's T-shirt

GOODENOUGH
early 1990's T-shirt

GOODENOUGH
mid 1990's T-shirt

GOODENOUGH
mid 1990's T-shirt

GOODENOUGH
early 1990's T-shirt

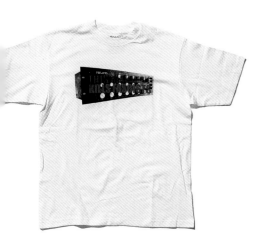

GOODENOUGH
early 2000's T-shirt

GOODENOUGH
late 1990's T-shirt

GOODENOUGH
mid 1990's T-shirt

GOODENOUGH
mid 1990's T-shirt

GOODENOUGH
early 1990's T-shirt

ELECTRIC COTTAGE
mid 1990's T-shirt

ELECTRIC COTTAGE
early 2000's T-shirt

ELECTRIC COTTAGE
early 2000's T-shirt

ELECTRIC COTTAGE
mid 1990's T-shirt

AFFA

AFFA is a joint brand by Fujiwara and Jun Takahashi, the designer of UNDERCOVER. AFFA, which launched in the early 1990s, takes the first letters of the phrase: ANARCHY FOREVER FOREVER ANARCHY. Since then, the brand has continued to release items sporadically without a set schedule. A punk philosophy that has inspired the two founders since their younger days lies at the root of the brand. A far cry from run-of-the-mill pieces with the typical punk vibe, AFFA products take their cues from Malcolm McLaren and Vivienne Westwood's Sex and Seditionaries shop. The designs are standard yet avant-garde, disciplined yet unruly. Since Fall/Winter 2011, the brand has been operating under the name ASSEMBLE.

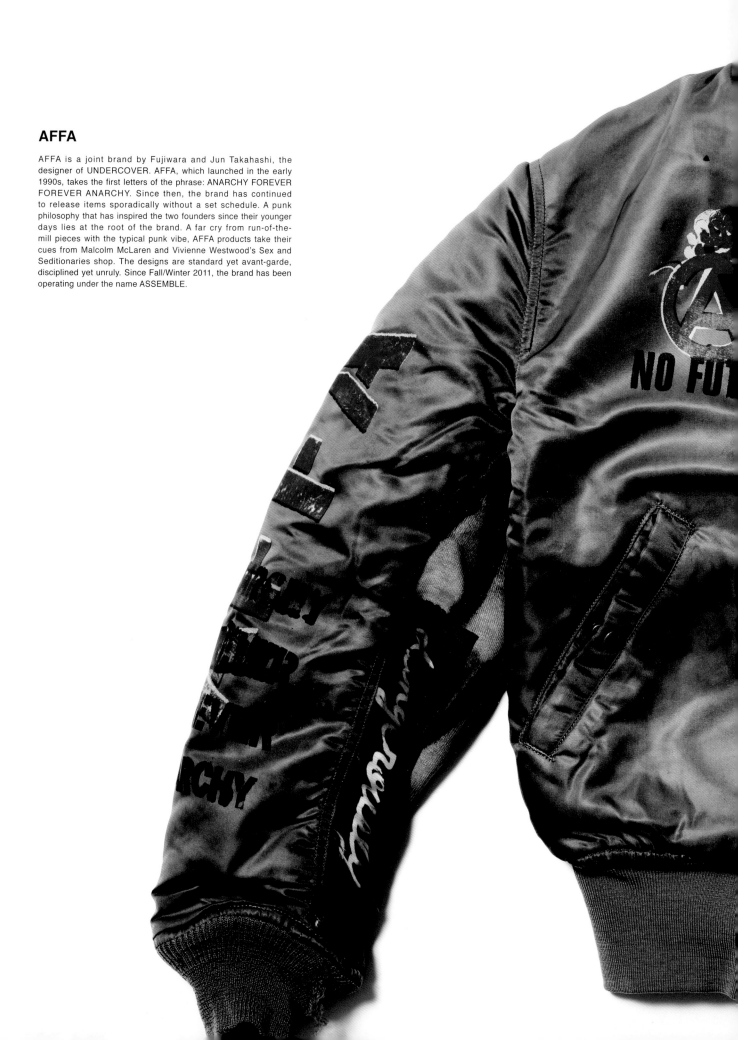

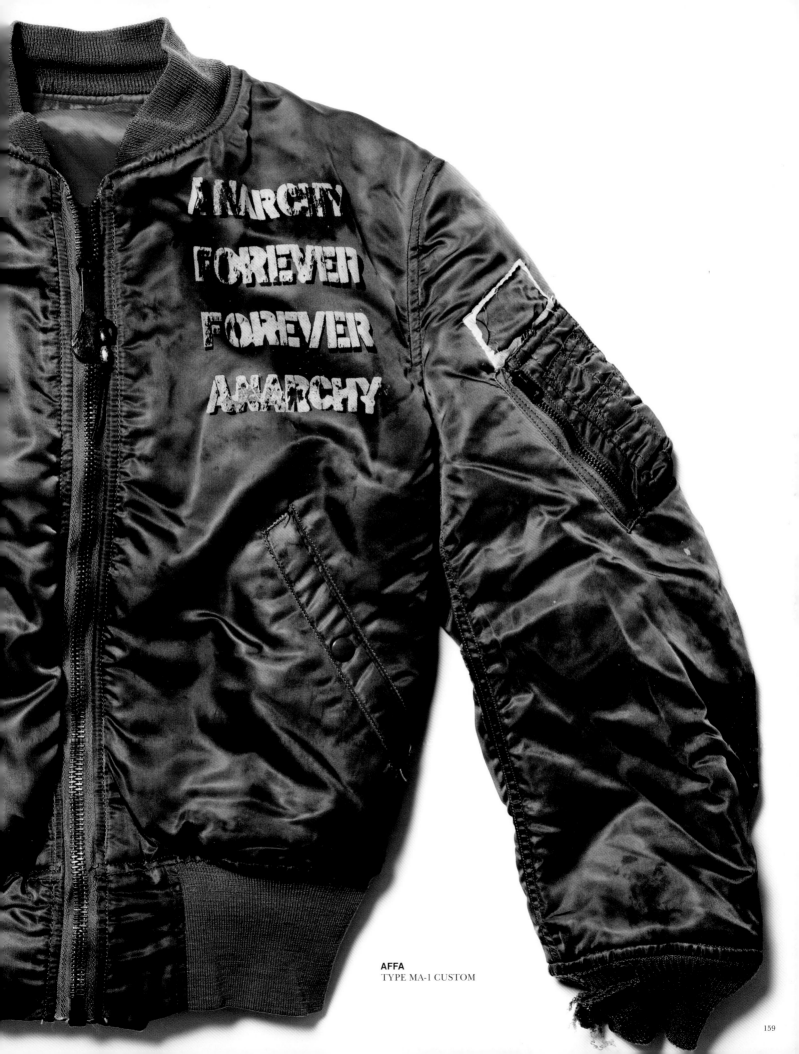

AFFA
TYPE MA-1 CUSTOM

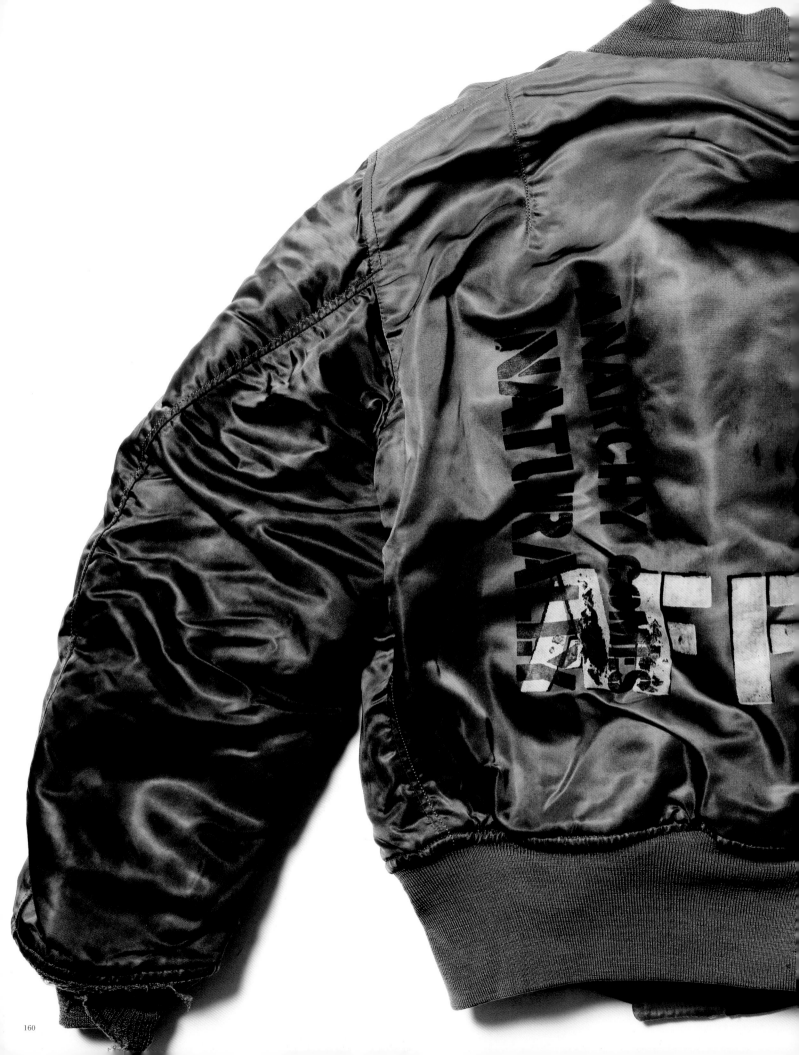

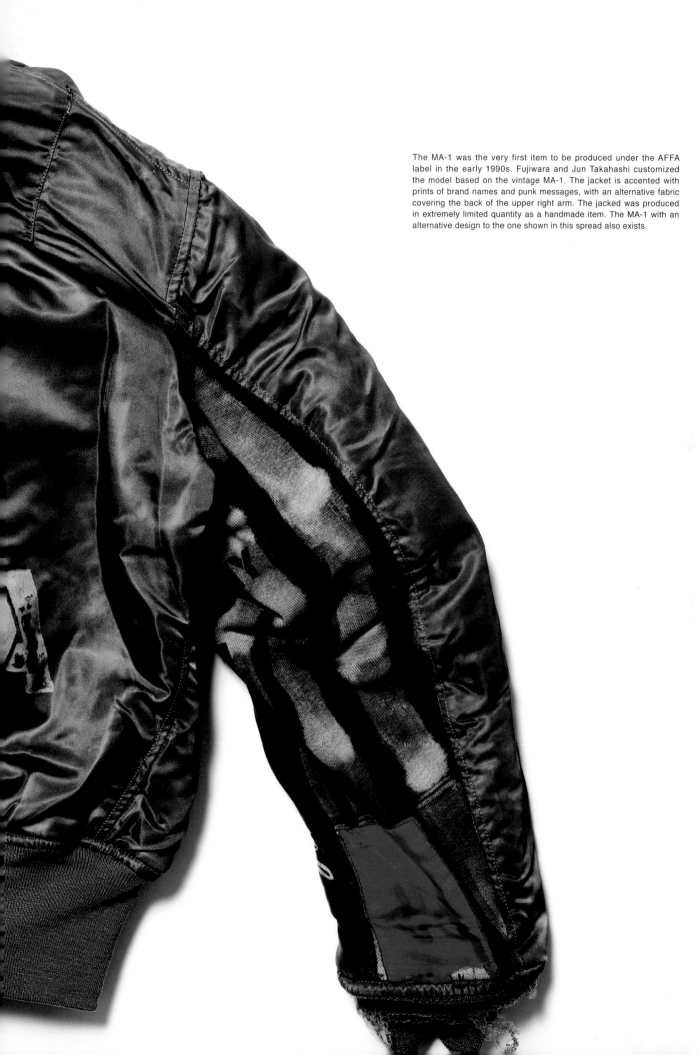

The MA-1 was the very first item to be produced under the AFFA label in the early 1990s. Fujiwara and Jun Takahashi customized the model based on the vintage MA-1. The jacket is accented with prints of brand names and punk messages, with an alternative fabric covering the back of the upper right arm. The jacked was produced in extremely limited quantity as a handmade item. The MA-1 with an alternative design to the one shown in this spread also exists.

ASSEMBLE
early 2010s Scarf

AFFA
mid-late 2000s Product

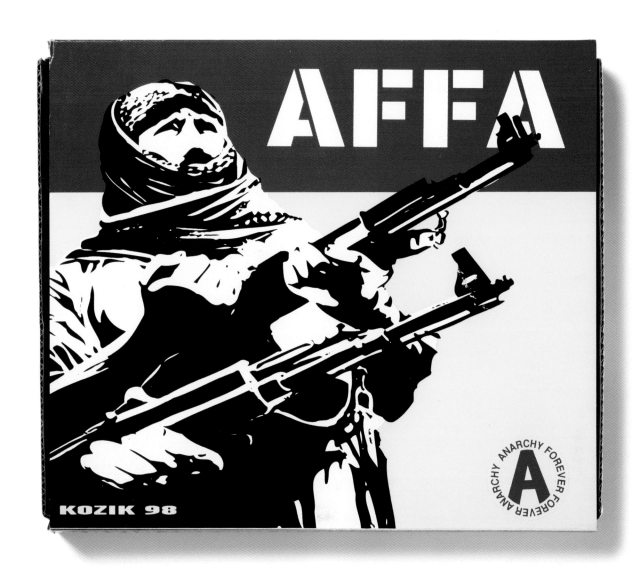

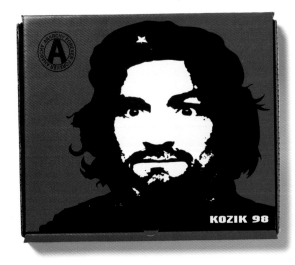

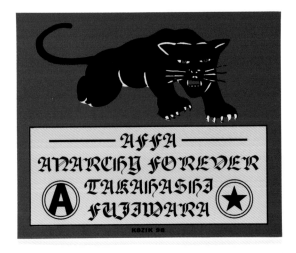

AFFA
KOZIK ARTWORKS

The artist Frank Kozik shot to fame in Japan when Fujiwara introduced his posters and other works in magazines and other media around 1996. The collaboration between AFFA and Kozik was realized in 1998. A poster box illustrated with revolutionary motifs and parodies was sold exclusively at Ready Made.

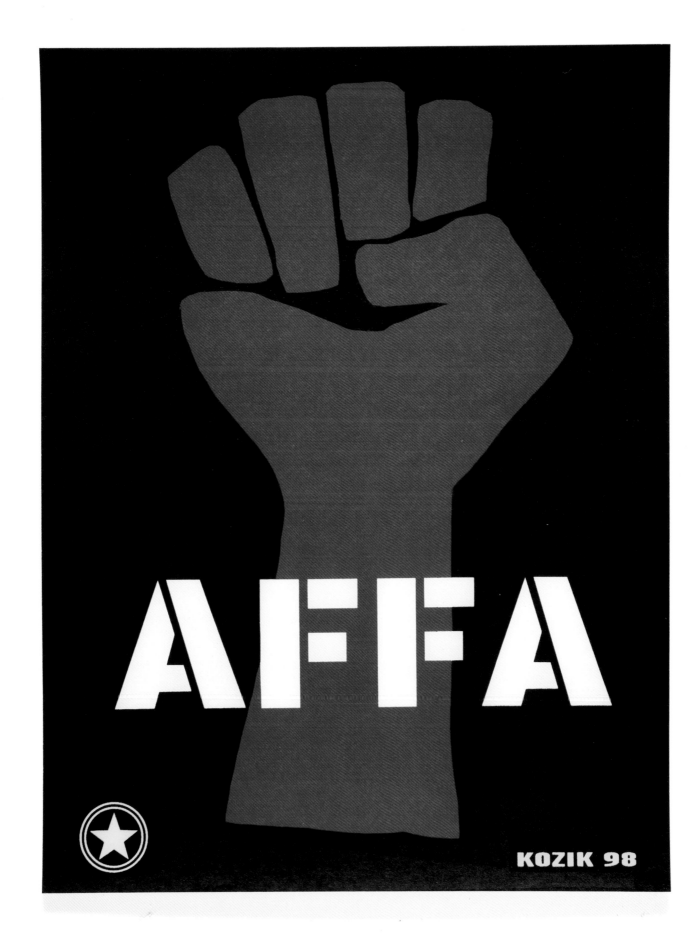

BURTON
ROOT148 THE WALL

The premier snowboarding brand Burton opened its pop up store, Burton Backcountry House, in Omotesando's Batsu Art Gallery in December 2012. Root 148 The Wall was released as a specially designed board at the venue. Inspired by city walls, Fujiwara produced ten one-off boards with Motoki Mizoguchi, the art director of the graphic agency mo'design inc.

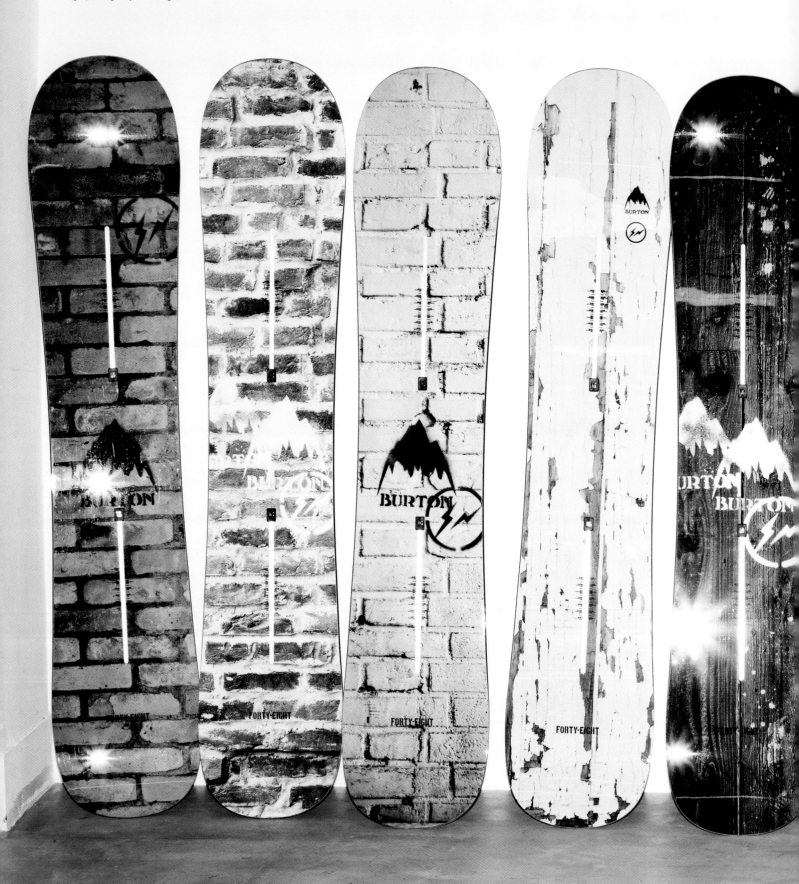

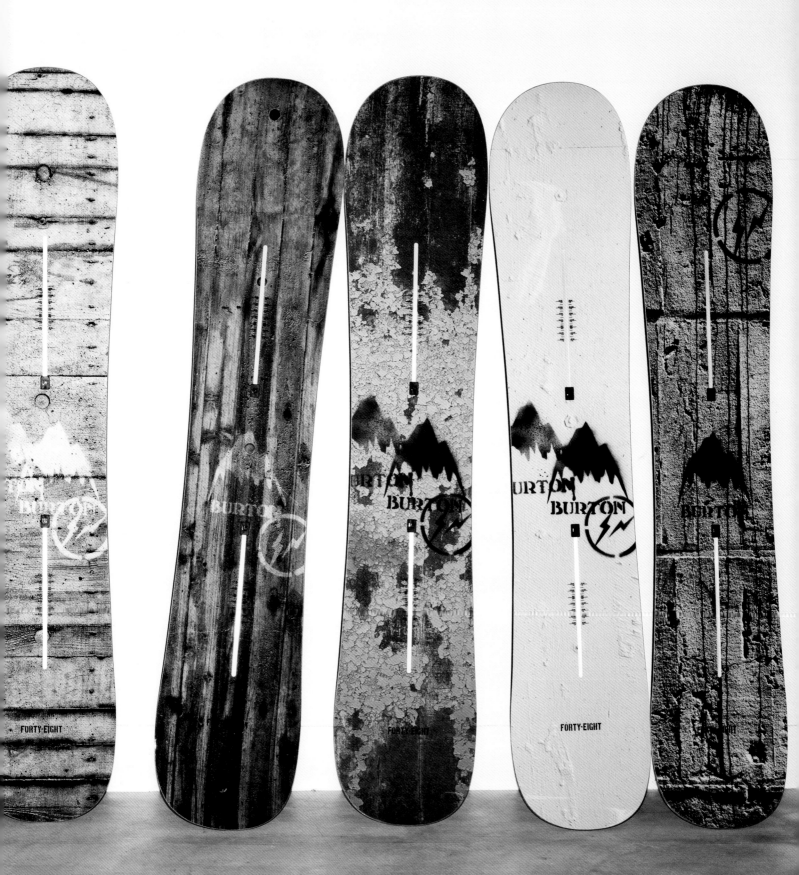

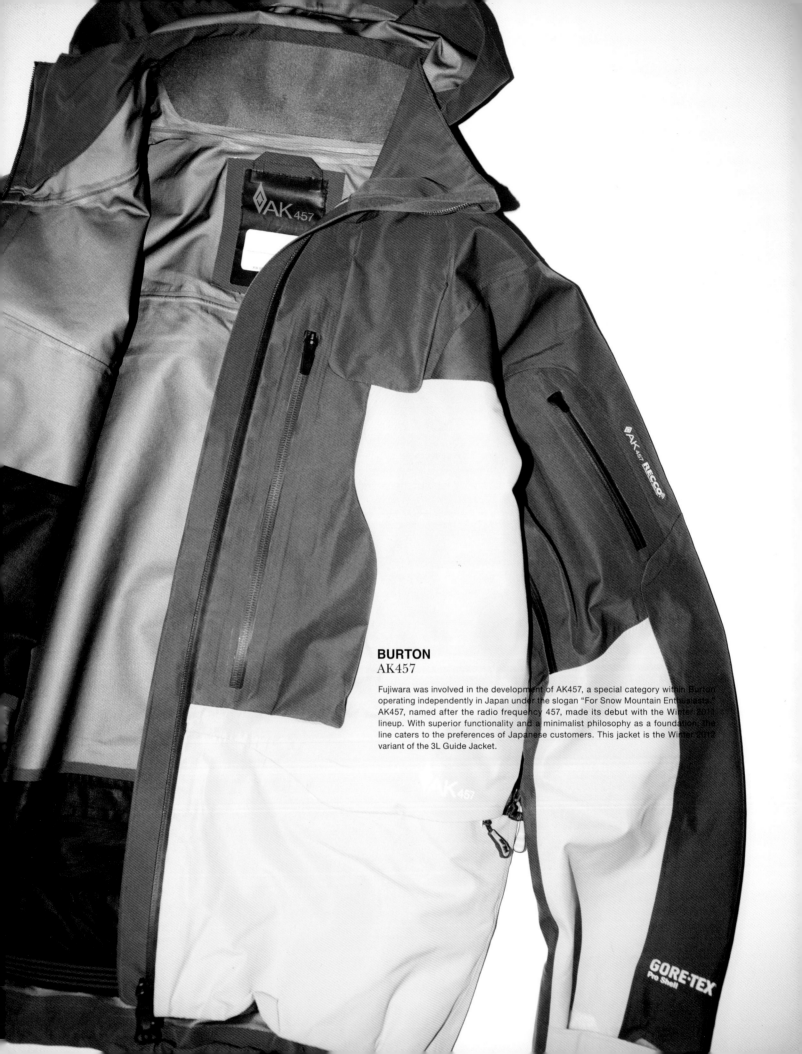

BURTON
AK457

Fujiwara was involved in the development of AK457, a special category within Burton operating independently in Japan under the slogan "For Snow Mountain Enthusiasts." AK457, named after the radio frequency 457, made its debut with the Winter 2011 lineup. With superior functionality and a minimalist philosophy as a foundation, the line caters to the preferences of Japanese customers. This jacket is the Winter 2012 variant of the 3L Guide Jacket.

BURTON
DUCT LINE

Duct Line is the new collaborative series by Burton and Fragment Design, introduced during the 2012 season. The silver material is made of Dimension Polyant's X-Pac™, a high-performance, three-layer fabric that utilizes a special method to combine PET film (surface cloth), Polyester X-Ply®, and polyester taffeta (liner fabric). Aside from the rider pack shown here, the series includes a total of five items, including a tote bag and a wheeled suitcase.

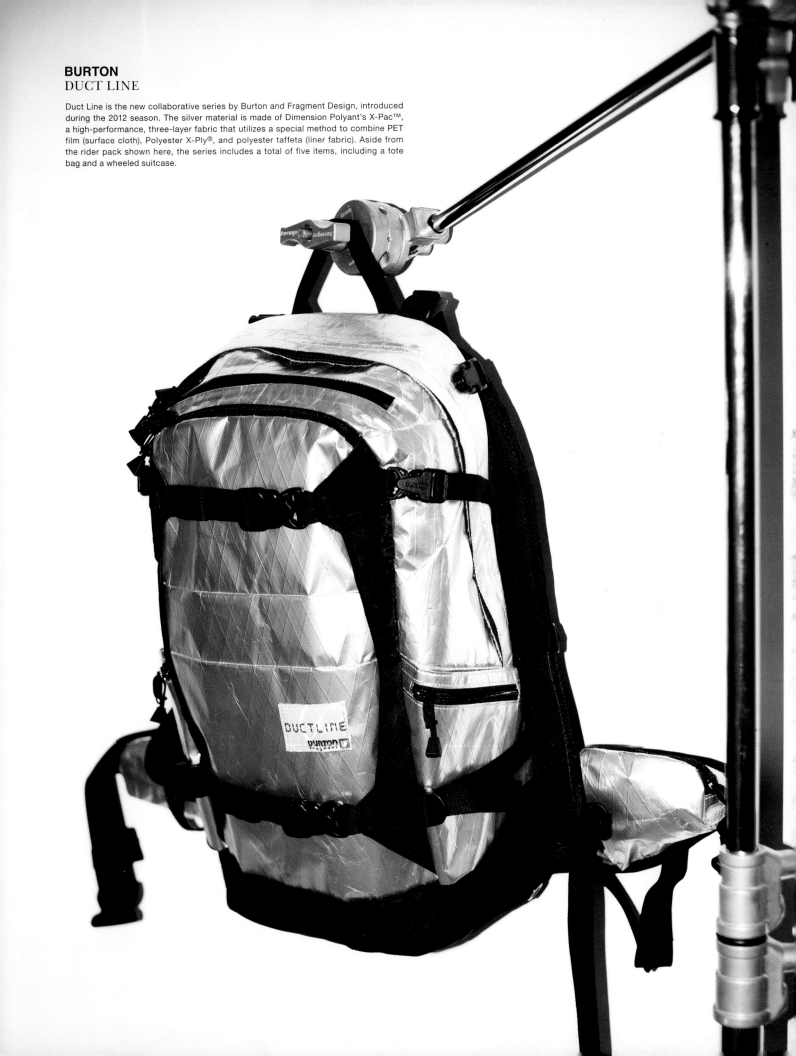

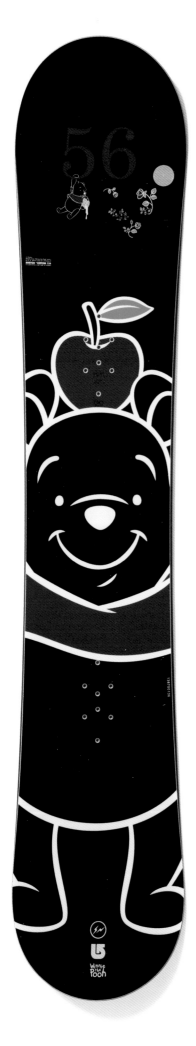
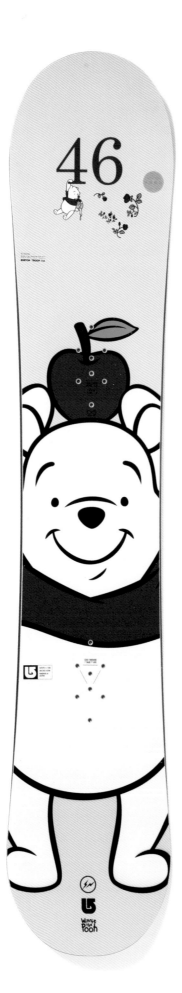

BURTON
POOH CUSTOM & POOH TROOP

The world's first collaborative snowboard by Burton and Disney was introduced as a late entry in the 2005 season. Fujiwara and Frank Kozik handled the graphic design. Fujiwara suggested new colorways for Winnie the Pooh, beloved for his trademark yellow color, and include a black Pooh bear on Burton's Custom board for men, and a white Pooh bear on the women's Troop board.

MEDICOM TOY
Winnie the Pooh (Hf version)

This Winnie the Pooh vinyl toy was released in 2009. Fujiwara suggested a jet-black version of the iconic character. Fragment Design's trademark thunder logo marks the back of Pooh's red outfit. A stuffed animal version in the same black color was released at the same time.

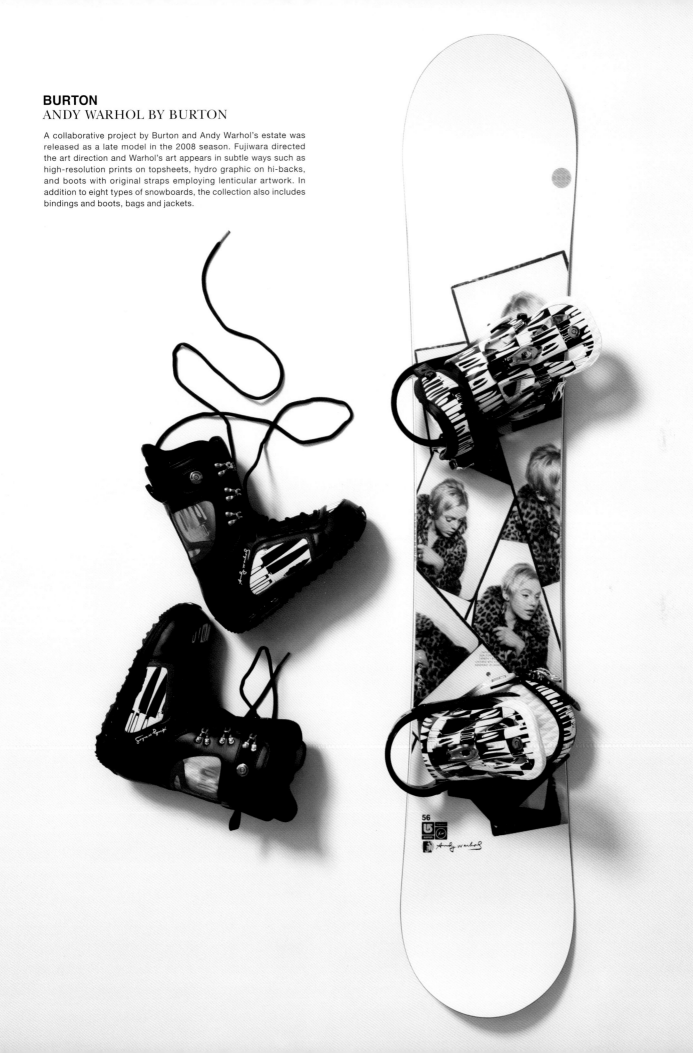

BURTON
ANDY WARHOL BY BURTON

A collaborative project by Burton and Andy Warhol's estate was released as a late model in the 2008 season. Fujiwara directed the art direction and Warhol's art appears in subtle ways such as high-resolution prints on topsheets, hydro graphic on hi-backs, and boots with original straps employing lenticular artwork. In addition to eight types of snowboards, the collection also includes bindings and boots, bags and jackets.

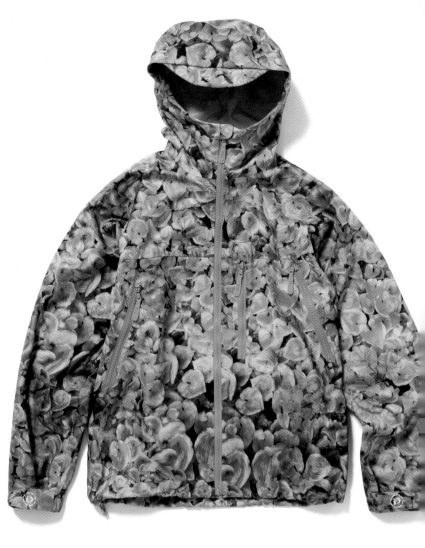

BURTON
iDiom JACKET

The pinnacle of snowboard equipment, iDiom was created exclusively for Japan in 2002. The line includes boards and bindings, in addition to boots, gloves and other gear. The streamlined and sophisticated designs by Fragment garnered high praise from both snowboarders and fans of street fashion, who readily adapted the apparel as everyday urban outerwear. The jackets embody the season's trends and come in many variations—their bold designs worthy of the outerwear of an established fashion brand. A collaboration with Mastermind Japan also took place in 2006.

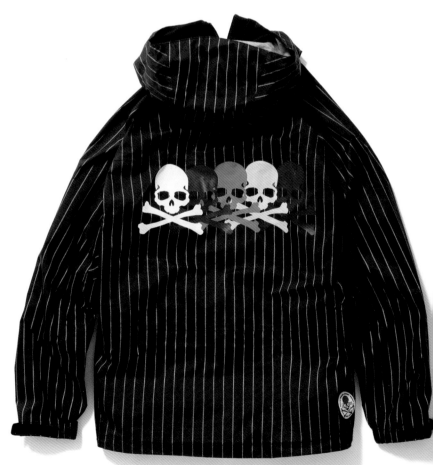

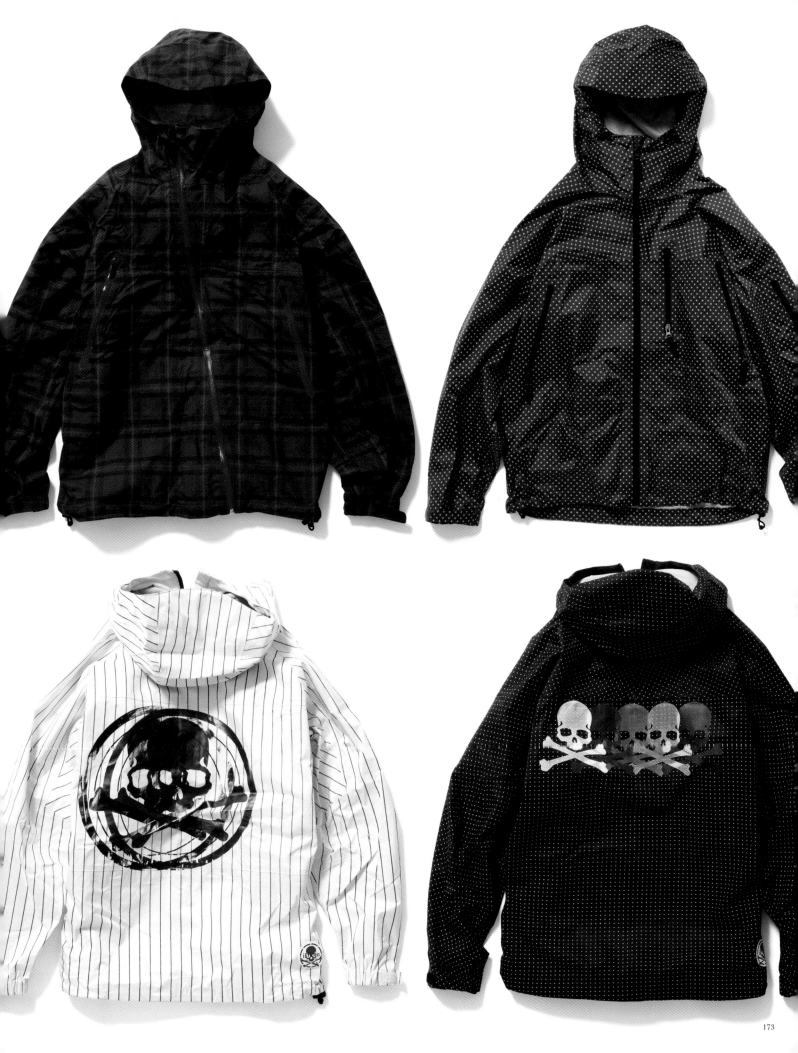

BURTON
iDiom 3L JACKET

The three-layer jacket from the 2011 season. The sleeves feature Haaken pockets for storing ski goggles, which drew its inspiration from snowboarder Terje Haakonsen's ideas. The taping on all of the seams is an iDiom signature. This model also showcases a cityscape at night on the outer shell with a vivid yellow interior reminiscent of neon lights.

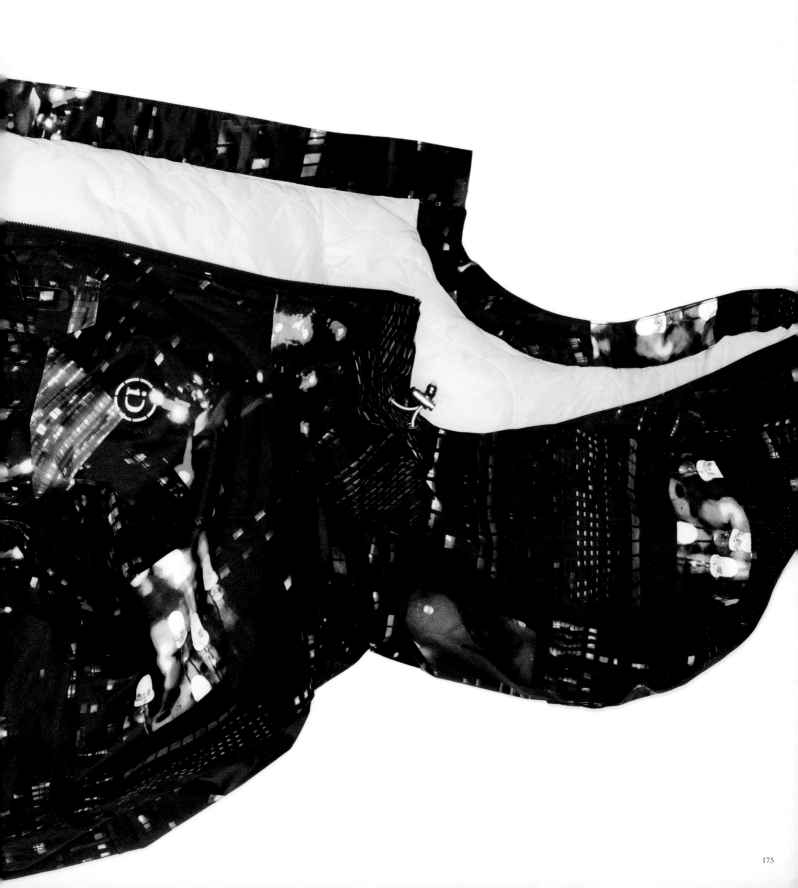

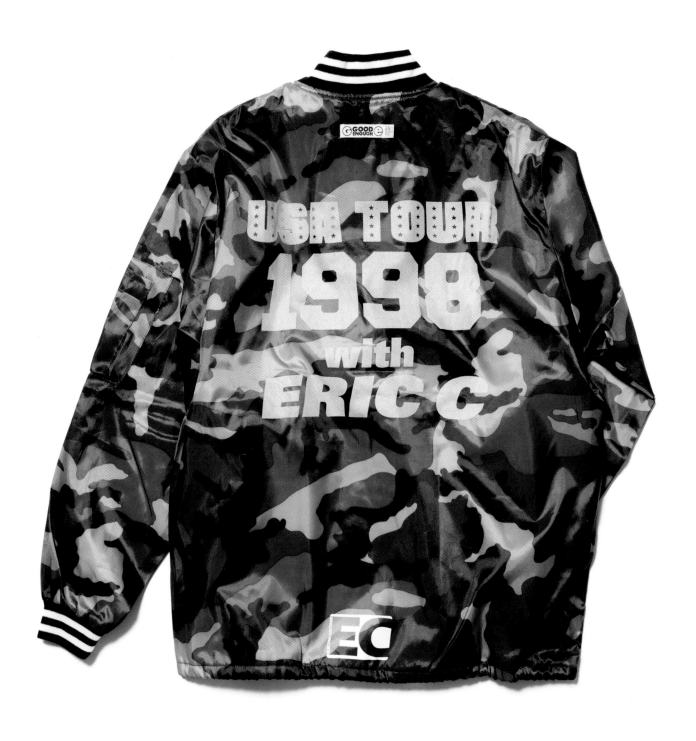

ELECTRIC COTTAGE
ERIC CLAPTON 1998 TOUR JACKET

Coach jackets worn by the crew on Eric Clapton's 1998 U.S. tour. Goodenough designed the body of the jacket, with the "GE" logo proudly emblazoned on the front left chest. Fujiwara employed a camouflage pattern for a coach jacket, then an unprecedented idea.

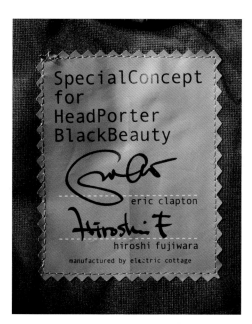

ELECTRIC COTTAGE
BLACK BEAUTY JACKET

Electric Cottage's mountain parka produced in 2001. Created for crew on Eric Clapton's tour, the jacket features both Fujiwara's and Clapton's autographs on an interior tag. The body employs the same fabric from Head Porter's popular "Black Beauty" series.

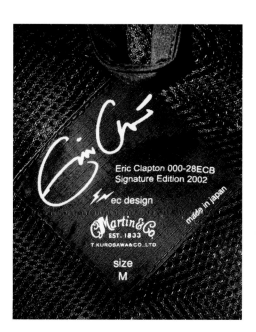

ELECTRIC COTTAGE
BLACK BEAUTY JACKET

Electric Cottage's mountain parka was offered as a special feature to buyers of Eric Clapton's signature guitar 000-28ECB released by Martin & Co. in 2002. Clapton's autograph adorns the backside of the jacket along with the logo of Electric Cottage.

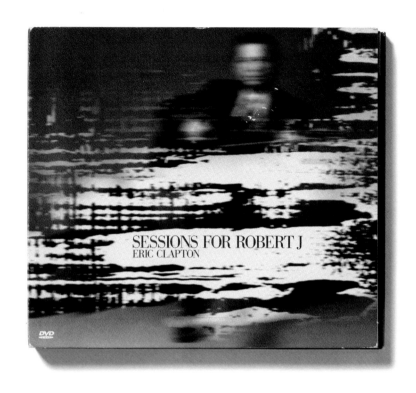

ERIC CLAPTON
SESSIONS FOR ROBERT J (CD+DVD)

The special CD and DVD set from 2005 of the album Me and Mr. Johnson, which was made in honor of Eric Clapton's idol, the legendary bluesman Robert Johnson. Fujiwara produced the package design and the footage of the DVD.

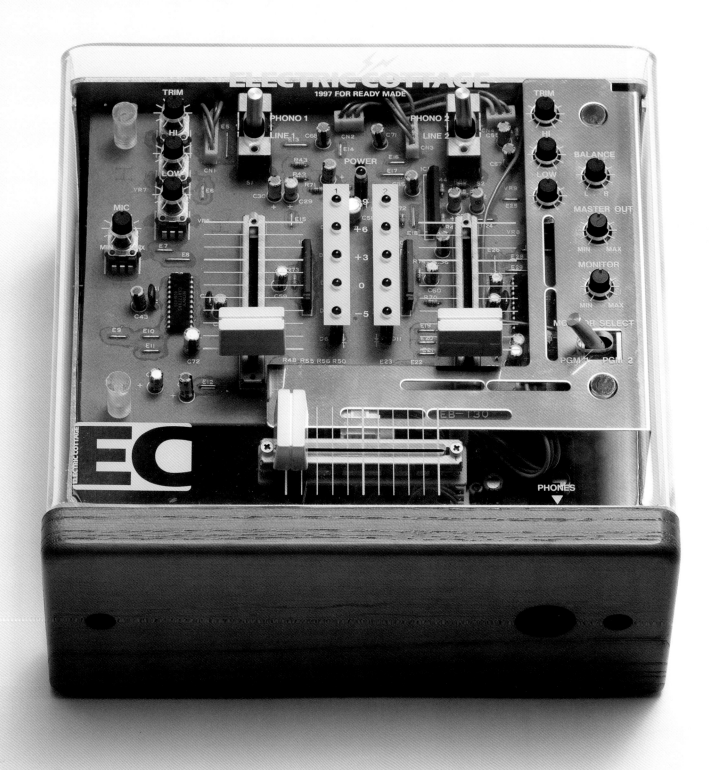

VESTAX CORPORATION
SOUND MIXER PMC-01

Electric Cottage's made-to-order model of the Vestax PMC-01 released in 1997. Available only at Ready Made, the model has an acrylic external skeleton—an unprecedented finish for a mixer that drew much attention. The spec is the same as the regular PMC-01.

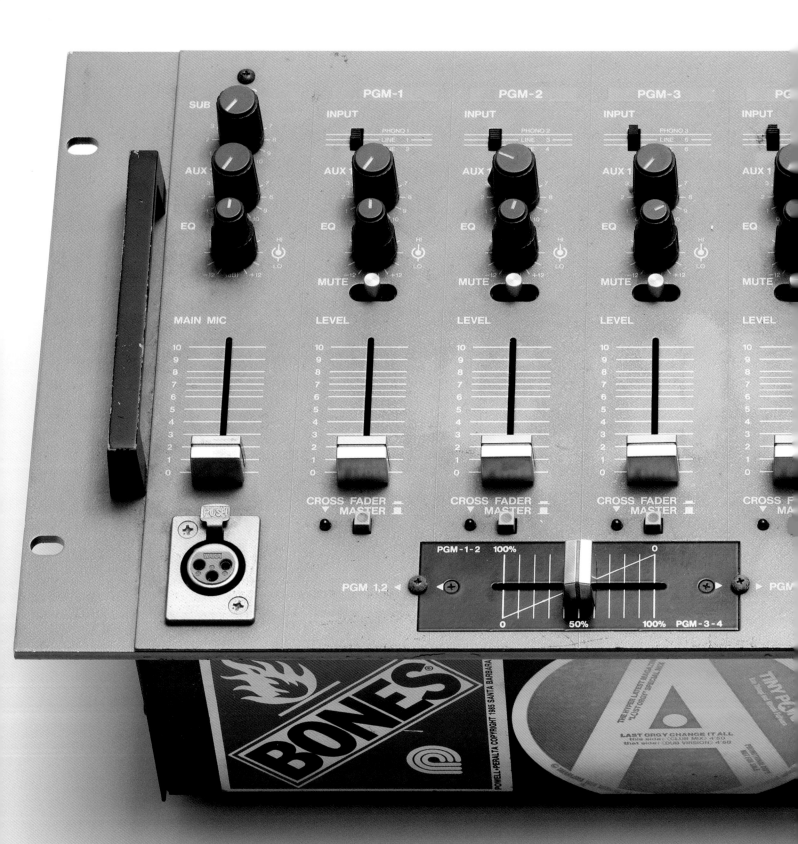

VESTAX CORPORATION
SOUND MIXER PMC-30 HF

The PMC-30 was ranked one of the top models among Vestax-produced mixers in 1980. The model is equipped with a large seven-band graphic recognizer with a wide range. Since the graphic equalizer is separated into left and right, it is also treasured as an ideal mixer for sound production. Fujiwara's special model comes with his autograph on the plate.

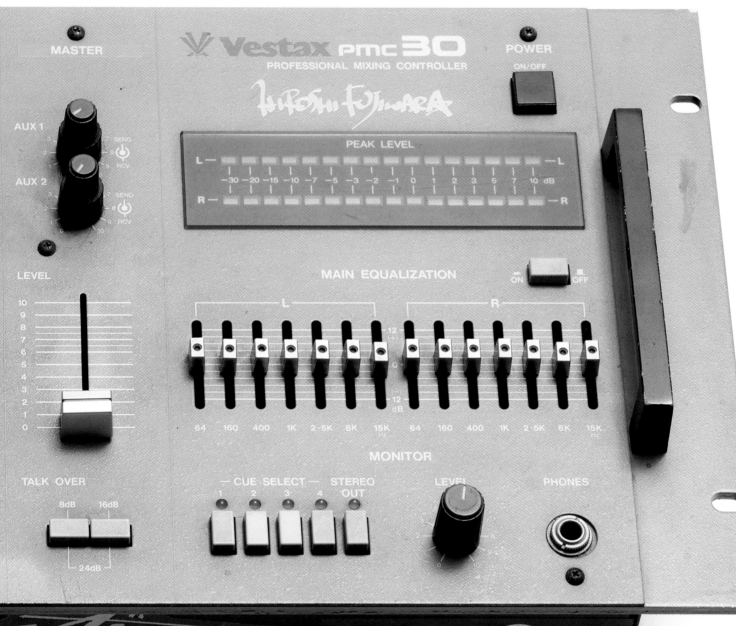

HIROSHI FUJIWARA
HIROSHI FUJIWARA IN DUB CONFERENCE
1995 VICTOR ENTERTAINMENT

HIROSHI FUJIWARA
manners
2014 SMAR

HIROSHI FUJIWARA
CLASSIC DUB CLASSICS
2005 CRUE-L RECORDS

SUBLIMINAL CALM
SUBLIMINAL CALM
1992 VICTOR ENTERTAINMENT

HIROSHI FUJIWARA
BEST
1997 VICTOR ENTERTAINMENT

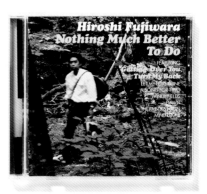

HIROSHI FUJIWARA
NOTHING MUCH BETTER TO DO
1994 VICTOR ENTERTAINMENT

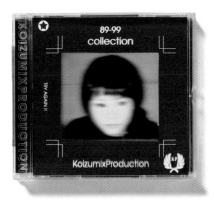

KYOKO KOIZUMI
88-99 COLLECTION
1998 VICTOR ENTERTAINMENT

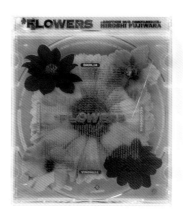

HIROSHI FUJIWARA
FLOWERS
1998 APE MOOD

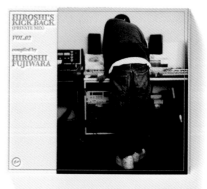

HIROSHI FUJIWARA
HIROSHI'S KICK BACK (PRIVATE MIX) VOL. 2
2005 ASMIK ACE

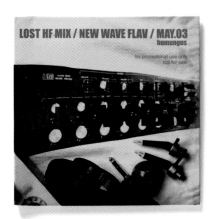

HIROSHI FUJIWARA

LOST HF MIX / NEW WAVE FLAV /
MAY.03 HUMUNGUS

2007 STTEPERS RECORDS

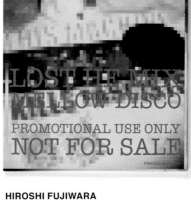

HIROSHI FUJIWARA

LOST HF MIX MELLOW DISCO#1

2007 STTEPERS RECORDS

HIROSHI FUJIWARA

LOST HF MIX ROOM ENOUGH
FOR BIRDS TO FLY

2006 STAPLE DESIGN

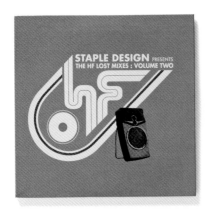

HIROSHI FUJIWARA

STAPLE DESIGN PRESENTS
LOST HF MIX VOLUME TWO

2007 STTEPERS RECORDS

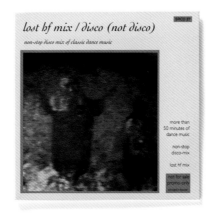

HIROSHI FUJIWARA

LOST HF MIX/DISCO (NOT DISCO)

2007 STTEPERS RECORDS

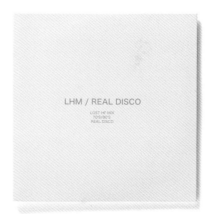

HIROSHI FUJIWARA

LOST HF MIX REAL DISCO

2007 STTEPERS RECORDS

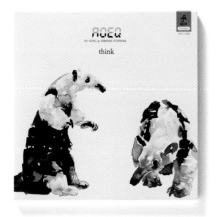

AOEQ

THINK

2011 SMAR

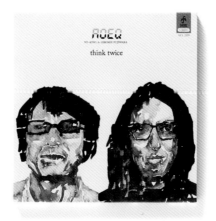

AOEQ

THINK TWICE

2011 SMAR

HIROSHI FUJIWARA

UP AHEAD

2012 SMALLER RECORDINGS

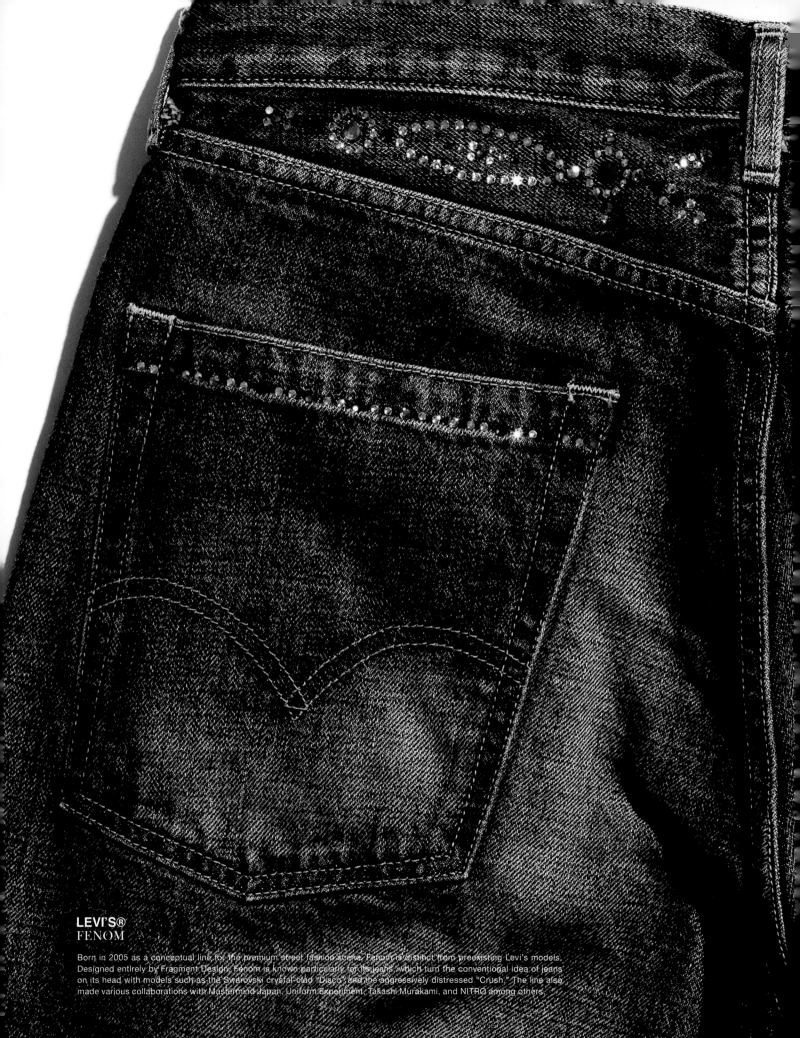

LEVI'S®
FENOM

Born in 2005 as a conceptual line for the premium street fashion scene, Fenom is distinct from preexisting Levi's models. Designed entirely by Fragment Design, Fenom is known particularly for its jeans, which turn the conventional idea of jeans on its head with models such as the Swarovski crystal-clad "Disco" and the aggressively distressed "Crush." The line also made various collaborations with Mastermind Japan, Uniform Experiment, Takashi Murakami, and NITRO among others.

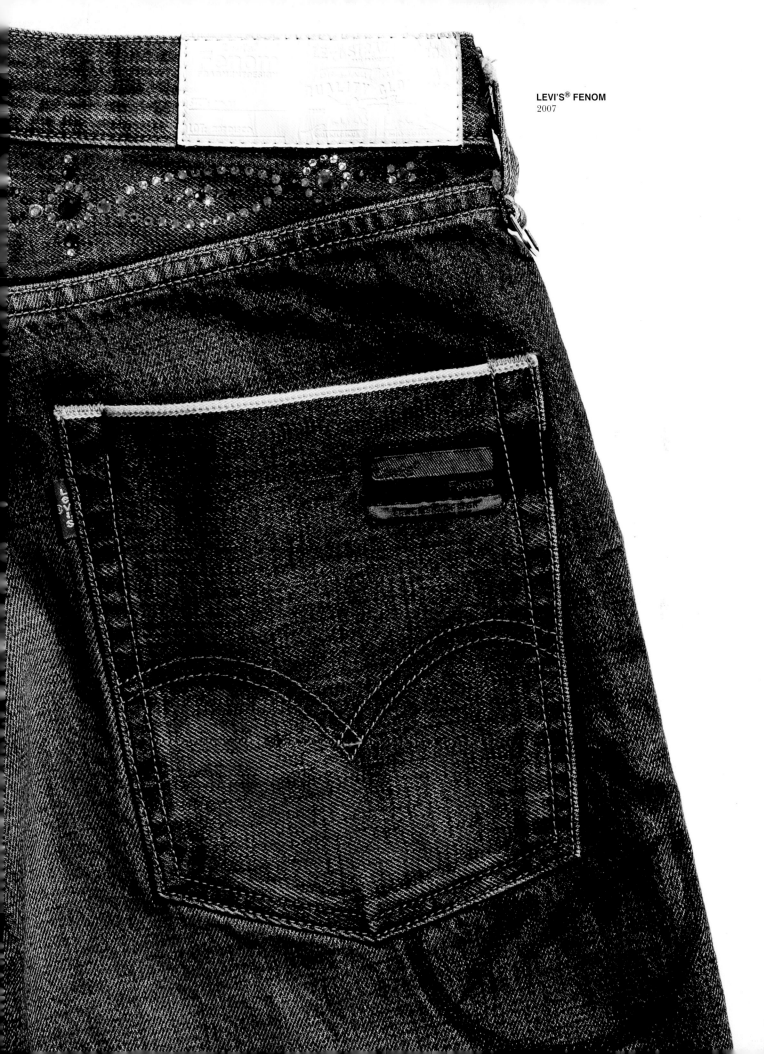

LEVI'S® FENOM
2007

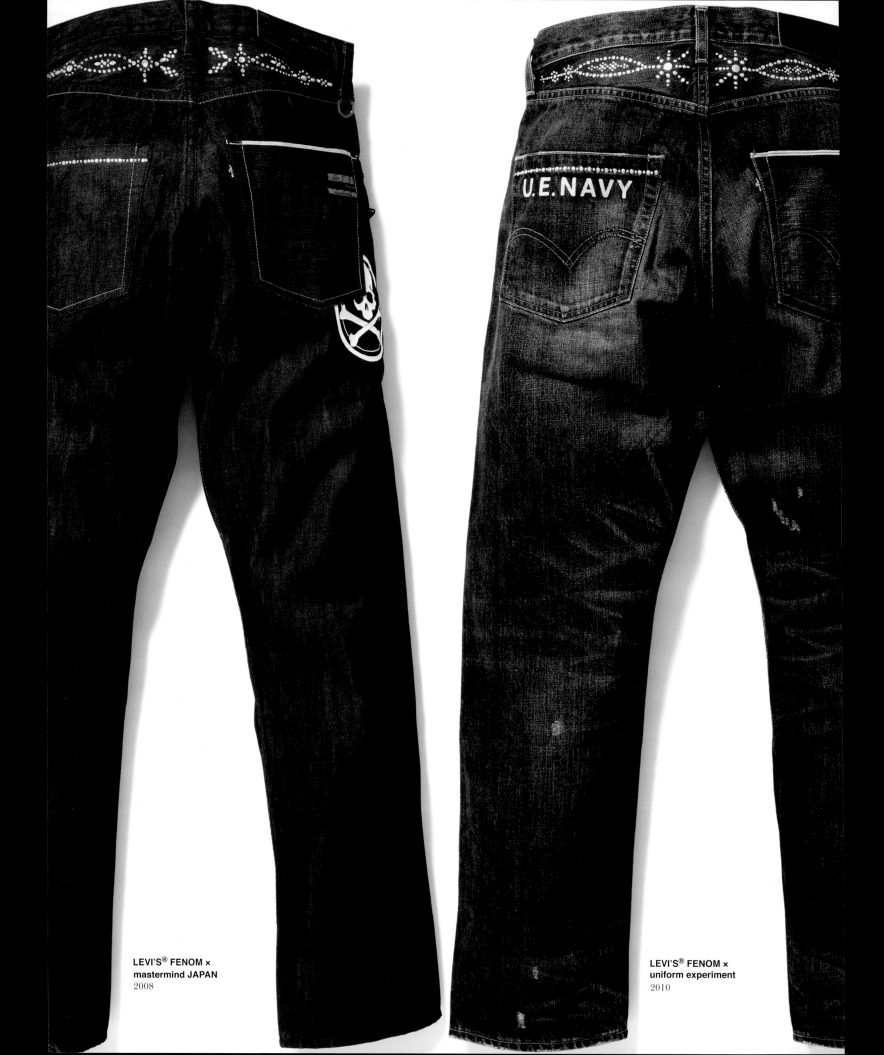

LEVI'S® FENOM ×
mastermind JAPAN
2008

LEVI'S® FENOM ×
uniform experiment
2010

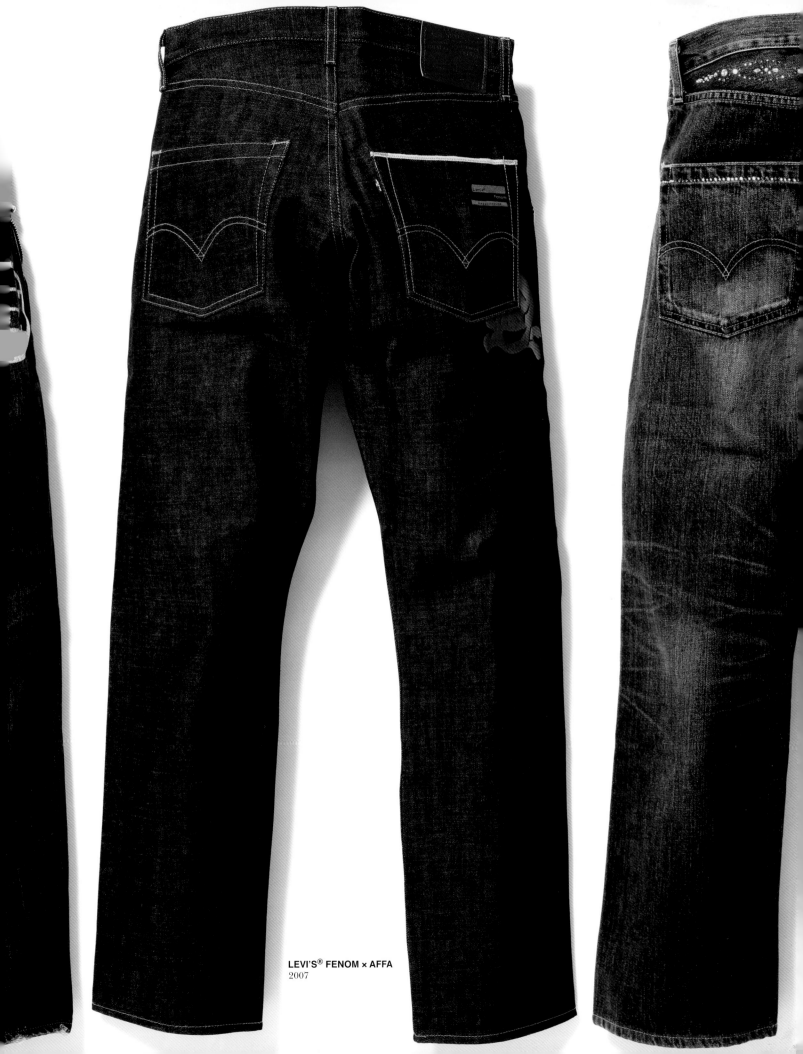

LEVI'S® FENOM × AFFA
2007

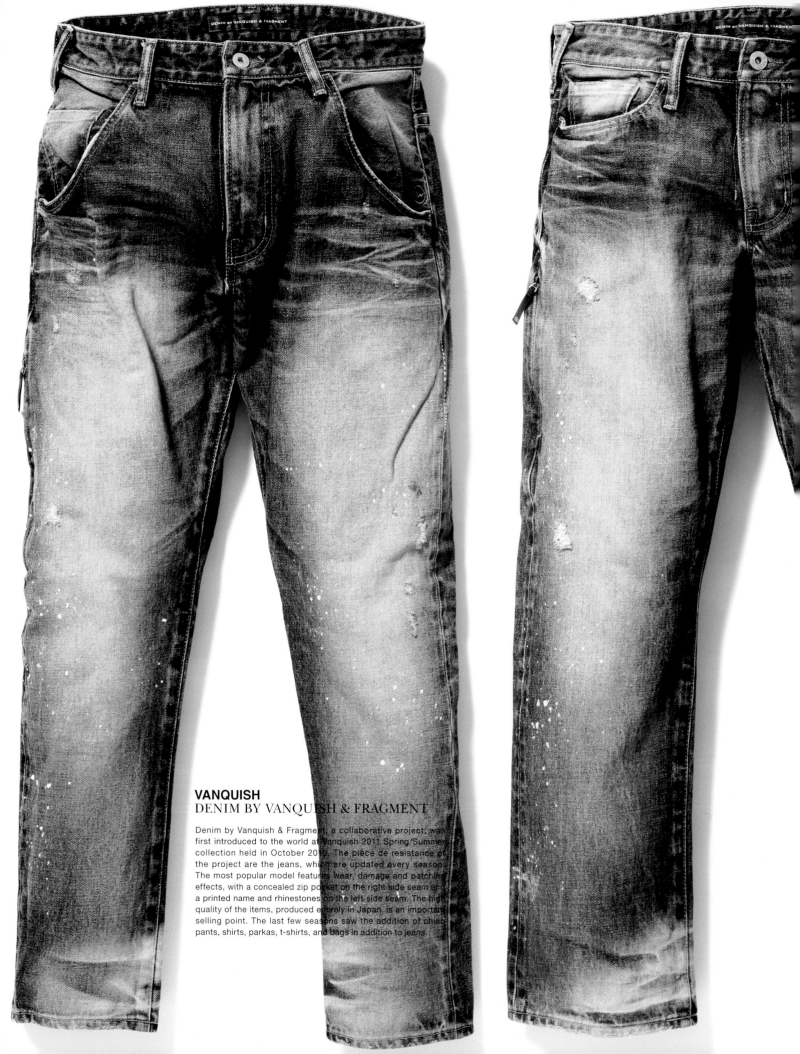

VANQUISH
DENIM BY VANQUISH & FRAGMENT

Denim by Vanquish & Fragment, a collaborative project, was
first introduced to the world at Vanquish 2011 Spring/Summer
collection held in October 2010. The piece de resistance of
the project are the jeans, which are updated every season.
The most popular model features wear, damage and patching
effects, with a concealed zip pocket on the right side seam and
a printed name and rhinestones on the left side seam. The high
quality of the items, produced entirely in Japan, is an important
selling point. The last few seasons saw the addition of chino
pants, shirts, parkas, t-shirts, and bags in addition to jeans.

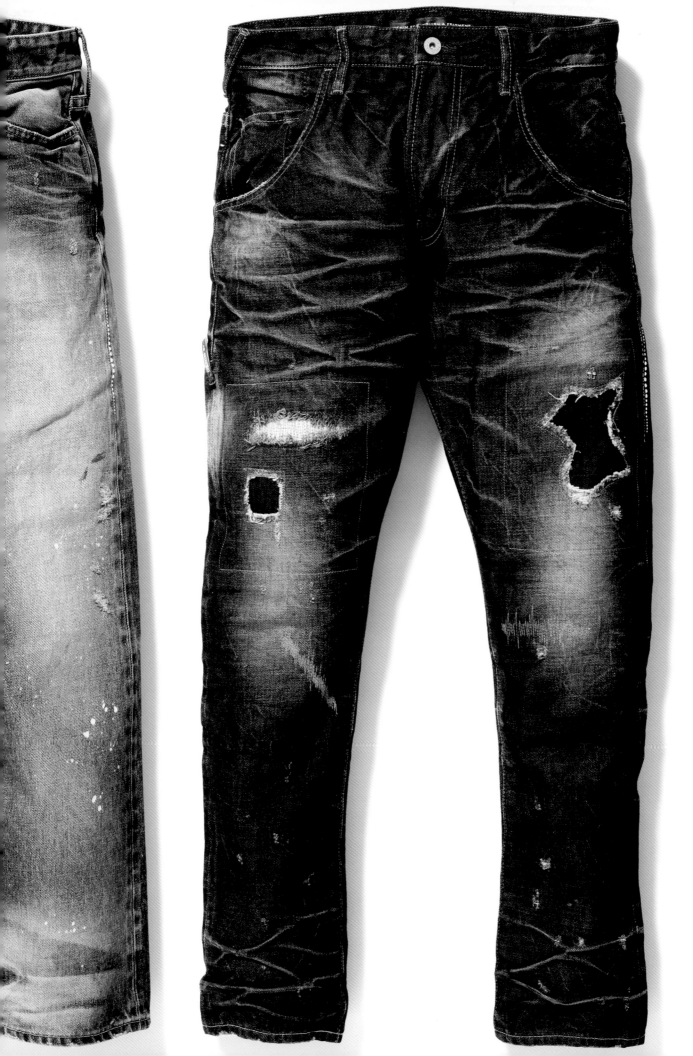

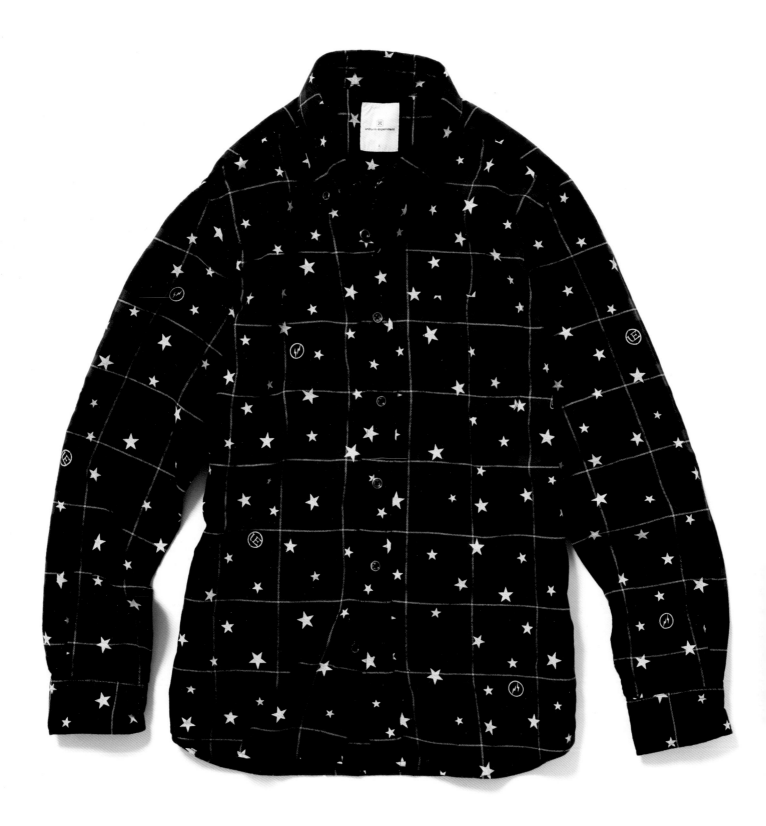

uniform experiment
STAR PRINT FLANNEL CHECK B.D SHIRT

Uniform experiment started with the 2008 Spring/Summer season. A line of experimental products by Fujiwara and SOPH.CO., LTD's Hirofumi Kiyonaga, uniform experiment explores creative ideas that open the door to a new era, as symbolized by its key icon. The image above shows the 2009 Fall/Winter season's cotton flannel shirt, covered entirely in the brand's logo and stars of various sizes. The UE star pattern shirt has also been incorporated into other seasons as well, and has since turned into one of the brand's signature designs.

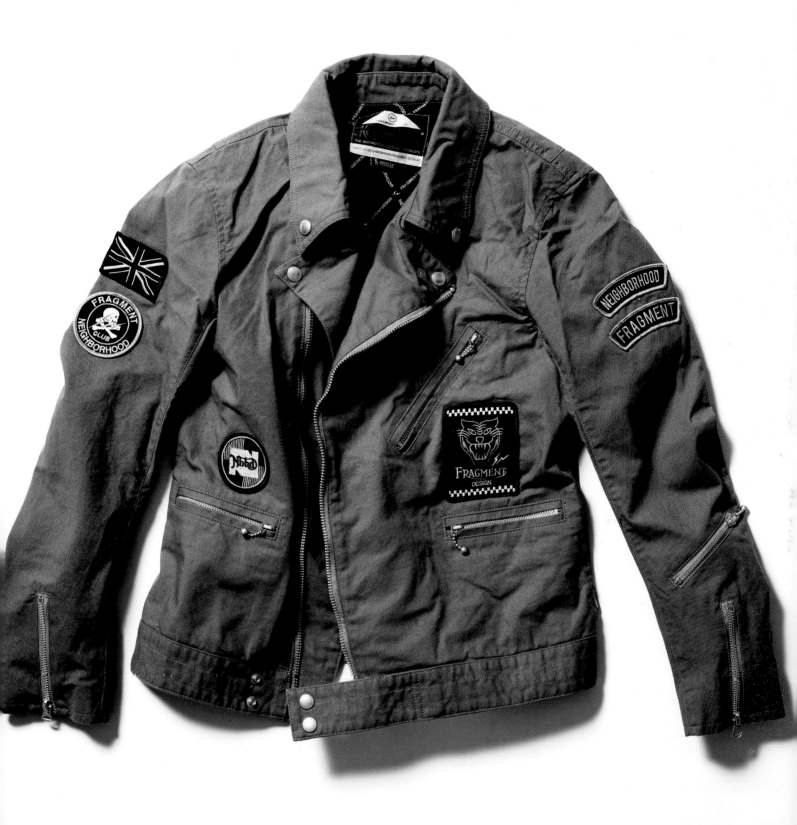

NEIGHBORHOOD
COTTON RIDERS JACKET

The cotton riders jacket by Neighborhood and Fragment Design was released as the first retail item of the year in 2010. The jacket reproduced the simple, beautiful silhouette of Lewis Leather's masterpiece Cyclone. Four zippered pockets with a ball and chain detail accents the front while the interior lining utilizes a special fabric printed with Neighborhood and Fragment Design trademarks. Patches adorn the body and arms. The jacket comes in black in addition to blue.

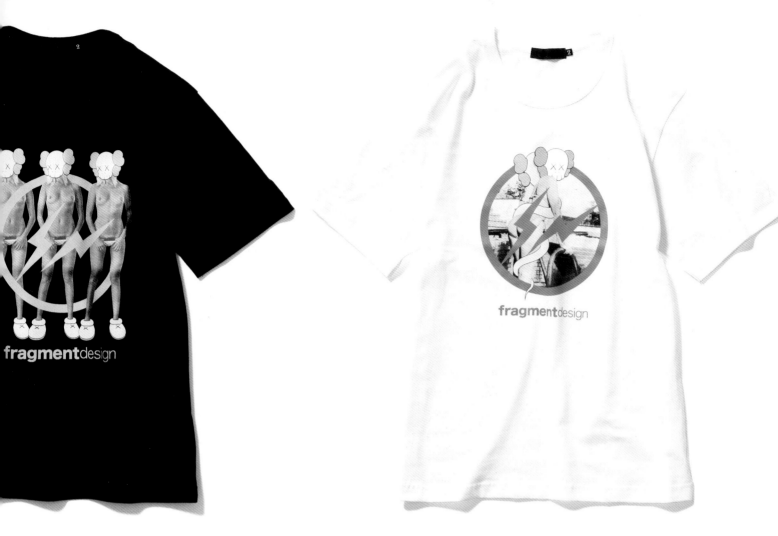

OriginalFake
OriginalFake × Fragment Design T-Shirt

OriginalFake, which aspires to take the fusion of art and fashion to the next level, features the artwork of the New York–based artist KAWS. This collaborative T-shirt from the 2012 Spring/Summer collection marked the sixth anniversary of the brand.

STUSSY
CHARITY T-SHIRT

STUSSY produced this collaborative t-shirt with Fragment Design's cooperation in the wake of the Great East Japan Earthquake on March 11, 2011. All proceeds from the sale of the t-shirt were donated to affected communities through the Japanese Red Cross.

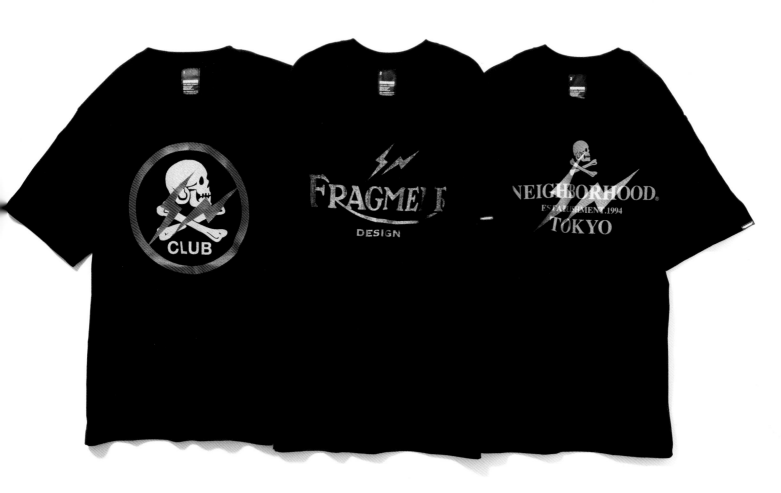

NEIGHBORHOOD
late 2000s T-shirts

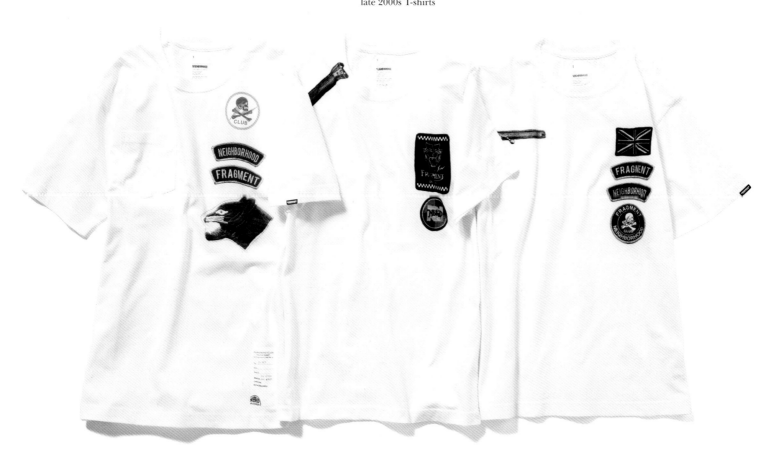

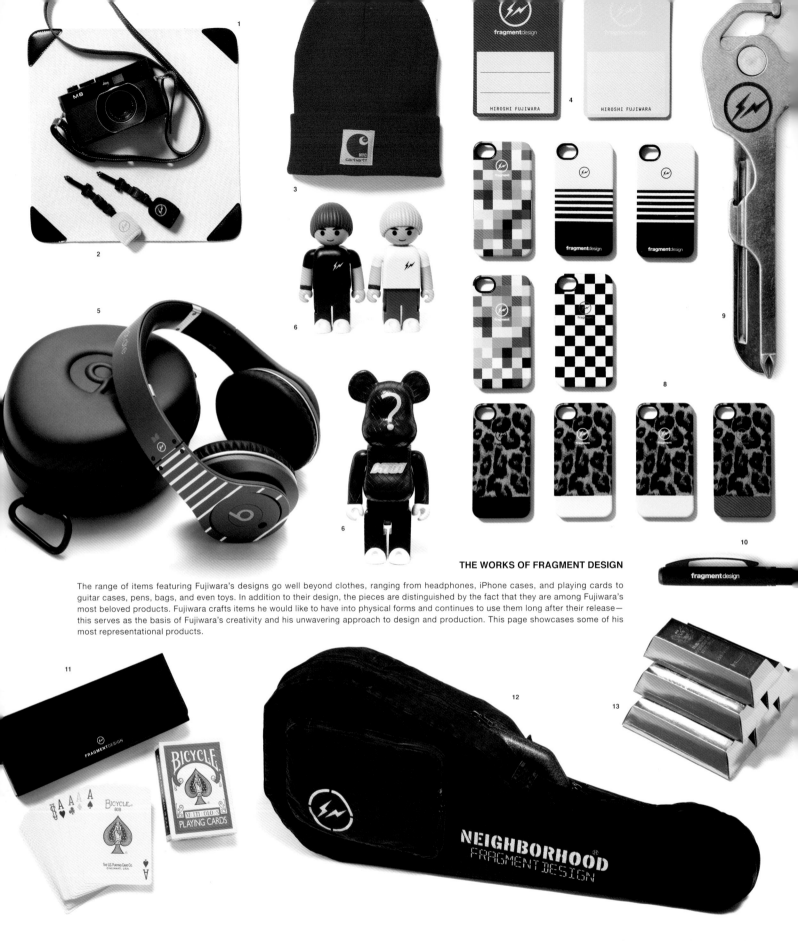

THE WORKS OF FRAGMENT DESIGN

The range of items featuring Fujiwara's designs go well beyond clothes, ranging from headphones, iPhone cases, and playing cards to guitar cases, pens, bags, and even toys. In addition to their design, the pieces are distinguished by the fact that they are among Fujiwara's most beloved products. Fujiwara crafts items he would like to have into physical forms and continues to use them long after their release—this serves as the basis of Fujiwara's creativity and his unwavering approach to design and production. This page showcases some of his most representational products.

1_FRAGMENT DESIGN late 2000s Tech-Wrap,　**2_FRAGMENT DESIGN** late 2000s Tech-Wiper,　**3_CARHARTT** early 2010s Beanie,　**4_FRAGMENT DESIGN** late 2000s Business Card,　**5_BEATS BY DR.DRE** early 2010s Headphone,　**6_MEDICOM TOY** early 2000s　BABEKUB HF [BLACK/WHITE Ver.],　**7_MEDICOM TOY** early 2000s　BE@RBRICK HF,　**8_UNCOMMON** early 2010s iPhone Case,　**9_SWISS TECH** mid 2000s Utili-Key,　**10_PILOT** late 2000s FRIXION 2,　**11_BICYCLE** late 2000s Machiavelli Starter Set,　**12_NEIGHBORHOOD** early 2010s Guitar Case,　**13_uniform experiment** early 2010s SOPH. Hong Kong Opening T-Shirt

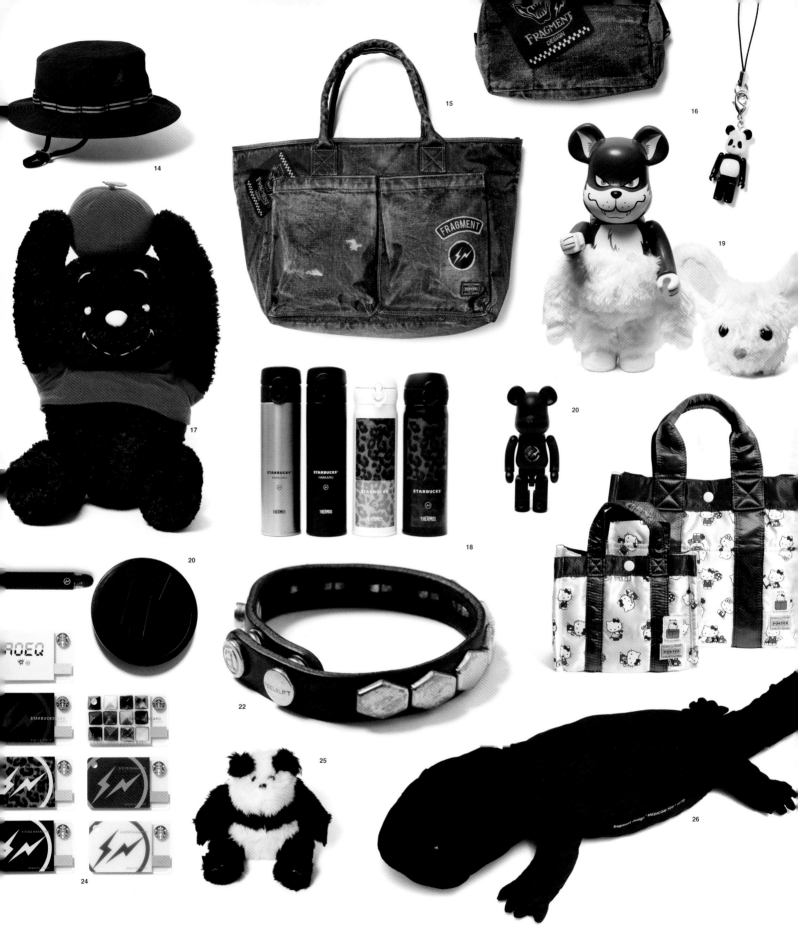

14_KANGOL early 2010s Jungle Hat, 15_HEAD PORTER early 2010s Denim Print Series, 16_MEDICOM TOY early 2010s BE@RBRICK fragmentdesign PANDA 50%, 17_MEDICOM TOY late 2000s Plush Winnie the Pooh(HF version), 18_STARBUCKS COFFEE early 2010s STARBUCKS Coffee Stainless Bottle, 19_MEDICOM TOY early 2010s BE@RBRICK WORLD WIDE TOUR fragmentdesign 400%, 20_MEDICOM TOY early 2010s CHOGOKIN BE@RBRICK fragmentdesign, 21_GALLERY1950 early 2010s Non-slip Mat, 22_ASSEMBLE x PEEL&LIFT early 2010s Small Hex Wristband, 23_HEAD PORTER x HELLO KITTY mid 2000s Kitty Ex. Tote Bag, 24_STARBUCKS COFFEE early 2010s Starbucks Card, 25_BOUNTY HUNTER early 2010s Stuffed Panda, 26_MEDICOM TOY early 2010s Plush Andrias japonicus

SUPREME
BIKE CHAIN

Fragment Design and Supreme created this exclusive bike chain in 2007. While most bike chains are thick and heavy by nature, this model has been updated into a light and smart style at Fujiwara's direction. The colored chain is surprisingly light and is cast in rust resistant aluminum. The product also features a catchy design of the two brands' respective logos. Offered in three colors of black, blue, and red.

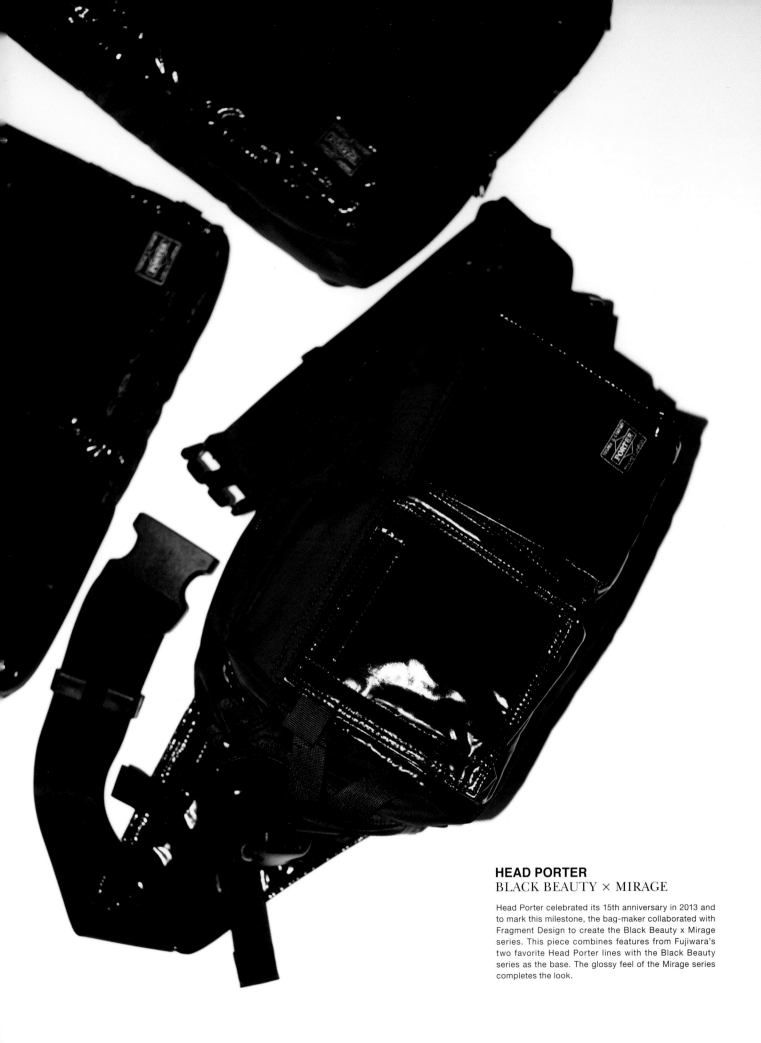

HEAD PORTER
BLACK BEAUTY × MIRAGE

Head Porter celebrated its 15th anniversary in 2013 and
to mark this milestone, the bag-maker collaborated with
Fragment Design to create the Black Beauty x Mirage
series. This piece combines features from Fujiwara's
two favorite Head Porter lines with the Black Beauty
series as the base. The glossy feel of the Mirage series
completes the look.

retaW
FRAGRANCE ROOM TAG

Tokyo-based lifestyle label retaW offers "a lifestyle enveloped by fragrance." Founded in 2008, retaW began developing a line of new products: "fragrances you can wear." 2011 saw the release of Fragrance Room Tag, which is shaped like a "Do Not Disturb" sign. The thick cardboard sheet has been treated with retaW's [...] perfume and can be readily hung in other places besides a door handle from towel hangers to closets.

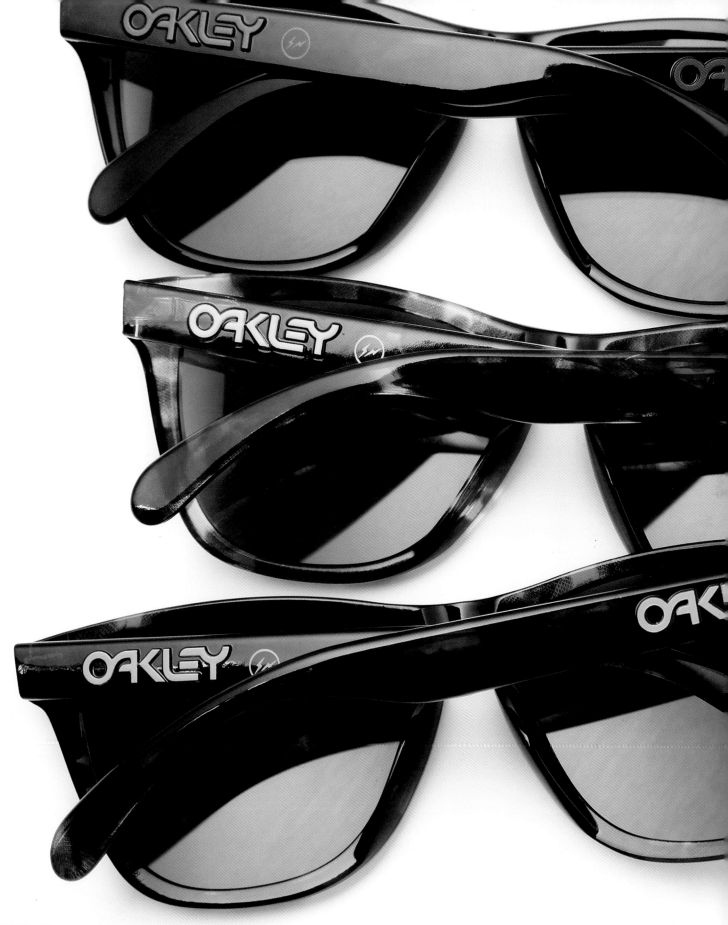

OAKLEY
FROGSKINS

This special model by Fragment Design and Oakley was released in 2011. While the model was discontinued once after its release back in 1985, the latest adaptation is based on the masterpiece Frogskin, which was first reissued in 2007. With a tortoiseshell frame, the model features the Oakley and Fragment Design brand logos on the left exterior temple. A discreet Fragment Design logo is also printed on the upper left lens. The accompanying original case is also designed with the signature thunder mark.

Personal Effects

Eric Clapton

(with Issey Enomoto)

I think he's a passionate man, an extreme intellectual, and very shy…
Once, I saw Hiroshi and Katsu [Katsuyuki Yoshida] of Porter acting like kids together
and having a good time and that toppled my first impression of him: serious.
Now, I think Hiroshi is crazy. But then again, I'm crazy too.
—Eric Clapton

Personal Effects

Eric Clapton and Hiroshi Fujiwara: the god of guitar and the charisma of Ura-Harajuku. From an outsider's point of view, they make an unlikely combination. Nevertheless, what could be more inspiring than two people from different generations and nationalities forging a friendship built on mutual respect? This is all the more true when the pair consists of two people who have mastered the art of growing older with incomparable grace.

Fashion is the key word that first brought Clapton and Fujiwara together. Back in 1999 or so, Clapton happened upon a store in London that sold one of the fashion brands that Fujiwara had produced. Clapton took home one of the pieces, and found himself thoroughly impressed by it. Curious to know more about the individual behind the name Hiroshi Fujiwara, he took the initiative and gave him a call during his next trip to Japan.

When looking back on their initial encounter, Fujiwara admits that he would not have described himself as a die-hard fan of Eric Clapton back then. Yet perhaps it was his down-to-earth demeanor that Clapton naturally sympathized with. The two immediately hit it off, and since then they have remained good friends. Whenever they are together, their conversations (in English of course) span the worlds of fashion, art, cars, and guitars—the sundry topics of their mutual interests.

While they may seem to work in completely different fields, they share a commonality in music. Fujiwara was a former DJ and a musician in his own right who has composed songs for numerous artists. Clapton and Fujiwara's friendship has also resulted in a collaborative work. For Clapton's album Sessions For Robert J, released in January 2005, Fujiwara produced the companion DVD. Collaborations between two artists are common; yet theirs, borne of a mutual understanding of each other, is truly collaborative. It also marks Clapton's trust in Fujiwara's creativity.

It is no secret that Clapton, who has visited the country numerous times for concerts, is a Japanophile. But perhaps Fujiwara's presence served as a catalyst in his growing interest in its culture. For instance, thanks to the influence of Fujiwara, a Japanese mixed martial arts aficionado, Clapton has also turned into a fan. Since then, Japanese fans have occasionally been privy to sights of Clapton and Fujiwara sitting ringside at PRIDE Fighting Championships.

Theirs is a friendship that symbolizes a simple truth that a man of unfaltering style is never without a friend of equal distinction.

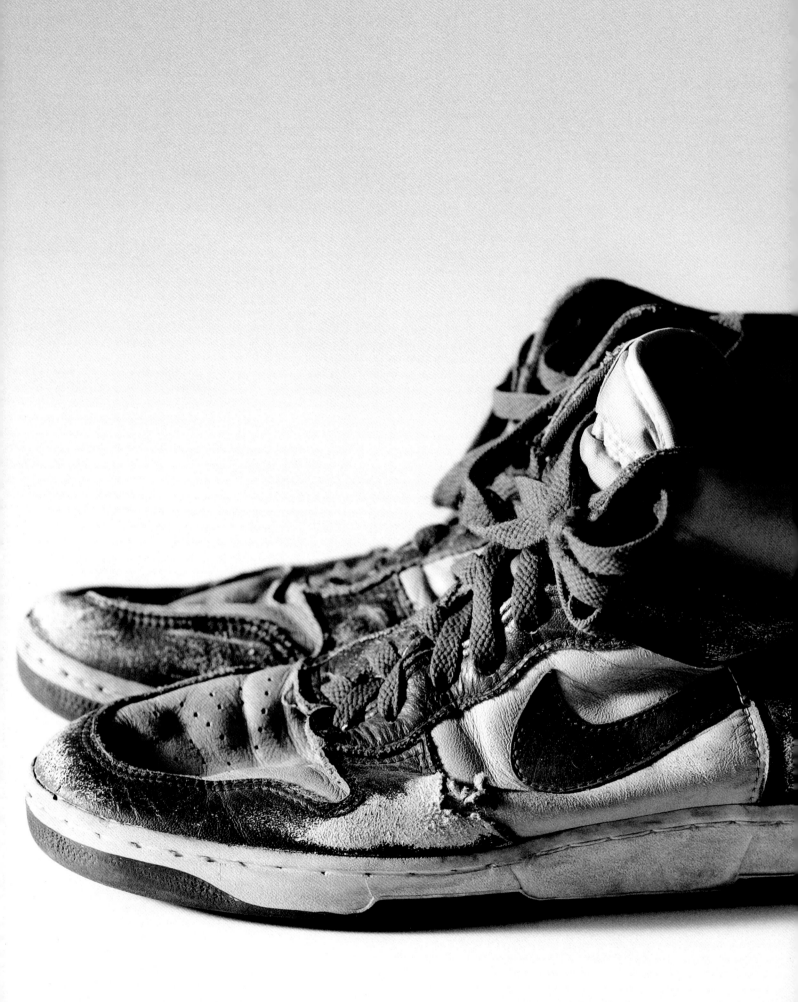

NIKE
DUNK

Nike released Dunk in 1985. I started wearing them in the late 80s after discovering new colorways in a sporting goods store in Korea—like this navy/yellow pair—that I had never seen before in Japan. At first I thought it was a peculiarly colored Air Jordan 1, and only learned that it was a model called Dunk later on. I remember very well how when I happened upon them in Korea, I purchased around twenty to thirty pairs as souvenirs and gave them out as presents to friends. I used to wear a DUNK not for basketball but skateboarding. Like the Air Jordan 1, Dunk has a comparatively thin midsole which enables you to attain just the right amount of contact with the ground. This is why it was the perfect shoe for skateboarding. In addition to this navy/yellow pair, I also had them in other colorways such as white/orange and red/gray. I believe I continued to wear Dunk for skateboarding right up to the first half of the 1990s.

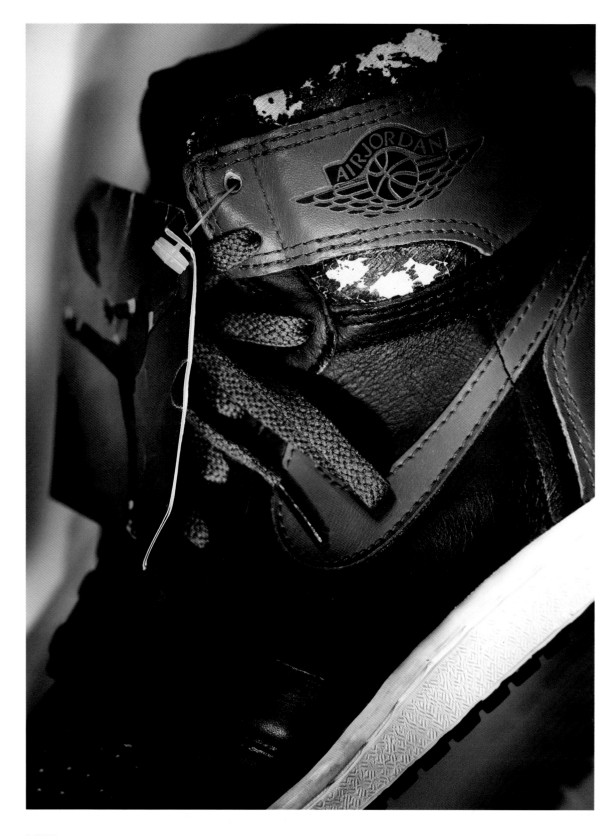

NIKE
AIR JORDAN 1

Michael Jordan's signature model was born in 1985. I learned about Air Jordan 1 for the first time when I saw skaters overseas wearing them. In the 1980s, my good friend Skatething knew a lot about the shoe through videos and other media, and shared what he had learned with me. By the way, he used to wear a differently colored Air Jordan 1 on each foot. The first pair I purchased was in red/black. LL Cool J wore the same ones and I thought they looked really cool. Back then I had a strong image of LL Cool J being all about Nike while Run-DMC was about Adidas. I purchased this blue/black pair a little later after its release. I think I bought it at BEAMS. I used to wear Air Jordan 1s while skateboarding, but it's not as if I was not interested in Michael Jordan—far from it. I loved basketball so I watched NBA games whenever he was playing. I still love this particular model and wear the revamped version every so often.

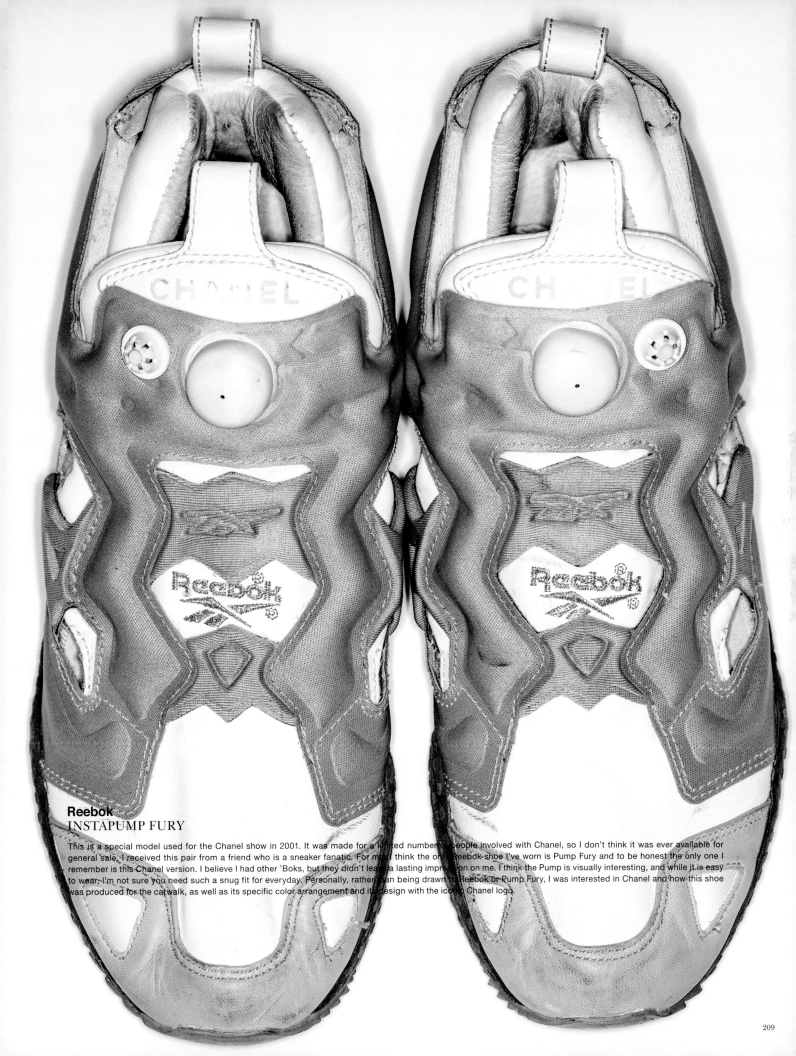

Reebok
INSTAPUMP FURY

This is a special model used for the Chanel show in 2001. It was made for a limited number of people involved with Chanel, so I don't think it was ever available for general sale. I received this pair from a friend who is a sneaker fanatic. For me, I think the only Reebok shoe I've worn is Pump Fury and to be honest the only one I remember is this Chanel version. I believe I had other 'Boks, but they didn't leave a lasting impression on me. I think the Pump is visually interesting, and while it is easy to wear, I'm not sure you need such a snug fit for everyday. Personally, rather than being drawn to Reebok or Pump Fury, I was interested in Chanel and how this shoe was produced for the catwalk, as well as its specific color arrangement and its design with the iconic Chanel logo.

PANArt
HANG DRUM

The Hang Drum was made by the Swiss-based company PANArt. While it has a strange circular shape reminiscent of a U.F.O., it is a bona fide musical instrument. I learned about it through DETZ (Matsuda). When you hit the sunken holes with your hand, it makes a wondrous, colorful sound that is similar to that of the steel pan. It can produce eight or nine sounds, and depending on the model it has many different keys. The one shown in the spread is type G. I saw musicians playing this instrument in the streets, the subway passageways, and outdoor festivals whenever I went to Europe. This is one of the instruments I'm considering using for my next recording session.

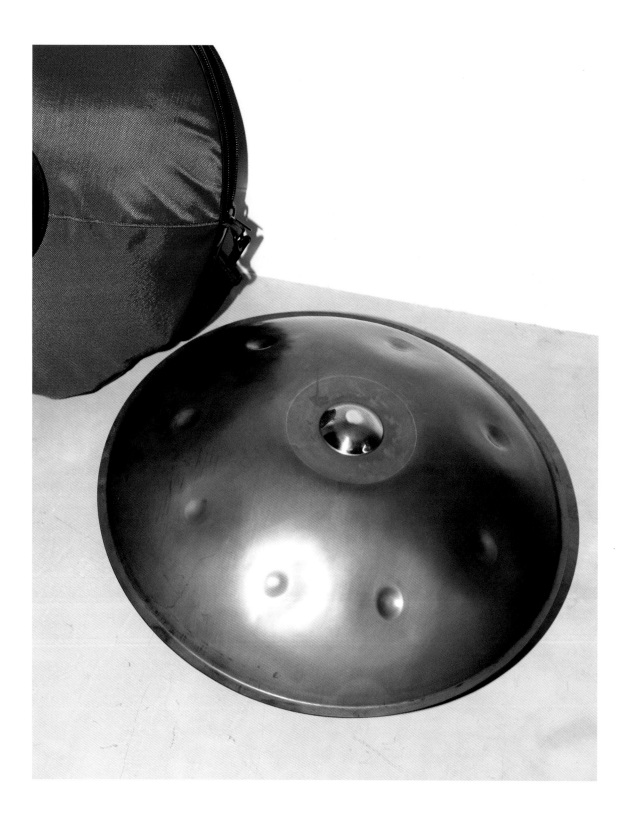

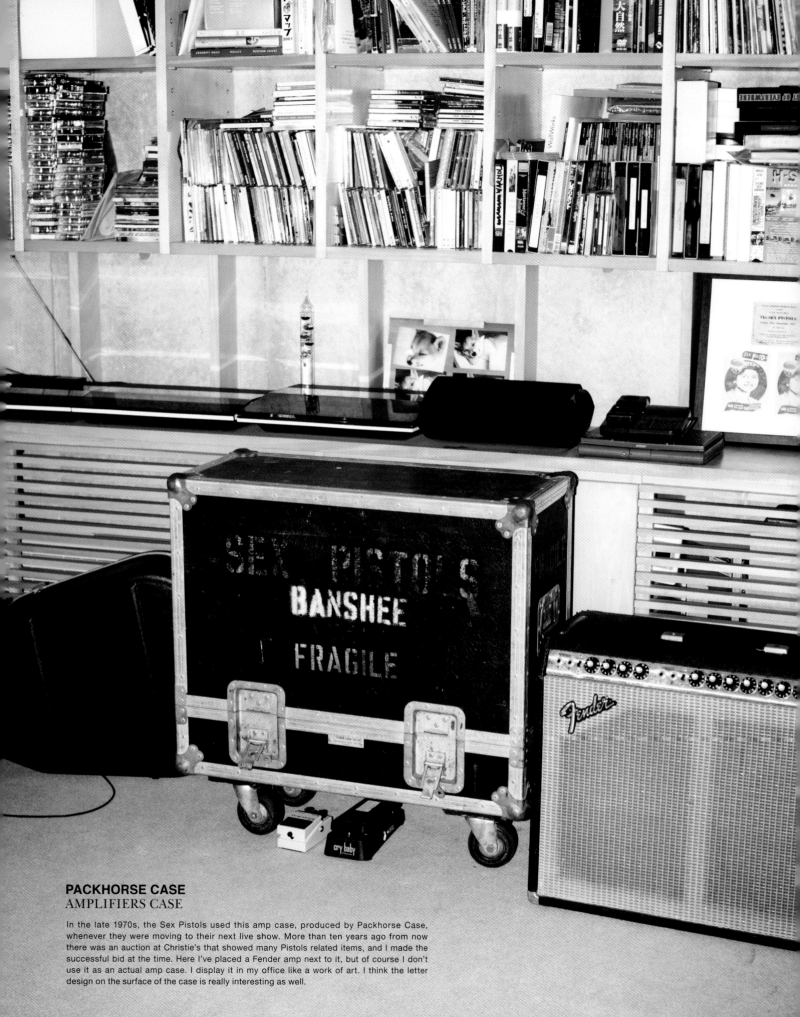

PACKHORSE CASE
AMPLIFIERS CASE

In the late 1970s, the Sex Pistols used this amp case, produced by Packhorse Case, whenever they were moving to their next live show. More than ten years ago from now there was an auction at Christie's that showed many Pistols related items, and I made the successful bid at the time. Here I've placed a Fender amp next to it, but of course I don't use it as an actual amp case. I display it in my office like a work of art. I think the letter design on the surface of the case is really interesting as well.

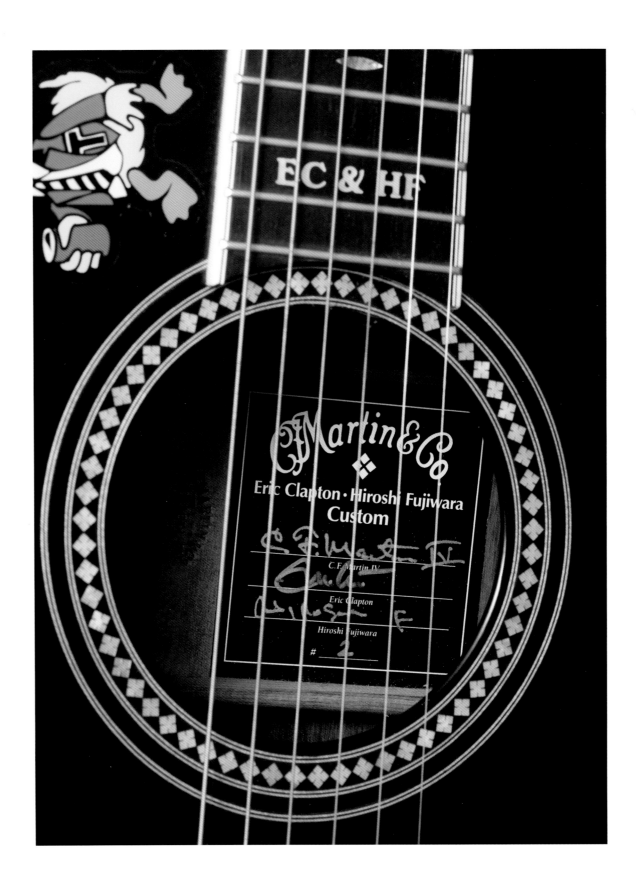

C.F. Martin & Co., Inc.
000-28 ECHF

This acoustic guitar was born in Los Angeles when I asked Eric Clapton, "Would it be possible to create a black guitar that's nothing like what we've seen before?" He spoke with Martin & Co. and made it happen. Since we produced them as gifts for ourselves as well as people who help us out every day, we made only seven guitars at first. Later on, the model was released with the official name Bellezza Nera from Martin. The one I own has the letters EC&HF on the fretboard, but the general version has a Mother of Pearl inlay that reads Belleza Nera. We made the white version in 2006 and released it under the name Belleza Bianca. The navy version came later. We had actually ordered it two years ago but because we've had to ask that it be redone when its first sample came back with a color similar to Hollywood Blue, it wasn't finished until last year. I coordinate the color of the guitar depending on my mood and what I'm wearing.

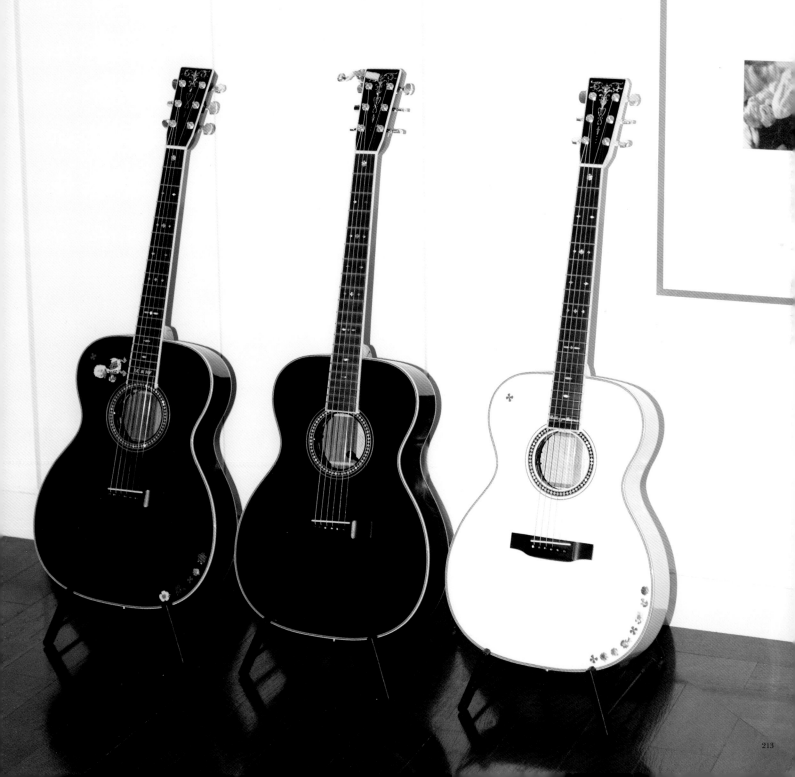

C.F. Martin & Co., Inc. / Gibson
O-18E, SJ-200, SJ-100

These are all vintage guitars. The one shown on the left is the 0-18E model by Martin. In the 1990s, I saw Nirvana's "MTV Unplugged in New York" for the first time and Kurt Cobain had a guitar with knobs for pickup, volume, and tone control and that was Martin's D-18E model. Since then, I began looking for Martin's acoustic guitars whose name had the letter "E" for electric after the number and purchased a few of them. One of them was this 0-18E. I believe this model is one of a kind model that someone had custom made. The middle and the right are both by Gibson. The middle is the SJ-200 model. The SJ-200, which began to be produced in 1937, was called the "King of the Flat-Tops" and is considered the finest guitar of the Gibson models. I love the large shape of this SJ (Super Jumbo) series and have a number of them, but the 1938 model shown here is my favorite. Not only does it look great, it produces a deep, exquisite sound. Gibson's prewar models are hard to come by and I've been checking them out for two decades. This is a model I found in the U.S. and I finally happened upon it after searching for it for about ten years. The one on the right is the SJ-100, a simplified version of the SJ-200. This was also produced around 1938. The sounds of vintage guitars differ according to their generation even if they share the same model number—each of them truly happens once in a lifetime. This is why I love them and is the reason why to this day I continue to check out websites looking for something interesting.

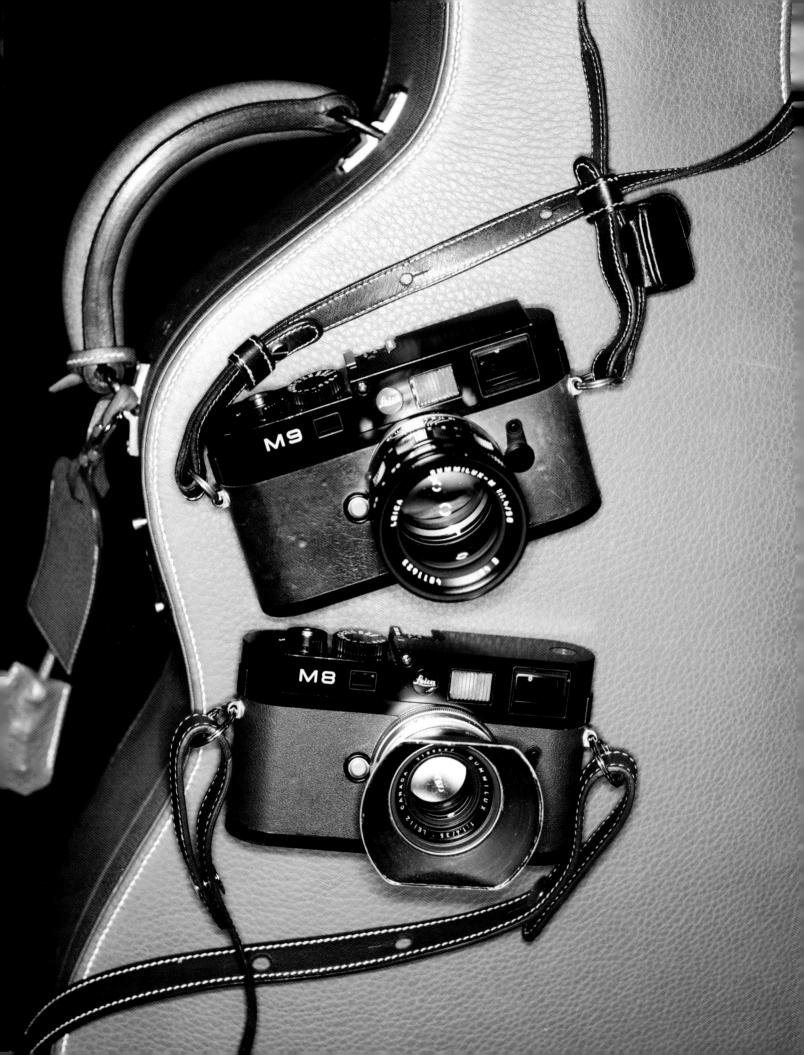

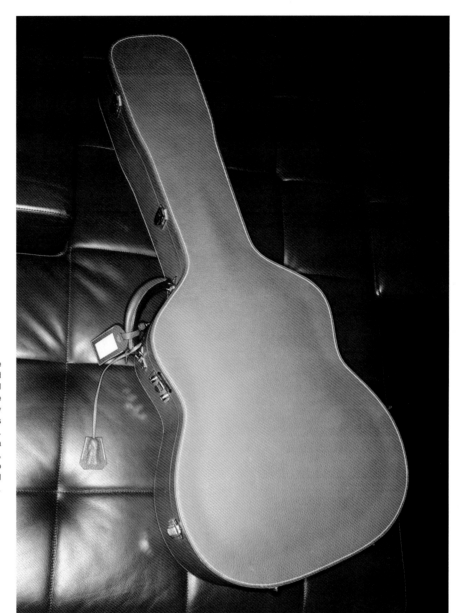

Hermès
Guitar Case

I'm not that particular about guitar cases but I made this model when I went to Hermès with a friend and he invited me to order a guitar case together. I ordered it in 2002, and the friend presented it to me for Christmas in 2003. The case is made specifically for the size of Martin's 000 (triple O) series, and is capped off with Hermès' brand of sophistication. Rather than just a guitar case, it is crafted as a solid bag. The interior, lined with a blue silk velvet, screams luxury, and the clasp on the case also features the Hermès mark. Since the guitar cases I have at home are all old, this one is a clear stand out.

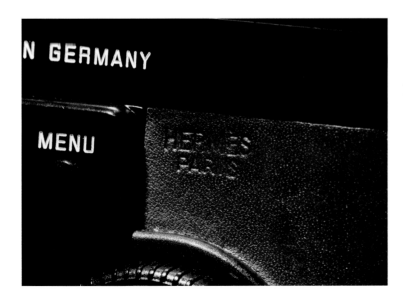

LEICA
M8, M9

The M8 is the first digital camera in Leica's renowned rangefinder M series. The crucial difference from the typical digital camera is that almost all functions of the M8, including exposure and focus setting, are done manually. However, there is no need for difficult maneuvering; it is rather fun to try out the string of functions available. There are plenty of lens options and swapping them changes the layout and the texture of the image entirely, which is another reason to love Leica. I have the M8 and the M9, but I mostly use the M9 these days. Moreover, I've asked Hermès to customize all leather parts, including the straps. In addition to the refined surface texture, I also love the subtle seal of the Hermès logo. The strap for the M9 comes with a case just for the viewfinder. Of course, the rangefinder series requires the user to focus manually. Since there are no auto focus functionality seen in compact cameras and single-lens reflex cameras, it helps to have a viewfinder that can display a magnified finder image. I use the 1.4X model.

The trunk was a present from my friend Kim Jones back when he was the designer for Dunhill. Offered in three sizes they lend themselves to a variety of uses, but I was drawn to the beauty of the silver color and have taken to stacking them in lieu of displaying a work of art. The lamp is the same one the Italian lighting manufacturer FLOS presented at the 2009 Salone Milan. Designed by Phillippe Starck and equipped with crystal from Baccarat and LED display by the artist Jenny Holzer, it is a unique, luminous collaboration. I was not drawn to the piece because it involves Starck and Baccarat. I was rather intrigued by the work of Jenny Holzer. I have always liked her work and chose this lamp because I found the moving LED message quite beautiful.

dunhill
Trunk

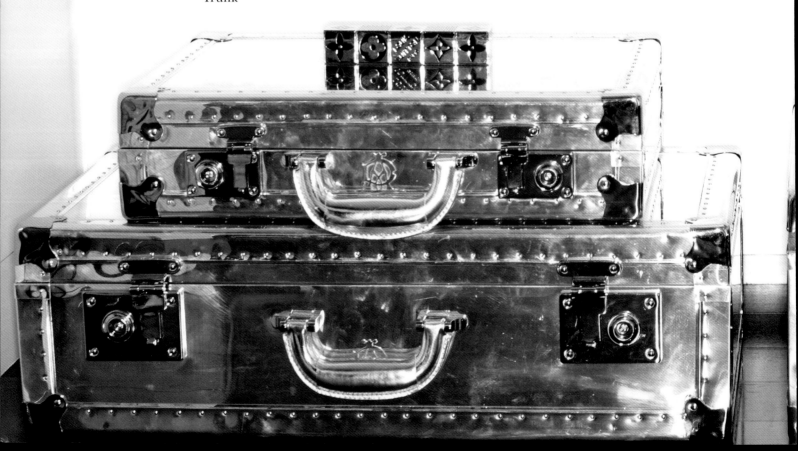

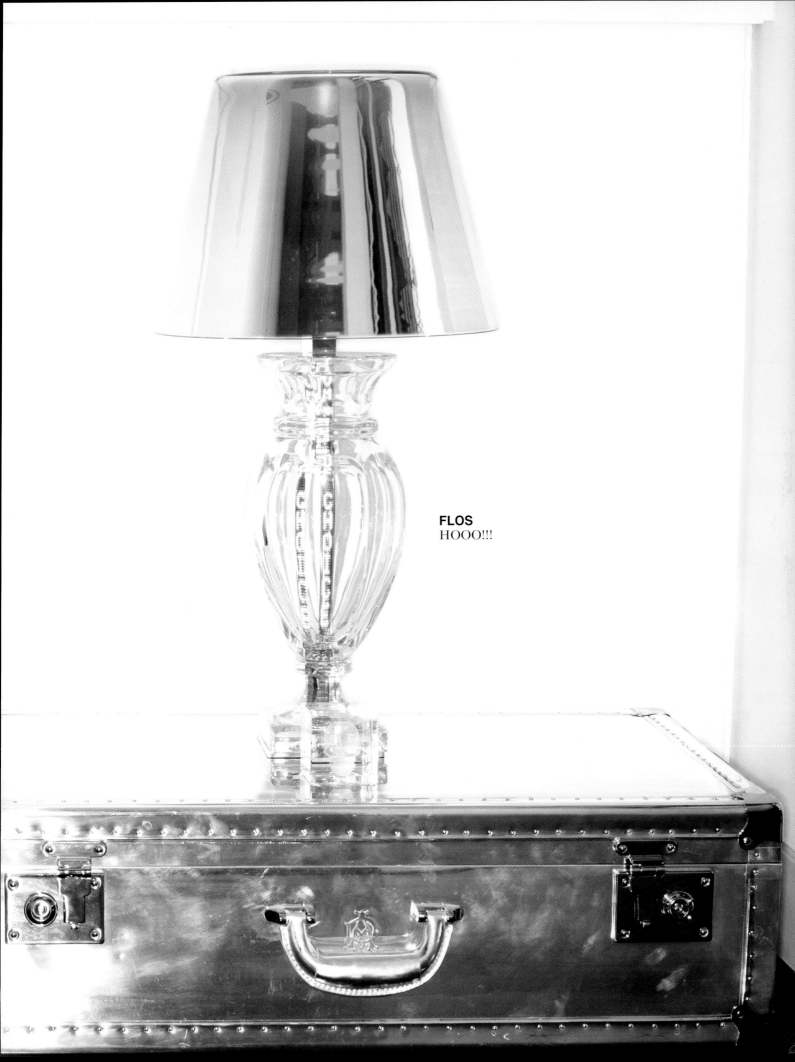

FLOS
HOOO!!!

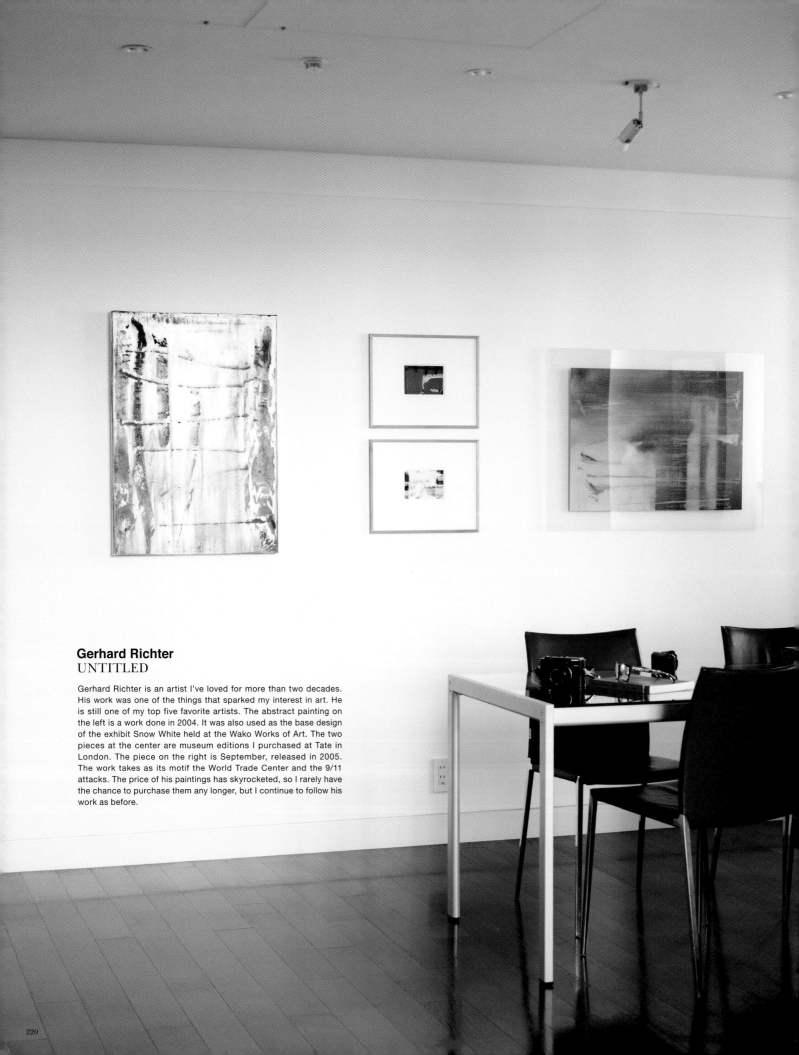

Gerhard Richter
UNTITLED

Gerhard Richter is an artist I've loved for more than two decades.
His work was one of the things that sparked my interest in art. He
is still one of my top five favorite artists. The abstract painting on
the left is a work done in 2004. It was also used as the base design
of the exhibit Snow White held at the Wako Works of Art. The two
pieces at the center are museum editions I purchased at Tate in
London. The piece on the right is September, released in 2005.
The work takes as its motif the World Trade Center and the 9/11
attacks. The price of his paintings has skyrocketed, so I rarely have
the chance to purchase them any longer, but I continue to follow his
work as before.

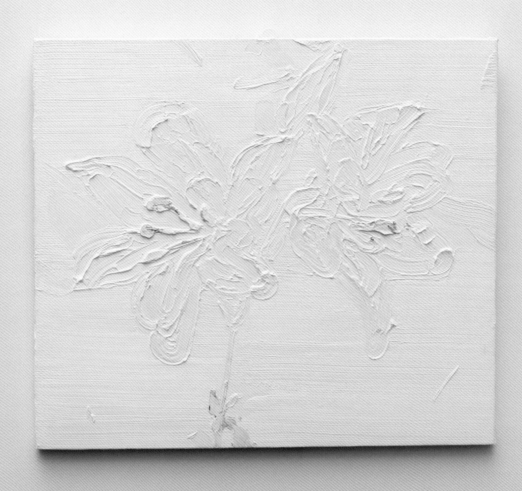

Marefumi Komura
UNTITLED

This work is by the artist Marefumi Komura, who was born in 1977. I encountered his work for the first time in 2006 when I participated in Takashi Murakami's GEISAI #10 as a guest judge. I was mesmerized by his portraits, which feel similar to abstract works that I tend to love. In the end, we awarded him with the Special Jury Prize (Hiroshi Fujiwara Prize). I have several of Mr. Komura's works, but I chose to display this particular one, with its floral motif, at home. I purchased this piece when I went to his exhibit that opened last year. I feel a sense of fragility from his paintings somehow. I think he is very successful at expressing the beauty within the fragility from his own unique perspective. I am also intrigued by his selection of motif. I am endlessly curious about what kind of work he will tackle next.

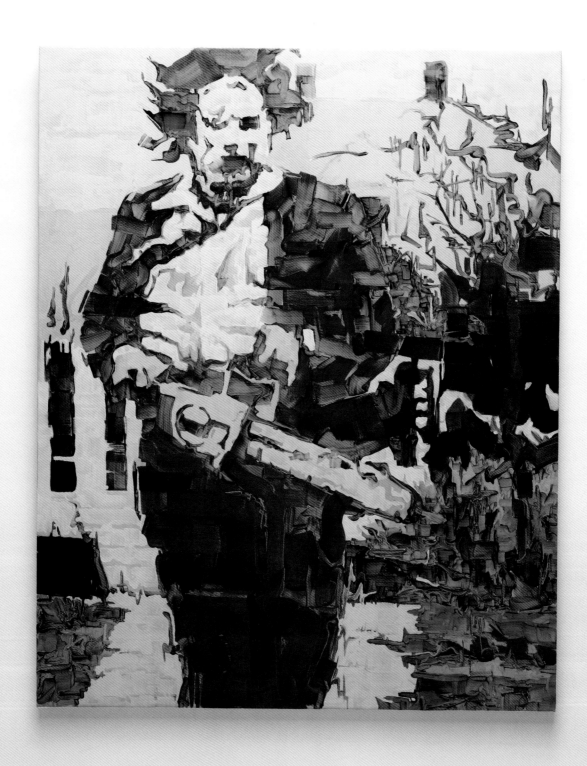

TAKESHI MASADA
UNTITLED

Six or seven years ago, when I attended the Wako Works of Art to see a different artist, I saw a flyer for Masada's exhibition and was immediately drawn to his work. His pieces showcase a very detailed brushwork, and his avant-garde ideas are part of the appeal. I would describe him as a cross between a graffiti artist and an art university graduate. Artists typically lean one way or another, so he is an important rarity. Mr. Masada has also drawn the cover art of AOEQ's album released in 2011, and we've also had him draw the floral motif painting for the interior of the Head Porter store.

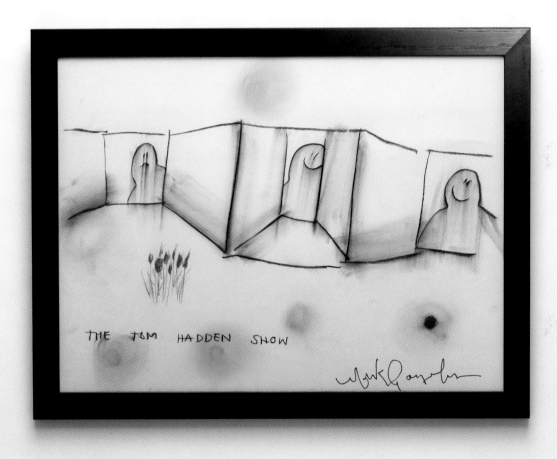

THE TOM HADDEN SHOW

MARK GONZALES
UNTITLED

Mark Gonzales is an artist and poet who hails from Los Angeles, California, and he is the most famous professional skateboarder in history. I've always loved his work and own a number of it, but this one, which I attained about 15 years ago, is my all-time favorite. I think it would not be an exaggeration to say that the vibrant use of crayons, painting, and markers is an expressive methodology that is uniquely Mark. There are clothes from SUPREME that feature his drawing as well, and I cannot help but like each one of them.

goro's
Deerskin Bag

Goro's is a store specializing in accessories and leather crafts helmed by Goro Takahashi. It hardly needs to be said that Goro's is also Japan's most iconic silver jewelry brand. I've used this deerskin bag for close to thirty years, but to me it never goes out of style. I predict this is an item that will be with me all my life. At the time of purchase it was much more simple, but I've added on the silver conch and feather details as I frequented Goro-san's store since then. During the 1980s I threw everything into this bag—including analog records—and strolled around Harajuku and Shibuya. Speaking of leather goods, aside from Goro's I also liked using products by World's End as well.

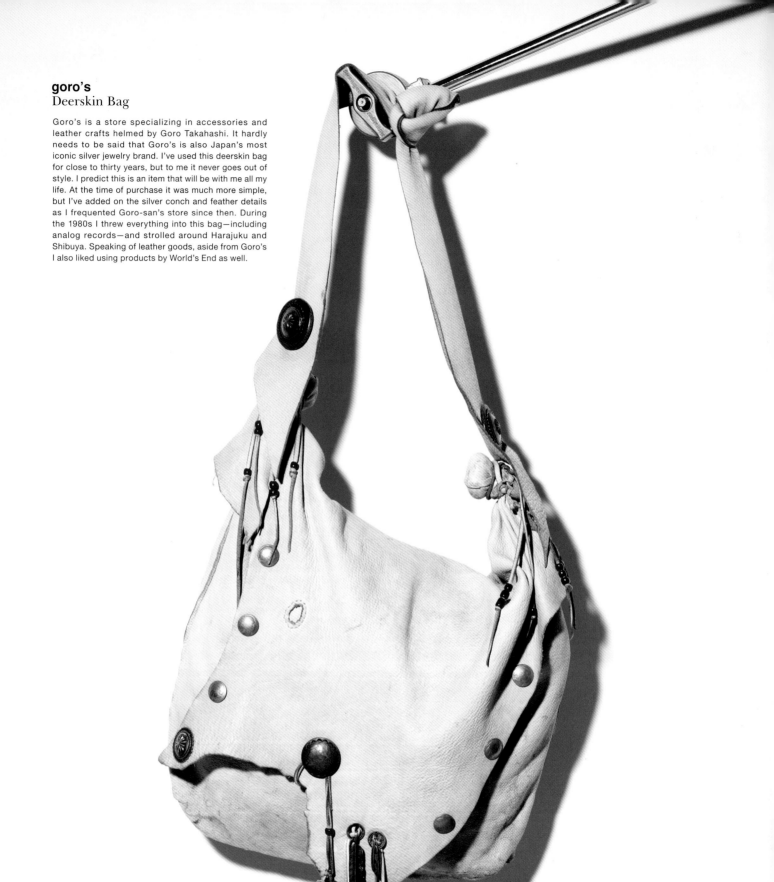

GOYARD
Saint Louis

Goyard is a French malletier with a 150-year history. It is known for its unique herringbone print travel bags. This tote bag, called the Saint Louis, saw its collaborative model with Mastermind and it was very easy to use. The original coated canvas fabric was durable yet light, and it was so pliable that it could be folded. The interior featured a simple design with no separation. The slightly larger size was just right and the wide gusset increased its capacity. The length of the handle, which can be hung on the shoulder, is just right. It is a daily use bag that you can throw things in freely, like a wallet. I spray painted my bag as shown in this spread. I don't know why I wanted to paint them, but once I started this was the unexpected design I came up with, so I tried painting a few.

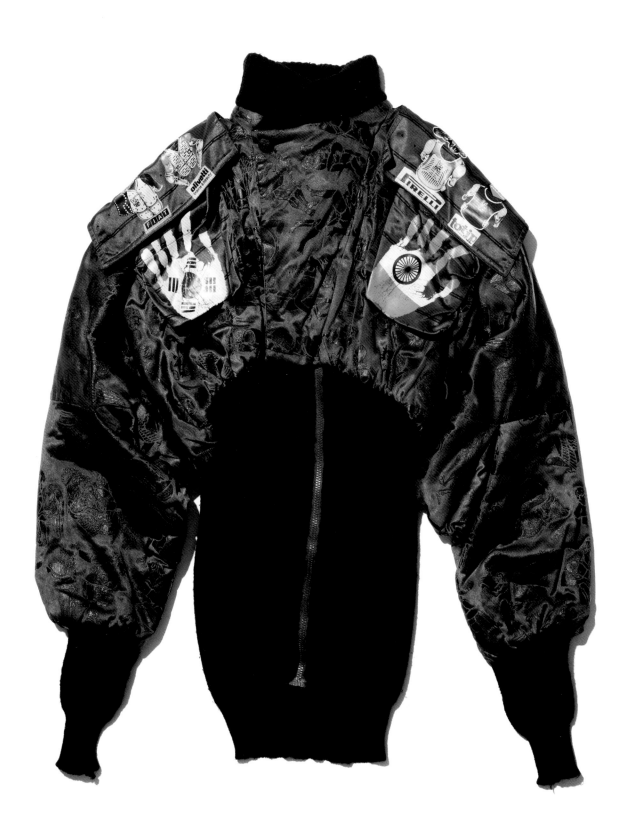

Vivienne Westwood
Clint Eastwood Jacket

This is the jacket from Vivienne Westwood's 1984-85 Fall/Winter collection, Clint Eastwood. The season was symbolized by its vibrant, neon coloring, big silhouette, and clothes covered in corporate logos and Day-Glo patches, which were in turn inspired by Tokyo's neon lights. I received this particular jacket from a girlfriend who was a model at the time. I loved the piece so much; I wore it very often. Better yet, back then, the brand had this power where I could have worn anything by Vivienne Westwood without any complaints.

Vivienne Westwood
Pirate Jacket

A jacket from the Fall/Winter collection Pirates from 1981-82, the year when Vivienne gained attention for holding her first-ever catwalk show. While it may appear as a classic checkered pattern on first sight, the jacket actually reflects Vivienne's preferences down to its precise details: pieces of red fabrics as accents, the original pirates pattern on the lining, and the gorgeous A-line silhouette. Vivienne herself gave me this jacket the first time I went to London. Several seasons had passed since the Pirates collection, and Vivienne knew I had been searching through her archives for quite some time, so she gave me this jacket as a gift. It goes without saying that this is an unforgettable piece that I will treasure my entire life.

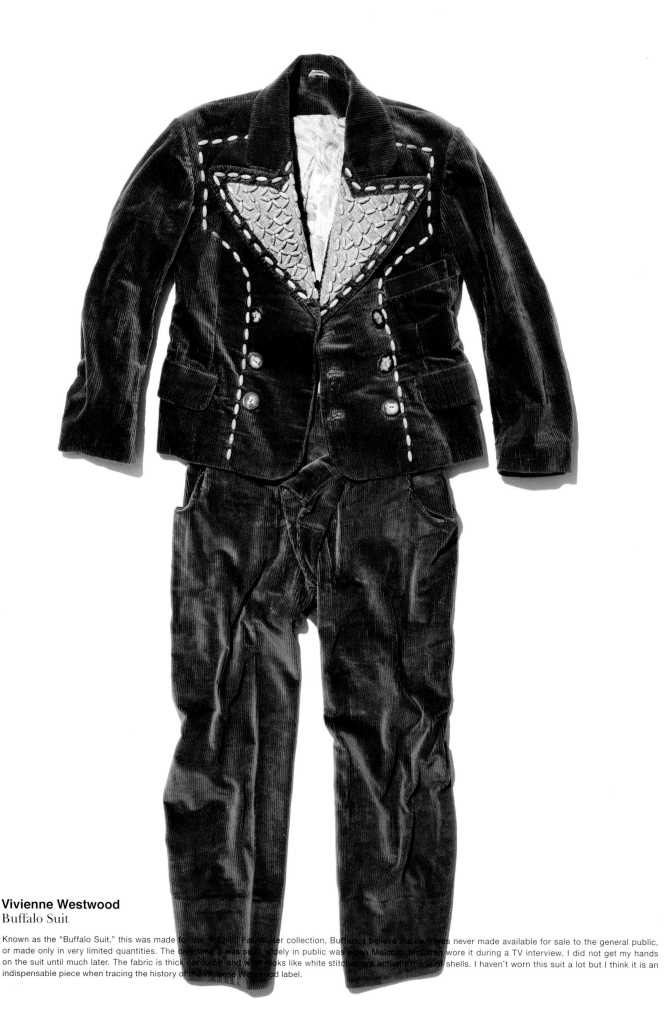

Vivienne Westwood
Buffalo Suit

Known as the "Buffalo Suit," this was made for the autumn Fall/winter collection, Buffalo. I believe the item was never made available for sale to the general public, or made only in very limited quantities. The one time it was seen widely in public was when Malcolm McLaren wore it during a TV interview. I did not get my hands on the suit until much later. The fabric is thick corduroy, and what looks like white stitching are actually made of shells. I haven't worn this suit a lot but I think it is an indispensable piece when tracing the history of the Vivienne Westwood label.

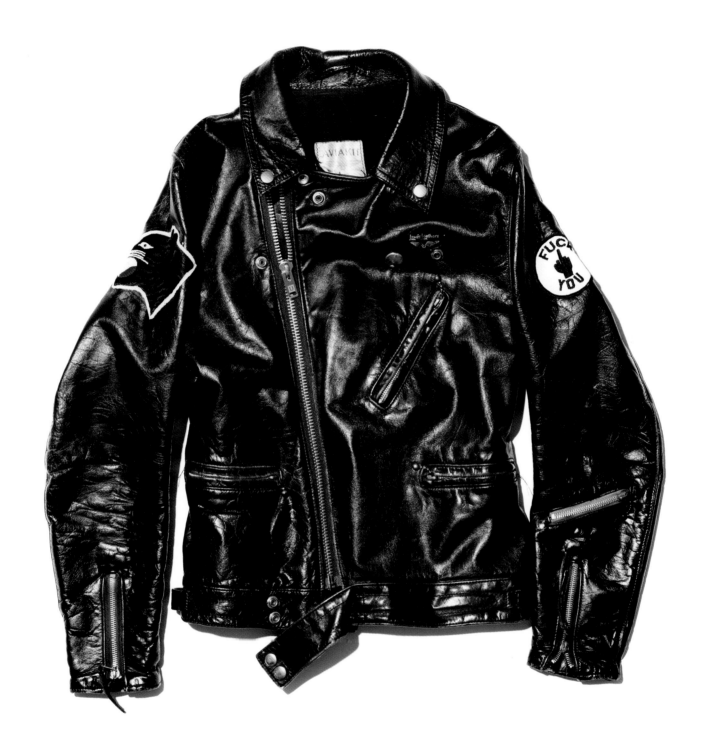

Lewis Leathers
Cyclone

I was overcome by a leather jacket obsession three or four years ago. I learned the meaning of a leather jacket from the three leather jacket experts: Jonio from UNDERCOVER, Hikaru from Bounty Hunter, and Takishin from Neigborhood. The journey took me at last to the Cyclone. The jacket is vintage, but I had it customized at Undercover. We made the silhouette a little tighter and swapped the original zipper with the one made by UNDERCOVER. The Cyclone, when compared with Schott, has a longer length and has no kilting so it's easier to wear. Of the two patches on both arms, the left one is from Takishin while the right was transplanted from another leather jacket I owned in the 1980s. I have a few of this same jacket in other colors like navy. At this rate, I don't think the leather jacket fever will subside for quite some time.

SEDITIONARIES
Donkey Jacket

I'm sure a lot of people hold a DIY image of punk fashion, such as a t-shirt riddled with holes or safety pins, but Seditionaries as a brand drew a firm line at such assumptions. While referred to as punk, the brand greatly inspired many designers with its superior sensibility and sophisticated design. I learned about this brand from Vivienne and Malcolm in the late 70s, but back then prices were prohibitive and there were only a few items available in Japan that I could get my hands on. A version of this inside-out jacket made with a different type of material was available at Harajuku's SMASH, a store that's sadly closed now. The fact that I had stood before the jacket in admiration is a fond memory.